917
.16
044
Bar

9014

Barrett, Irwin R.
 Wilderness Nova Scotia : a photographer's journal /
Irwin R. Barrett. --Halifax, N.S. : Nimbus Pub., 1997.
 xiv, 122 p. : col. ill., map.

 856774 ISBN:1551091410

1. Natural areas - Nova Scotia - Pictorial works. 2.
Nova Scotia - Pictorial works. I. Title

119 98FEB09 3559/cl 1-505175

Wilderness Nova Scotia
A Photographer's Journal

Wilderness Nova Scotia

A Photographer's Journal

Irwin R. Barrett

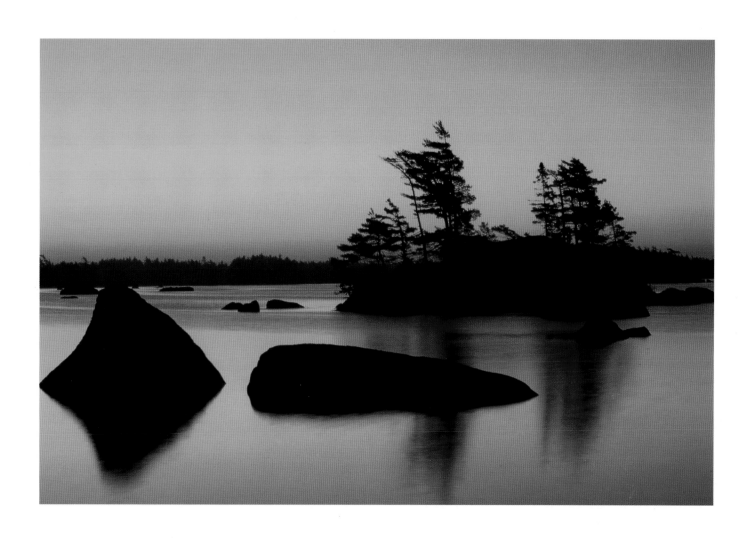

NIMBUS
PUBLISHING LTD

Nimbus Publishing Limited
PO Box 9301, Station A
Halifax, Nova Scotia B3K 5N5
(902)455-4286

Design: Arthur B. Carter, Halifax
Printed and bound in Hong Kong

Canadian Cataloguing in Publication Data
Barrett, Irwin R.
Wilderness Nova Scotia
ISBN 1-55109-141-0
1. Natural areas—Nova Scotia—Pictorial works.
2. Nova Scotia—Pictorial works.
I. Title
FC2312.B37 1997 917.1604'4 C97-950065-6
F1037.8.B37 1997

Title page: The molten colours of dawn overwhelm Sand Beach Lake in the Tobeatic wilderness.

This book is dedicated to all those who love wilderness and strive to protect it wherever it still exists.

Table of Contents

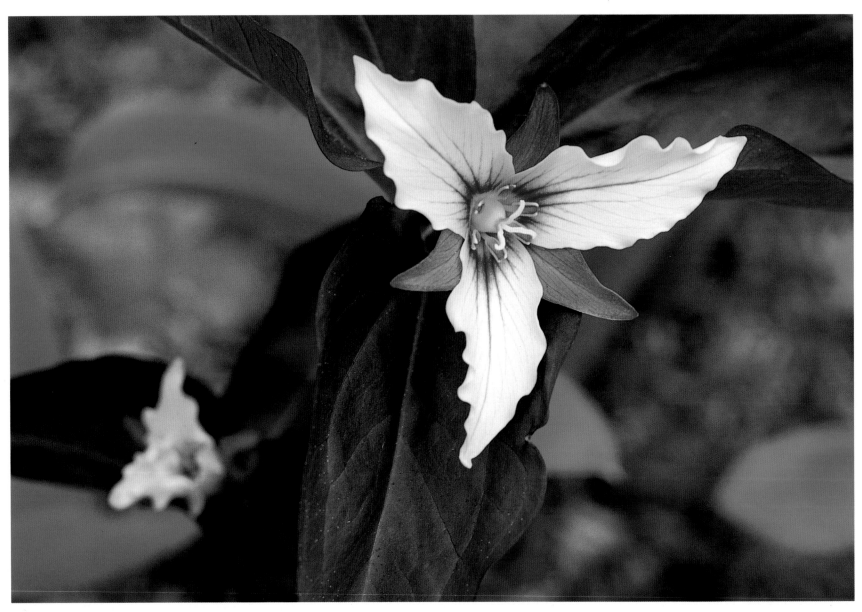

Painted trilliums are one of Nova Scotia's most
distinctive spring wildflowers.

Acknowledgements

There are many people without whose assistance this book would not have been published: First and foremost is Dorothy Blythe, Managing Editor of Nimbus Publishing, whose patience with me over the three long years I have spent in getting this book together now seems remarkable. Thank you for giving me the chance to do this book!

Thanks to John Leduc, Planner with the Department of Natural Resources, Parks and Recreation Division, whose first-hand knowledge and experience with Nova Scotia's wilderness was an invaluable resource.

The publication Natural History of Nova Scotia by M. Simmons, D. Davis, L. Griffiths, and A. Muecke, Nova Scotia Department of Education and Lands and Forests, 2 vols., 1984, revised 1989, was an indispensable foundation for my research.

I am grateful to the helpful staff of both Kejimkujik and Cape Breton Highlands National Parks, especially to Elaine Wallace and James Bridgeland of Cape Breton Highlands National Park for their assistance.

Thanks to Alex Wilson, Curator of Botany at the Nova Scotia Museum of Natural History, for his endless generosity in helping me identify so many different botanical subjects over the years, including some of the subjects in this book.

Thanks to Scott Leslie and Don Rice of the Tobeatic Wilderness Committee for their knowledge and concern about the Tobeatic wilderness.

I am grateful to Oakie Peck for his considerate time and the gracious use of his helicopter and family cabin.

Thanks also to both my sister and brother, April and Herman Barrett, for the long, tough hours spent typing this manuscript; and to my parents, Herman and Vivian Barrett, without whose long-suffering love and support throughout the years, this book would not have been possible.

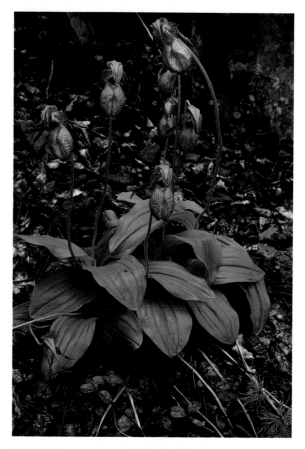

Lady's slippers nurtured by the forest environment.

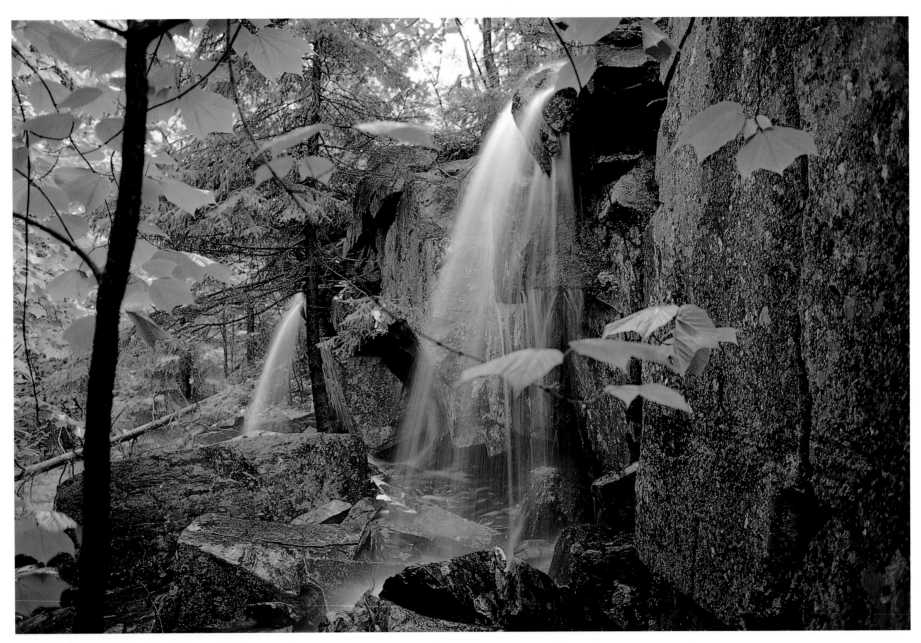

A memory of woods and waterfalls now vanquished
by development.

Preface

Wilderness is not always something that is found only in remote places. For some of us lucky enough, it can sometimes be found near our homes in small pockets of wilderness that have managed to escape a developer's eye.

As a boy growing up in Bedford, I had only to walk a few feet up my street, exit a power-line, and cross Parkers Brook to be in woods that stretched unbroken for several kilometres to the outskirts of Waverley and Dartmouth.

Years later, this route was altered when the Bedford By-pass Highway was completed in the mid-1970s, isolating a small section of the forest where I had played as a child. My woods were now a hundred-acre wilderness surrounded by houses and roads.

It wasn't until September 1977, when I first became interested in nature and landscape photography, that I came to appreciate what a rare and wonderful little forest this really was. I have never found another comparable forest containing such natural features packed into one small area.

The forest was a mixture of hardwoods and softwoods with trees such as red maple, white and yellow birch, red oak, white pine, balsam fir, and black, white and red spruce. Veiled in the shadows of these trees were glacial erratic boulders, some the size of half-ton trucks.

There were areas of lovely hardwood meadows of wild grasses and ferns. In summer, some of these meadows were thick in luxuriant swatches of cinnamon ferns that grew so high they reached my chest, as I waded through them as unobtrusively as possible to avoid marring their perfection.

The forest, except for areas near Parkers Brook which formed one boundary edge, was divided into a series of low granite ridges rising gradually to a hill beyond the Bedford By-pass Highway.

Cascading over these sometimes sheer cliff ridges were five sets of waterfalls, including one double or twin set only a few metres apart, flowing into streams wandering down through the woods into Parkers Brook and eventually emptying into Bedford Basin.

These waterfalls, ranging anywhere from 3 to 6 metres in height, reached their pinnacles of beauty after heavy spring and autumn rains, while in summer they were reduced to nearly invisible trickles.

On the flat ridges there were open barrens of blueberry, huckleberry, lambkill, and rhodora bushes, mosses, bare rock surfaces, and glacial erratics of all shapes and sizes covered with lichens.

The forest nurtured many kinds of wild-flowers such as bunchberries, painted trilliums, blue violets, starflowers, mayflowers, Indian pipes, and common lady's slippers. One year I discovered a rare cluster of nine pink lady's slippers growing together. I couldn't believe what I was seeing because common lady's slippers generally grow alone.

The forest kindled in me an enduring love for its abundance of ferns such as bracken, New York, Christmas, hay-scented, as well as cinnamon. I became captivated by their delicate, graceful shapes, their finely patterned textures and their spring through summer deepening shades of green, transforming in

autumn to yellows, oranges, golds (some, like the small New York ferns, fading to albino whites) to dying rusts.

On autumn days the hay-scented ferns, especially when wet, perfumed the forest with a fragrant aroma not unlike the pungent scent of fresh pipe tobacco.

It was in these woods that I cut my teeth, photographically speaking, where I matured as a nature and landscape photographer. This forest inspired me with its natural features—which have become enduring themes in my photography—such as waterfalls, flowers, and ferns. I became intrigued with capturing on film the simple beauty of the small waterfalls found in these woods. I still prefer the tranquil presence of a whispering waterfall to the thundering torrents of an overpowering one.

Having a pocket of wilderness so close by, a sanctuary where I could photograph such a marvellous array of subjects, was like living next to an unlikely paradise. When I couldn't, for whatever reasons, go further afield to photograph, I always had my forest to turn to for inspiration.

But storm clouds were gathering over paradise. One afternoon in August 1984, during a walk through the woods, I chanced upon a newly cut survey line. Further investigation found other lines cut as well, many intersecting each other. My heart sank for I knew what this grim sight implied: nearby, a large housing development had been in progress for several years; now its destruction was at my own doorstep. Reality was a bitter pill to swallow.

A few months later the onslaught began with the carving out of two major streets through

the forest, and the commencement of blasting to clear away obstructing granite ridges, destroying in their wake the most beautiful waterfalls in the entire woods and diverting their water courses.

It is now over a decade since development began, and the forest has long since disappeared. Ridgevale Village, a quiet and pleasant area, is now an attractive community with large ornate homes.

But for me and possibly a few of my neighbours, it will never compare to the wild and natural grandeur of its former self. A tiny wilderness enclave of fern glades and meadows, open barrens, granite ridges and cliffs, and a forest filled with wildflowers and coursing with waterfalls—these images remain in my memory (and in my slide files) as the most exquisite I have ever seen.

Man can never create or replace the glory of the natural world—the loving handiwork of the Creator. All we can do is try to preserve it for the sake of every living plant and creature—and for our own sakes. Our survival on this planet depends on a healthy functioning and intact natural environment.

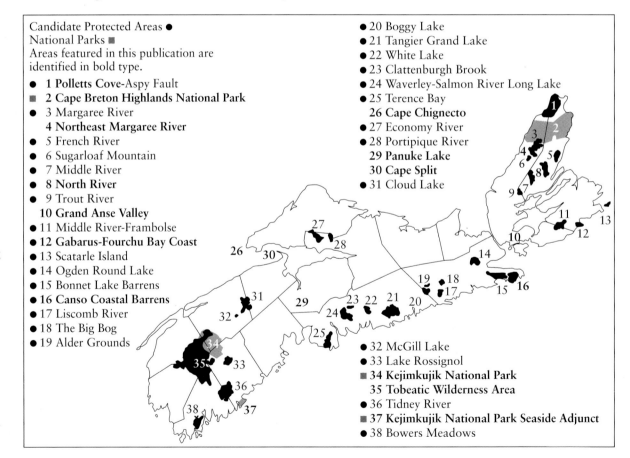

Candidate Protected Areas ●
National Parks ■
Areas featured in this publication are identified in bold type.
● **1 Polletts Cove**-Aspy Fault
■ **2 Cape Breton Highlands National Park**
● 3 Margaree River
4 Northeast Margaree River
● 5 French River
● 6 Sugarloaf Mountain
● 7 Middle River
● **8 North River**
● 9 Trout River
10 Grand Anse Valley
● 11 Middle River-Frambolse
● **12 Gabarus-Fourchu Bay Coast**
● 13 Scatarle Island
● 14 Ogden Round Lake
● 15 Bonnet Lake Barrens
● **16 Canso Coastal Barrens**
● 17 Liscomb River
● 18 The Big Bog
● 19 Alder Grounds
● 20 Boggy Lake
● 21 Tangier Grand Lake
● 22 White Lake
● 23 Clattenburgh Brook
● 24 Waverley-Salmon River Long Lake
● 25 Terence Bay
26 Cape Chignecto
● 27 Economy River
● 28 Portipique River
29 Panuke Lake
30 Cape Split
● 31 Cloud Lake
● 32 McGill Lake
● 33 Lake Rossignol
■ **34 Kejimkujik National Park**
35 Tobeatic Wilderness Area
● 36 Tidney River
■ **37 Kejimkujik National Park Seaside Adjunct**
● 38 Bowers Meadows

Introduction

When I was approached to do this introduction in the fall of 1996, I was encouraged by the slow but sure progress that Nova Scotia had made toward a new provincial system of protected areas: thirty-one wilderness areas in the province had been recently designated as candidates for protection under the system. These, added to the national parks, increased the percentage of the province's protected areas to over 8 per cent of total land mass. While this currently ranks Nova Scotia third after British Columbia and Alberta, all provinces are committed to doing even better.

Nova Scotia, because of its location on the Atlantic Ocean and its unusual geological history (parts of it were once West Africa), has widely diverse landscapes in a relatively small area. In this important book, Irwin Barrett, a dedicated landscape photographer, has beautifully captured the flavour of that rich diversity. However, there is not much wilderness left in the province. Nova Scotia is one of the most densely populated provinces in Canada, and its remaining undeveloped lands have traditionally supported forestry, an activity which is increasingly pervasive and intense.

Unfortunately, in December 1996, the government removed the Jim Campbells Barren in northern Cape Breton from the sites to be protected because of the promise of jobs from those who successfully lobbied for its delisting.

The thirty-one new protected areas suddenly became thirty for the sake of economic opportunity. The development pressures which have claimed and changed most of the province's landscape—and which protected areas are meant to withstand—have again reduced our heritage. Action must soon be taken if we are to preserve what little wilderness remains.

Before preserving representative portions of land became a priority for concerned environmentalists, two national parks had been created in the province: the Cape Breton Highlands National Park in 1936 and Kejimkujik National Park in 1968. In the deep valleys of the Cape Breton Highlands National Park are lush hardwood stands that surely must belong further south. Most of the park, the plateau, is seldom visited—except briefly at highway speeds. It is characterized by balsam fir forest and bogs, except at the highest elevations where the trees give way to bogs and barrens.

Kejimkujik, at the centre of the other end of the province, is characteristic of the Atlantic Coast Uplands sitting on granitic rock lightly covered by the debris of the last glaciation. Located as far from the ocean as one can get in Nova Scotia—which isn't very far—it is known for its tea-stained lakes and rivers and the canoeing opportunities these provide. More of the park is forest—some of it old hardwood and mixed wood stands—but most of it is younger, recovering from the cutting prior to the park's creation.

Kejimkujik later gained an adjunct on the Atlantic coast at a time when Nova Scotians were concerned about foreign ownership of many of the province's beaches. Eventually the adjunct became part of Kejimkujik, adding softwood forest, coastal ponds and headlands, and dune and beach systems to the park. Among the

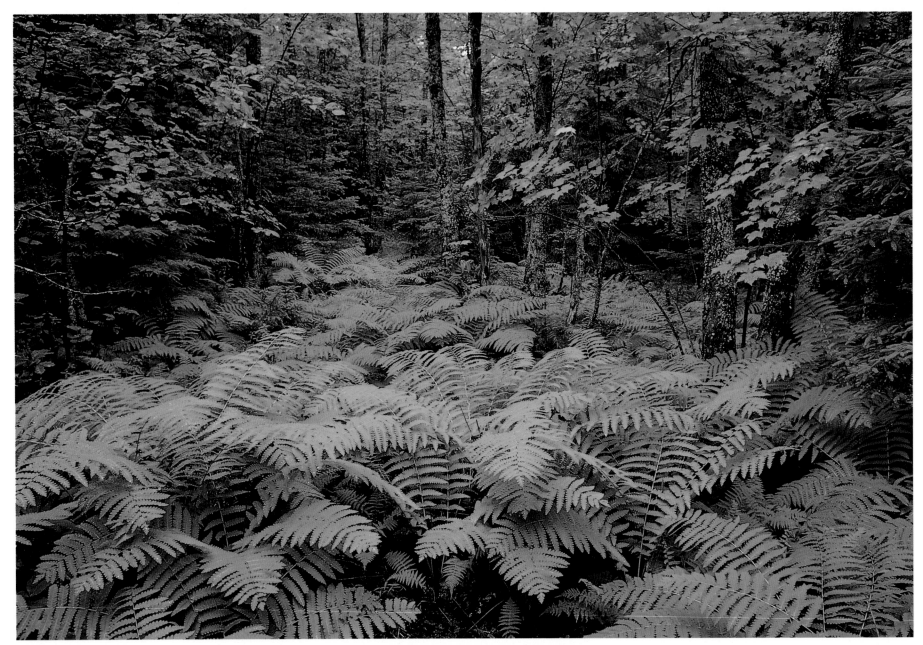

A forest glade of cinnamon ferns at Bedford.

beach's summer residents is the endangered Piping Plover.

During the sixties and early seventies, the smaller-scale provincial parks evolved from picnic and camping parks to a system which included recreation and natural areas. This evolution was facilitated by the private donation of outstanding properties such as Cape Blomidon. Within the existing provincial park system, there are about two dozen properties with significant natural features.

Ecological reserves came into vogue in the seventies, partly as an effort to save fragments of rapidly disappearing habitats. These Nature Reserves, as they are called in Nova Scotia, are not necessarily small and fragile. The Tusket River Nature Reserve, for example, supports species along a lake shore that can tolerate nine months of immersion and three months of exposure. This site is also home to the endangered Plymouth Gentian and the vulnerable Pink Coreopsis, two pink flowered Atlantic Coastal Plain species. The province now has seven nature reserves—the rest are old forests—and a long list of candidates. Thus we entered the nineties with the two large national parks and a selection of smaller provincial sites.

In 1994 the provincial Department of Natural Resources released A Proposed Systems Plan for Parks and Protected Areas in Nova Scotia. This plan listed thirty-one crown land areas across the province as candidate sites for protection. With the national and provincial parks, this area, amounting to about 8 per cent of the province, moves us toward the federal government's Green Plan, the United Nations' Convention on Biological Diversity, and the

Sustainable Development Strategy for Nova Scotia, which all urge a land area minimum of 12 per cent be set aside to preserve biodiversity. Achieving these representation goals will require further effort, much of it involving private land owners.

The intentions of the Proposed Systems Plan and the provincial government's recent Protected Areas Strategy (and the legislation to enact it) appear good. The process is that each candidate site will be officially designated for protection with management plans for each one developed in consultation with surrounding local communities. Until each area is formally designated, the existing moratorium on land use will be in effect.

A closer look at what protection will mean reveals both limitations and promise. All forestry and new mineral claims will be prohibited. Existing mineral claims will be honoured. Traditional hunting and fishing are, for now, permitted, with final decisions for each area to be made as part of the management planning process.

The widespread and often severe damage caused by ATVs and other off-road vehicle use is being addressed. The government has accepted the recommendation to exclude motorized use, except in limited cases for access to existing camp leases or private land inholdings.

Of course, these advances apply only to the wild areas that are part of the systems plan. Many of our wild places remain unprotected.

The integrity of this major protection advance is called into question by the removal of Jim Campbells Barren from the list of candidate sites. The reason given for its removal

is mineral exploration jobs and a mine potential in this already heavily explored region. The Jim Campbells Barren, a small site on the northern Cape Breton plateau with a lichen barren and other unique features, may hardly seem worthy of protest, but that is how our wilderness heritage gets lost—in small pieces and without a whimper.

Using this precedent, another candidate area has been threatened with removal from protection. The Tobeatic is the gem of the system: headwater for eight rivers; a mix of forest, barren, bogs, and lakes; the core of Nova Scotia native moose population; and (with adjacent Kejimkujik) the largest protected piece of the Acadian forest.

A Proposed Systems Plan for Parks and Protected Areas in Nova Scotia is a significant step in the right direction towards conservation, but it is only the first step. How we respond now to the warning bell sounded by the removal of Jim Campbells Barren from the candidate site list will determine if we succeed or fail, whether future generations will thank us for our vision and courage or condemn us for our short-sighted ignorance and greed.

Colin Stewart
Endangered Spaces Coordinator,
World Wildlife Fund-Nova Scotia
March 1997

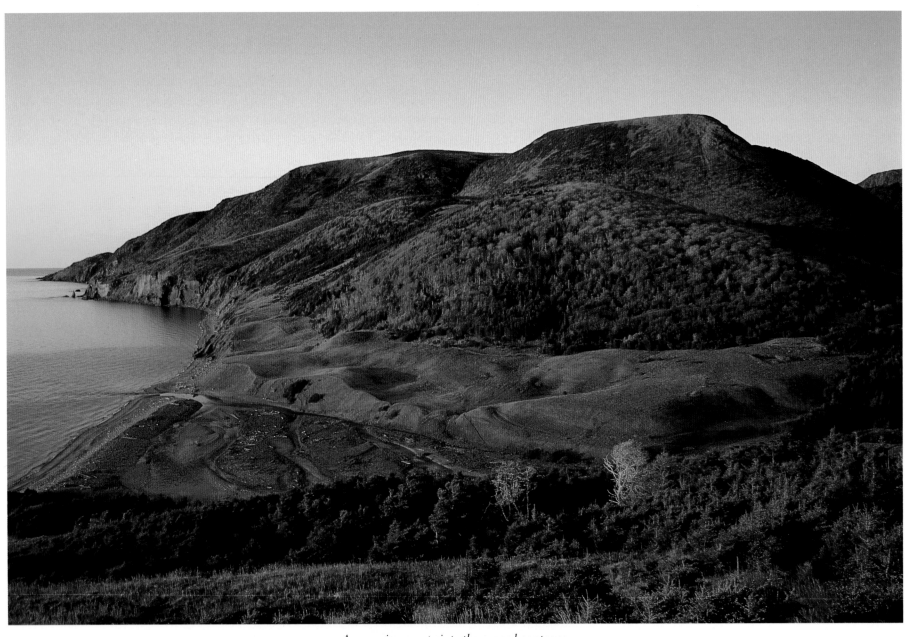

*An evening sun paints the rugged contours
of Polletts Cove.*

Polletts Cove

Located along the precipitous coast of northwestern Cape Breton near Pleasant Bay is one of the most outstanding wilderness areas in the province. Polletts Cove is a small coastal valley into which two river canyons emerge, the Blair River and the Polletts Cove River. These small and shallow rivers join at Polletts Cove Beach to empty into the Gulf of St. Lawrence.

Flanking the edge of the cove are large, overgrown fields in which a farmer still pastures his cattle every summer after driving them along the remote coastal hiking trail accessing the cove from Red River. In the nineteenth century there existed at Polletts Cove a small fishing village whose only entry was by boat or the foot path to Pleasant Bay. The fields and a few old stone walls are all that remain.

Polletts Cove, sheltered between the highlands on either side of the two rivers, with its sheer coastal views along the Gulf of St. Lawrence make for a very dramatic setting in itself. But the most impressive and important features of the cove are its two hidden river canyons resplendent with old-growth hardwoods of mainly sugar maples or yellow birch with some white birch, balsam fir, and the occasional American elm.

The vintage hardwoods of the Blair and Polletts Cove Rivers are productive habitats for a rich variety of bird species such as woodpeckers, warblers, nuthatches, and bald eagles. Although there are some moose, black bears, and coyotes around, the higher talus (rock rubble) slopes of the canyon support a number of smaller mammals such as Gaspé shrew and rock vole (usually found in more northern or mountainous areas), southern bog lemming, and weasels.

To get to Polletts Cove you take the road from Pleasant Bay to Red River, going past Red River on a dirt road that follows the steep coastline until you come to a small bridge and a lone cabin where the road ends. From here the Polletts Cove trail starts and ends, a 19.2 kilometre (12 mile) return trail that skirts the sheer rugged coast about 150 metres (492 feet) above sea level and which I found to be one of the most strenuous hiking trails in the province.

My first hike along this sometimes tortuous trail to Polletts Cove began late one morning during the second week of June 1993. The trail started out as an old cart-track crossing the field next to the cabin and descended through spruce woods over an old gate and down to Archies Brook about a kilometre away.

Crossing the shallow brook the trail became a narrow footpath that wound its way up a steep hillside. As I staggered like an old lame pack mule under all my gear, I had to stop and rest so often that I began to wonder what I had gotten myself into.

I finally huffed and puffed my way to the top where the path became a scenic vantage point looking back along the coast to Red River and a distant tiny Cabot Trail zigzagging up MacKenzies Mountain from Pleasant Bay.

Thankfully, the trail levelled off about 150 metres (492 ft.) above sea level, while passing through a couple of diminutive trickling brooks and some stunted but nice stands of newly leafed white birch. I was surprised when, after

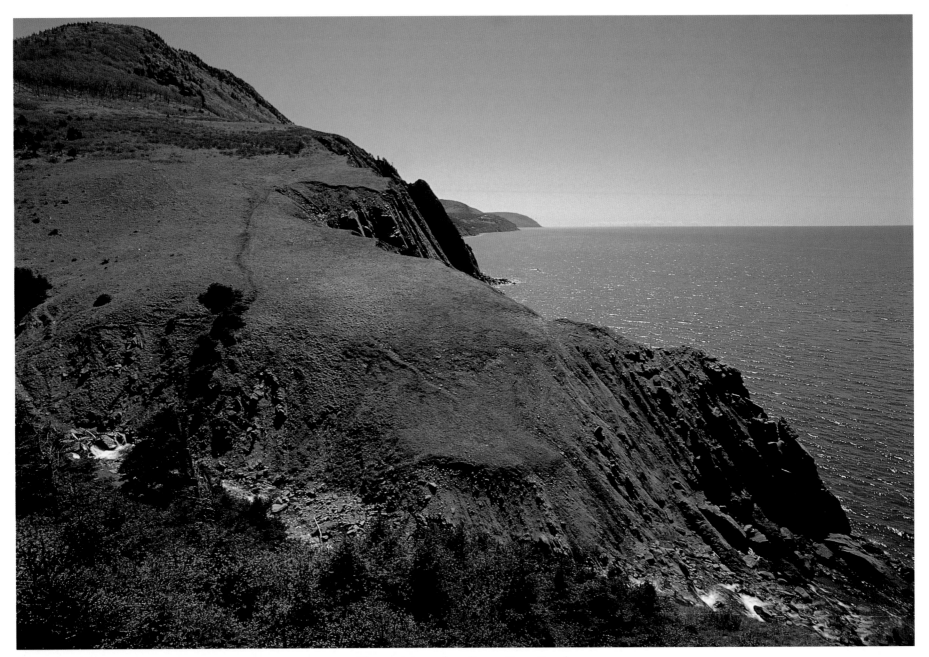

The precipitous coastline at Otter Brook.

almost 5 kilometres, the trail unexpectedly opened out onto a large field overlooking the craggy coastline, and I glimpsed Otter Brook below, nestling into the highlands.

I followed the path down to the brook where a small group of hikers—mostly young women—greeted me as they crossed the brook and made their way up the mountainside I had just come down. I didn't envy them their climb.

Because of my gear, I had to make two trips across the brook, jumping stepping stones and praying I wouldn't fall in. Then it was up the grassy hillside and out on the edge of a small cliff overlooking the brook where it flowed across jagged rocks into the embracing waves of the gulf.

The coastal views from Otter Brook were spectacular. The mountains and cliff faces were a sheer drop into the sea that receded into the distant blue horizons of the Gulf of St. Lawrence. An early afternoon sun sparkled in a thousand points of silver upon deep blue water tinged with shades of aquamarine along its shallow margins. With such a dramatic vista of mountains, sea, and sky before me I felt reluctant to leave this awesomely beautiful place.

To find the main trail to Polletts Cove I had to return to the field and start over. This time the climb was much easier. The trail levelled off, hugging the contour of the steep mountainsides but becoming even narrower, more precipitous, and dangerous in many places. After crossing a couple of small brooks, I passed through a lovely meadow of stately old-growth sugar maples. I lingered here for a short while, enjoying the ambiance of the towering hardwoods and the spicy scents of new ferns perfuming the warm air.

A few kilometres from there I finally crested a small hill onto a wide grassy field overlooking the scenic backdrop of Polletts Cove's striking mountains, river valley, and wild lofty coastline. After a tough 9.6 kilometres (6 miles) I had finally made it to Polletts Cove.

Hiking to Polletts Cove is like a lazy stroll in a park compared to hiking out. I've made two trips to the wilderness areas of Polletts Cove and on both journeys I literally prayed for the strength to make it back out the trail to my car, and I'm a fairly big guy, strong and healthy.

Part of the difficulty is that, as a photographer, I wear a camera vest loaded with lenses and accessories under a heavy backpack while balancing a camera on a tripod slung over one shoulder. After a few days of camping, hiking, and photographing from dawn to dusk, and living on limited rations (carrying a stove with various utensils and lots of food is too much extra weight), hiking these excessively steep trails over 200 metres (650 feet) or so high can be torturous. I often envy the ordinary backpacker who carries some food, a tent, and a few belongings.

Once you're down in Polletts Cove it helps if you have rubber boots (I did) to cross the wide, shallow mouth of the bone-chilling river, so you can set up camp in the old fields or woods near the rivers. Even with boots, I encountered several problems while camping at Polletts Cove.

Foremost are the often gale-force winds that blow into the cove from the broad expanse of the open Gulf of St. Lawrence. That first night I camped there, the wind abruptly picked up from the gulf and blew hard onshore in icy gusts. Even with all my clothes on and a space blanket over me in my sleeping bag, I shivered until dawn when the winds finally died out.

These gales off the gulf can be common enough, but the worst storm I ever experienced while camping was my last night in Polletts Cove in late October 1993. It had gotten windy the preceding afternoon, but a few hours after nightfall the storm increased to near hurricane proportions. Combined with intermittent sheets of rain, the frenzied gusts of wind whipped down from the surrounding highlands and funnelled through the Polletts Cover River valley and out to sea.

The storm pounded my tiny tent so severely that it collapsed four times that night, no matter how hard I fought to anchor it.

The second problem encountered, at least in the summer, is a small herd of cattle that is sometimes found roaming the old fields in the cove. When I was there, most were young and fearless bulls. Two in particular checked to see if the tent was something tasty to eat. Images of being suddenly charged by these "bullies" flashed through my mind, so I quickly decided to move to a safer spot, a grassy flood plain between the cove's two merging rivers.

A few hours later I came back from photographing Polletts Cove at sunset, and I was not surprised to find my tent flattened to the ground. Luckily though, my supplies were not trampled.

The most important wilderness areas of Polletts Cove are located up the Blair and Polletts Cove Rivers. These rivers are shielded by mountains of the Cape Breton Highlands through which they flow, forming river canyons or valleys. On my first trip, I explored the Polletts Cove River, which flows straight up the valley from the beach. On the ancient field between where the Blair and the Polletts Cove Rivers meet, there is a

weathered cart-path which runs through some stands of white spruce and balsam fir leading to a large open field with a small cabin. I followed an obscure little path along the river through an old-growth forest of mainly yellow birch with a few sugar maples, white birch, and balsam fir as well.

Along higher parts of the path, sweeping views of the newly green birches set against the backdrop of 397 metre (1,300 ft.) high mountains and the river made for dramatic scenery. Underneath the old-growth hardwoods, the forest floor was covered with a thick carpet of striped maples and yellow birch saplings.

The carpeted forest floor suddenly disappeared as I neared the main river's first tributary, so I decided to hike the short distance down to where it converged with Polletts Cove River.

Here, as in other areas along the tributary and open hardwoods, I found myself exposing a lot of film. The combination of brilliant sunshine and shimmering green leaves contrasted with a dramatic blue sky scattered with puffy white clouds all set against the background of lofty mountains made for superb landscape photographs. Although it wasn't noon yet, my day already felt complete.

Eventually I continued on up the main river, but when the highlands started to recede and bushwhacking against the dense underbrush of young saplings grew wearisome, I decided it was time to turn back.

～⌒～

I managed to return to Polletts Cove and explore the Blair River and its canyon early on a frosted, sunny morning in late October 1993.

A short way along, the thickets of spruce and balsam fir gave way to a beautiful grove of hardwoods, and I soon found myself in what I considered to be the most resplendent old-growth hardwood forest left in the entire province, with the exception of the immense virgin hardwoods near the Lone Shieling. (See the Grand Anse Valley.)

It was as if I had walked through a gateway into a wilderness wonderland. Here stretching for several kilometres along the lower flood plains of the Blair River, sheltered between its two narrow mountain ridges over 397 metres (1,300 ft.) high, were magnificent noble groves of old-growth sugar maples. Beneath their imposing golden crowns were spacious open meadows of grasses, maple saplings, and a rich diversity of ferns.

Most of the trees were at their peak flush of colour—brilliant yellows, oranges, or darker golds.

Walking along the expansive parklike meadows of the river, beneath the radiant colours of venerable sugar maples, I had a wonderful feeling of liberation. Here the only sound was the occasional sigh of leaves in the breeze or the soft trickle of water over rocks in the river. I believed I had found the most enchanted place in Nova Scotia—my own Shangri-La.

I have often recalled my amazement at the beauty I found in the meadows along the Blair River. A place this uncommonly lovely and undisturbed is an outdoor temple where the majesty of creation embraces you in all its fullness.

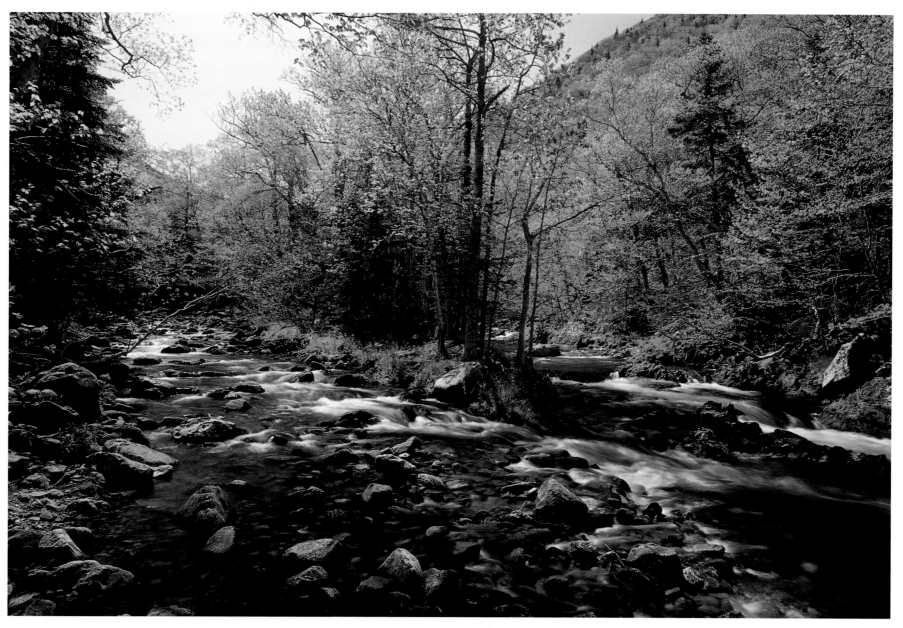

Spring along the Polletts Cove River.

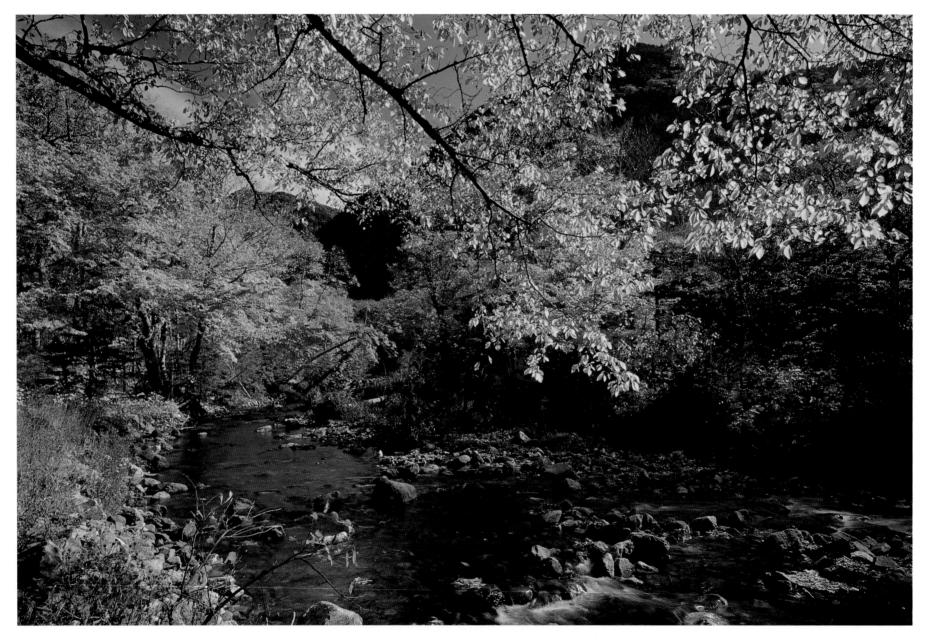

Blair River and Cape Breton Highlands.

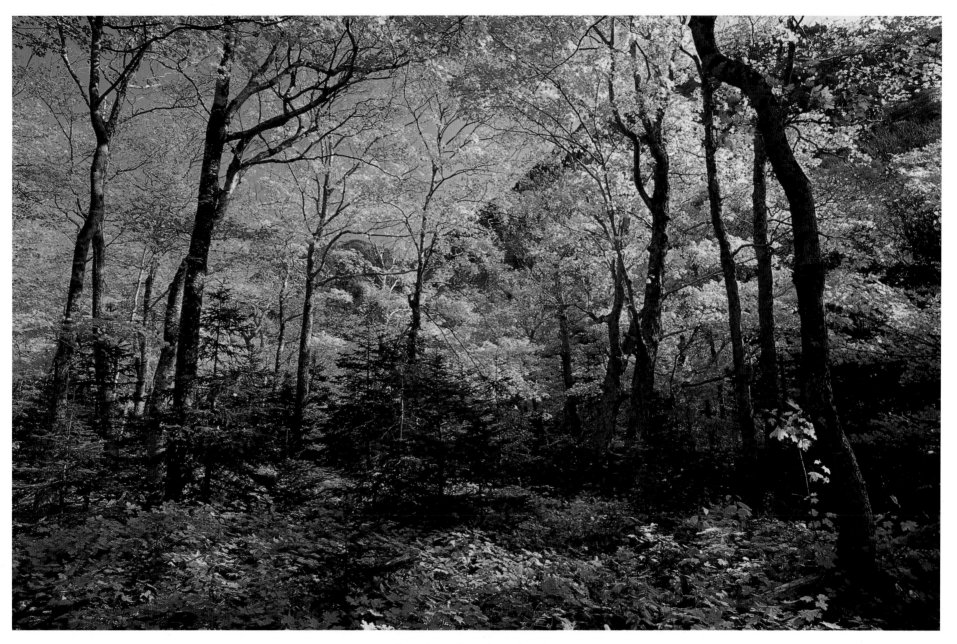

Hardwood meadow along the Blair River in
splendid autumn foliage.

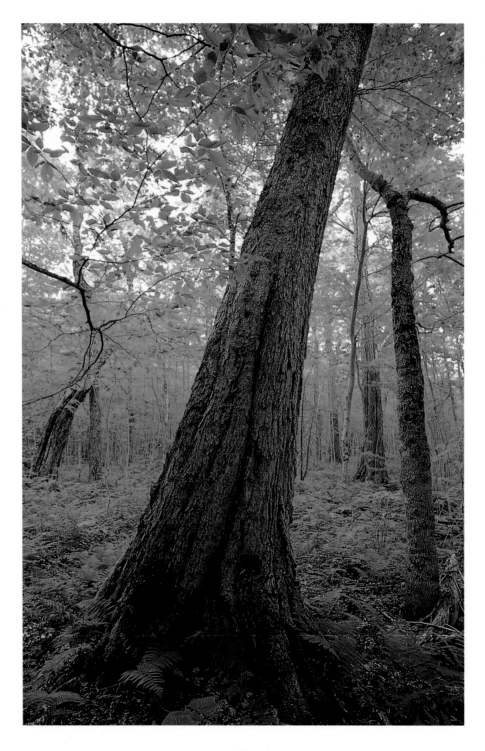

Grand Anse Valley

Although this valley is part of the Cape Breton Highlands National Park, it is so unique to the wilderness of Nova Scotia that it deserves its own chapter. Located near Pleasant Bay, Cape Breton, the Grand Anse Valley swings south at the base of North Mountain beginning at the Lone Shieling monument in the national park. From here the river runs through a deep sheltered valley surrounded by mountains on each side, some 453 metres (1,486 feet) high and fed by many small rivers and streams flowing down into it from the surrounding highlands.

Farther up this valley, and indeed the other river valleys and highland plateaus of the surrounding national park, is prime habitat for larger mammals such as moose, black bear, and lynx. The legendary eastern cougar, if it still exists in Nova Scotia, would best be rediscovered in this extensive rugged wilderness.

Typical of other areas of the Cape Breton Highlands, the tiny Gaspé shrew and rock vole (representatives of more northern and mountainous mammal species) are found in the rocky slopes of the high valley walls.

This is the largest area, approximately 808 hectares (2,000 acres), of virgin old-growth hardwoods left in the Maritimes. Surprisingly enough, the best examples of this forest are found at the entrance to the valley on the short loop trail at Lone Shieling, the park's monument to the Scottish Highlanders who settled Cape Breton over 200 years ago. Many of the sugar maples here are estimated to be over 350 years old.

In the numerous times I've been here, I have never failed to be impressed by the sheer size and height of these immense hardwoods consisting mainly of sugar maples with beech, yellow birch, and some American elms. These trees tower over 23 metres (75 feet) high and many are over 191 centimetres (6 feet) in circumference. There are trees near the Lone Shieling that two men with outstretched arms would have difficulty encircling. What is also distinctive about this part of Nova Scotia is that it represents the northernmost limit for Alleghanian tree species (trees associated with deciduous forests to the south such as sugar maples) in the Atlantic Provinces.

Whenever I walk beneath these imposing trees I am struck by the thought of what Nova Scotia and the other Maritime Provinces must have been like before the Europeans came with their axes and ploughs, and levelled the primeval forests.

Although hiking off the short loop trail at the Lone Shieling is officially discouraged, I have explored the Grand Anse River valley for several kilometres along old faint trails. Camping is not permitted and hiking is restricted for fear of damage, especially from forest fires.

On my first hike in early June 1993, I was surprised to notice that just beyond the Lone Shieling the most impressive of the big venerable hardwoods were replaced by much smaller ones. Here the valley floor becomes narrower, bringing disruptive erosion factors into play so that the trees never gain the age and size of their kin near the Lone Shieling.

Facing page: The impressive hardwoods of the Grand Anse Valley near the Lone Shieling.

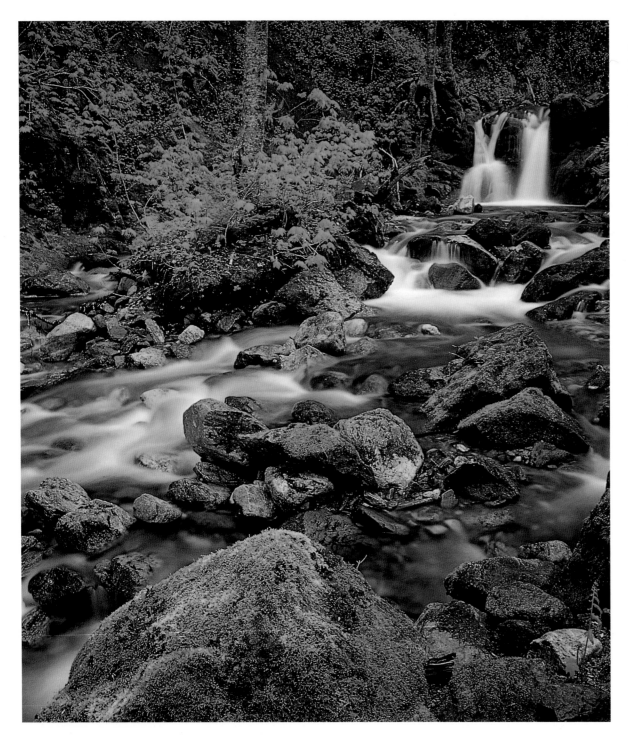

Near the Lone Shieling, the first of many small streams run into the Grand Anse River. Not far up the stream I happily discovered a beautiful waterfall a little over 3 metres (10 feet) high, tumbling down over a rock ledge. Downstream were strewn boulders of differing sizes mantled in coats of the most lush shades of emerald green.

Close by was an old tree trunk growing the most brilliant yellow mushrooms I have ever seen whose name is officially Sulfer Shelf or Chicken Mushrooms, and under the shade of the overhanging trees they almost seemed to glow.

Many kinds of ferns (such as Christmas, oak, wood, and cinnamon ferns) grow in the semi-open hardwood meadows along the Grand Anse River. Although this was early June, there was no evidence of wildflowers, probably because of the shaded conditions caused by the leafy canopy of the trees.

Continuing through the meadows along the main river I quite unexpectedly chanced upon another waterfall. This one was much larger, with a long sloping face over 10 metres (32 feet) high and wedged between steep hills of spruce and underbrush. Not far above this waterfall another stream ran down into the river from one of the surrounding hills in a small series of drops and turns, which also proved to be nicely photogenic.

Waterfall and feeder stream along the Grand Anse River.

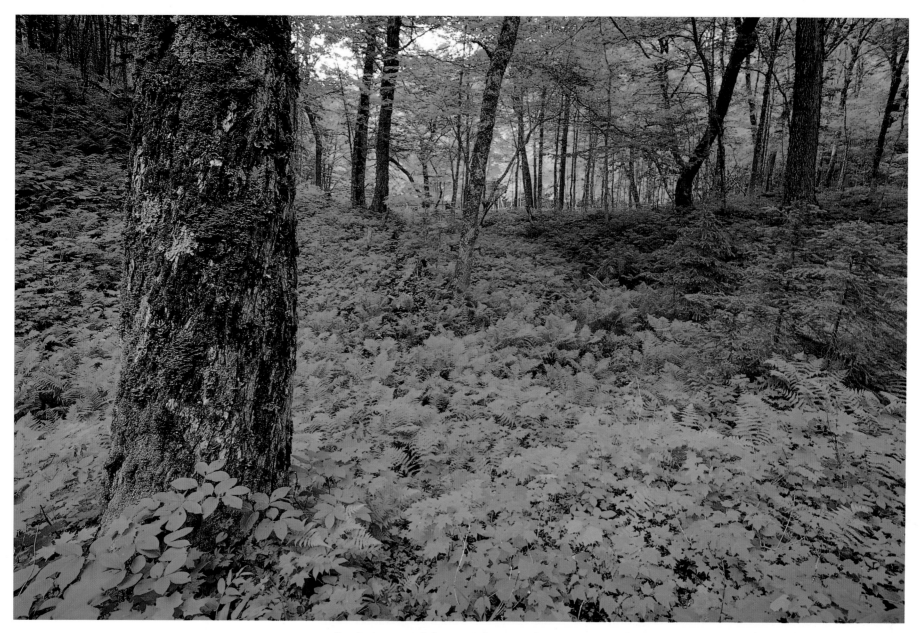

*Bordering one of the river's largest tributaries is
one of its fairest meadows.*

I returned to the Grand Anse Valley, on the second day of summer, June 22, 1994, resolved to explore it to its base where the Grand Anse River comes down out of the highlands. I had obtained permission from the national park to camp in the valley the previous night, but regrettably the weather was bad so I decided to go in one day and out the next, and to photograph only places I had not seen on my previous trip.

I had to criss-cross the river every few hundred metres or so, wearing my old sneakers to protect my feet from the icy waters.

Eventually, the forest changed from predominantly hardwoods to a mixture of younger spruce and fir among the hardwoods, until I came to a small pocket area where the bigger hardwoods predominated, and I had a nice view of the river curving away into the wet forest. But what most appealed to my photographic eye was the glistening sugar maple sapling leaves, the white flowering buds of false Solomon's seal, large cloverlike wood sorrel, and a starflower in amongst blue-bead lily leaves. Everywhere I turned I was tempted to photograph the silvery

radiance reflecting off each plant and leaf.

Reluctantly, I pushed on up the river, stopping to take a few pictures of one of the largest tributaries of the Grand Anse River, which I resolved to explore on my way back out.

It was late afternoon when finally I arrived at a spot where a meadow petered out at the bottom of a hillside out of which the Grand Anse River came tumbling and splashing down from the highlands.

Hiking along the many twists and turns of the river, fording it repeatedly and stopping to photograph its many beautiful places, I presumed I'd travelled 6 or 7 kilometres. I have double-checked a number of topographical maps of the area, and each time I have confirmed the remarkable distance of only 3 kilometres from the Lone Shieling to the valley's end. Distances in the bush can sometimes be deceiving, especially when you're a photographer.

Stopping only to photograph a mossy boulder in the river dotted with wild blue violets, I retraced my steps to the tributary, following its course, until a large open hardwood meadow with some giant trees spread out before me. After just passing through dark and murky softwoods this was a welcome surprise.

In the mud surrounding a small pond were scores of moose tracks, indicating where the great beasts had come down to find water.

Further upstream a miniature waterfall flowed as smooth as liquid silk in the crevice of a moss-carpeted rock ledge. On each side of the waterfall a pair of blue violets grew in the damp moss, one near the top, the other close to the bottom. This was one subject I could not afford to pass by. Setting up my tripod while straddling the stream, balancing between a couple of

Sulfter Shelf mushrooms.

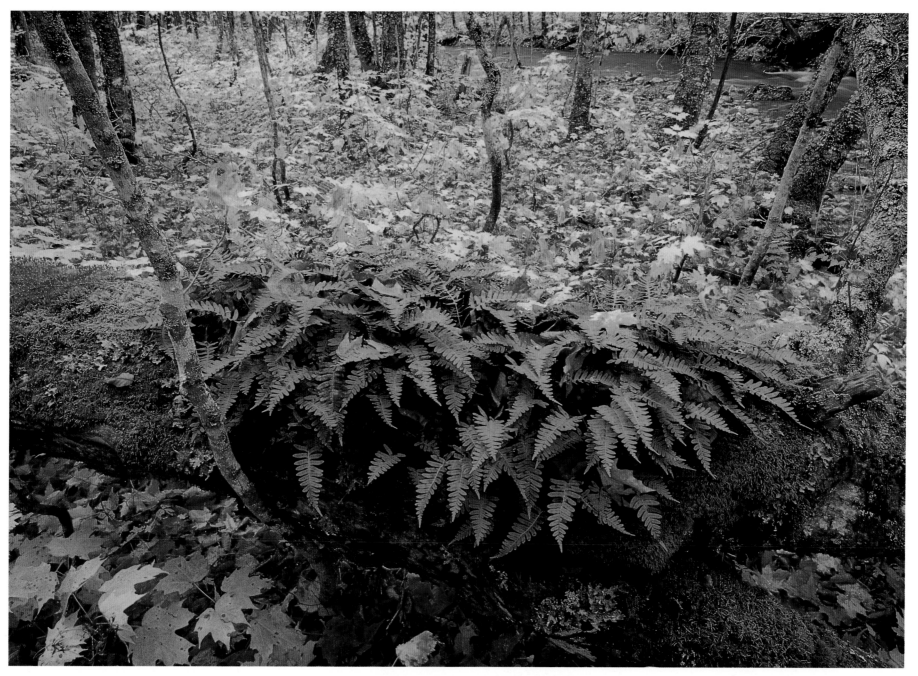

Despite the evergreen rocky polypody ferns,
autumn yellows sweep the Grand Anse Valley.

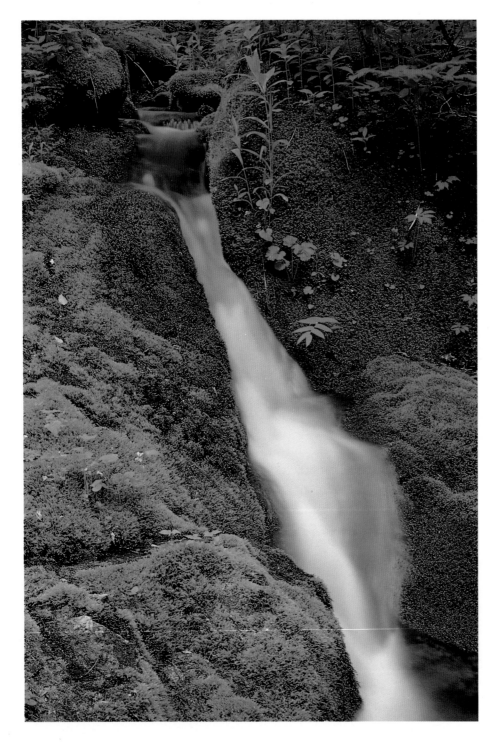

slippery rocks, I shot the scene before me from a number of different angles, finally ending with a close up of a single blue violet and the waterfall swirling behind it like soft flowing mist.

I followed the stream upward until it rounded the base of an abrupt high ridge, and I caught sight of another much bigger waterfall.

Still further upstream was a darkly shadowed pool surrounded by high embankments into which drained a slender ribbon of water sliding down a 5 metre high vertical mossy ledge. Another waterfall! I couldn't believe my luck. But as I began to set up my camera, the sun came out, spotlighting some areas of the waterfall while leaving others in shadows. This uneven light often proves disastrous in photographing waterfalls.

I stood vigil, determined to wait as long as possible for a chance cloud to appear. Almost an hour elapsed before, suddenly, the glowing sunlight disappeared, allowing me to shoot at my leisure.

Having patiently accomplished that task, I backtracked to the lovely and spacious hardwood meadow I had discovered earlier. Of all the wood meadows I had passed through along the Grand Anse River this was the most beautiful, situated between two small streams on one side and a grass-encircled pond on the other.

Beneath the lofty crowns of the meadow's hardwoods, the ground was uncluttered, populated mostly by different species of ferns and a few tiny saplings, not the thick undergrowth of waist-high hardwood saplings found in most other areas of the Grand Anse Valley. In this meadow there was space and freedom.

Evening was coming on so with one last appreciative glance about the meadow, I turned

away and followed the stream back out to where it joined the Grand Anse River and then, through heavy showers, to my car with a few minutes of daylight to spare.

In retrospect, in addition to the Grand Anse Valley's charming hardwood meadows and graceful waterfalls, for sheer inspiration and for lack of a better word—awe—the hulking sugar maples found at the Lone Shieling are still the valley's most striking feature. Here, and possibly only here, is found the province's largest virgin old-growth hardwoods. Here a glimpse still survives of what was once the true forest of much of Nova Scotia.

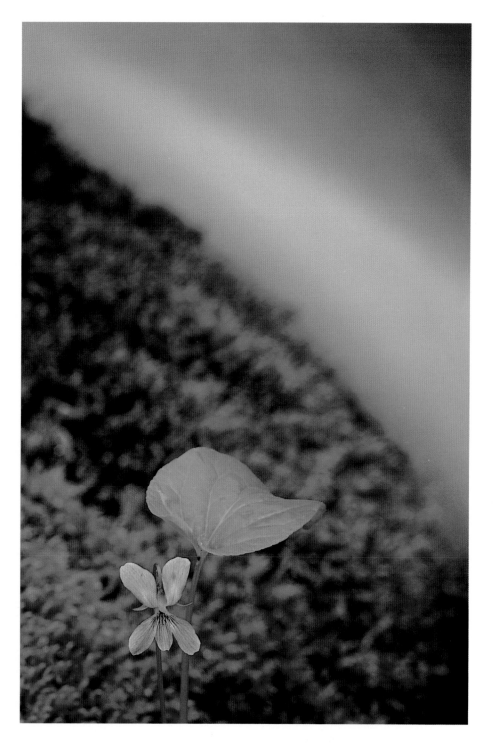

Facing page: Blue violets grow in the carpeting moss lining a small cascade.

Blue violet and misty waters.

15

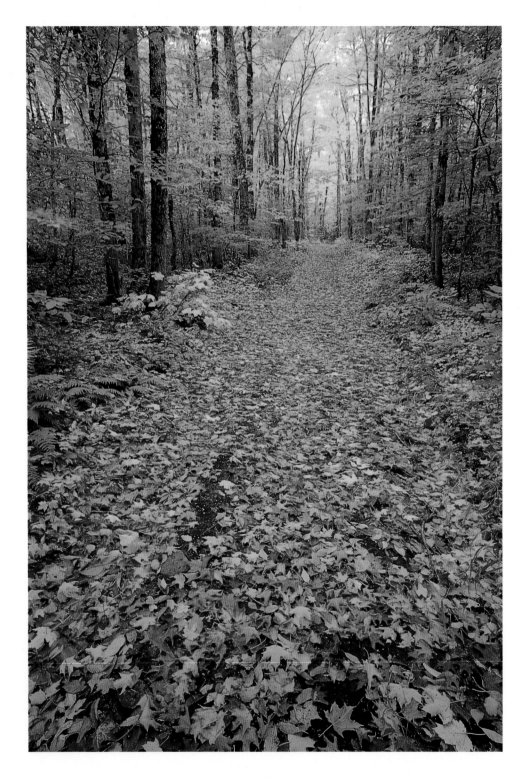

Cape Breton Highlands National Park

Located in northern Cape Breton, this park encompasses some of the most spectacularly rugged and diverse landscapes found in Nova Scotia. Inaugurated in 1936, it was the first national park to be established in the Atlantic Provinces.

The park covers an area of 950 square kilometres (367 square miles), is mainly a highland plateau ranging from 350 metres (1,148 feet) at its coastal margins to over 500 metres (1,640 feet) near its centre, carved by steep-walled canyons and broad valleys. From a distance, the top of the plateau appears flat, but it consists of rolling hills, barrens, lakes, and bogs whose highest point at White Hill, is 532 metres (1,745 feet), the highest point in Nova Scotia.

The plateau is the source for seventeen major watershed areas which drain through deep ravines down to the mountainous Gulf of St. Lawrence coastline, or the gently sloping coast flanking the Atlantic Ocean.

Because the plateau boasts the province's highest elevations it has a distinct climate. Precipitation averages 1,600 millimetres (64 inches) a year with 400-500 centimetres (over 157 inches), as snow; it is one of the heaviest snowfall areas in the Maritimes. Not surprisingly, snow can last here in shaded pockets until mid-June or later. The higher elevations have probably six to eight weeks less growing season than the coastal lowlands and valleys. Turbulent winds are another dominant feature on the plateau at any time of the year but especially in early winter, where violent gales have been recorded with gusts up to 200 kilometres an hour.

The park is comprised of three different regions—the Acadian, Boreal, and Taiga regions—according to elevation. The Acadian region, 23 per cent of the park, consists of either almost pure hardwood stands such as sugar maple, beech, and yellow birch in the rich soil of the coastal valleys, or of various mixed hardwoods and softwoods found along the lower coastal lowlands. The Boreal region representing the higher elevations (above 330 metres or 1,082 feet) covers about 55 per cent of the park and consists of shorter stands of balsam fir with some black and white spruce, punctuated with small bogs and lakes. The Taiga region, a boreal-tundra transition zone representing 22 per cent of the park area, is a land of exposed heath barrens, bogs, lakes, and stunted coniferous forest or dwarf fir, spruce, and larch found on the highest elevations of the plateau. Some trees are well over one hundred years old. The wind-scoured barrens also support plants such as sheep laurel, black crowberry, reindeer moss, lichens, and huckleberries, and blueberries which are popular with the black bears of the park.

The peat bogs and lakes of the plateau are heavily acidic, stained by seepage of dark tea-coloured tannin acids from the surrounding soils. A few species of rare Arctic alpine plants such as Alpine whortleberry, curly grass fern, and two species of dwarf birch grow on the uppermost reaches of the plateau. Interestingly, a relict Arctic aquatic species of animal, a small shrimplike creature, still officially unclassified, was discovered at Two Island Lake.

The park supports a variety of mammals

Facing page: Fall leaves carpet a section of the Clyburn Valley Trail.

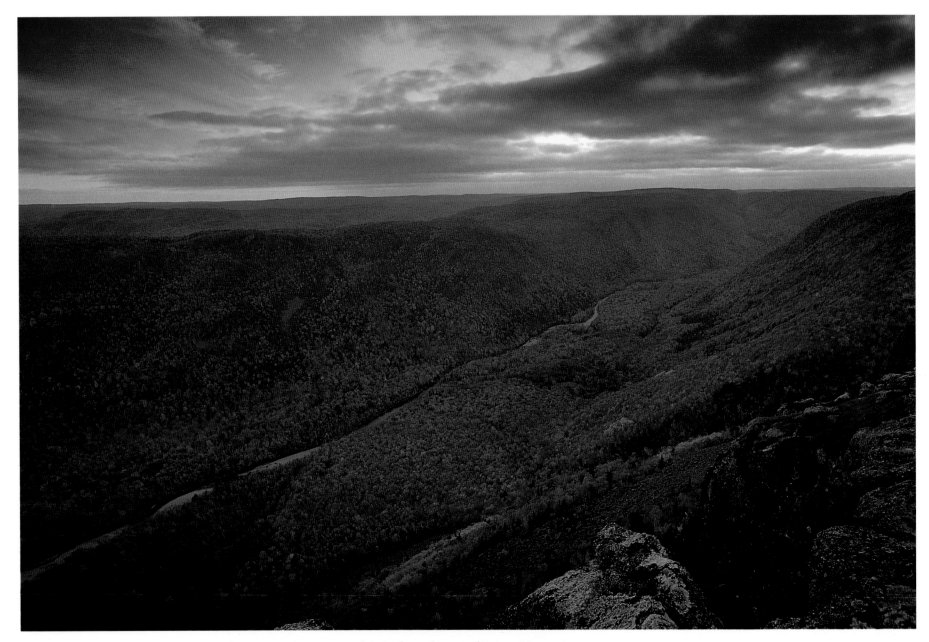

Sunset from the top of Franey Mountain.

such as moose, black bear, white-tailed deer, red fox, snowshoe hare, and others, and it is one of the last strongholds in the Maritimes for the Canada lynx and pine marten. It is possible that the legendary eastern cougar still survives in the wilds of the park. Since the completion of the Canso Causeway in 1955, bobcats, raccoons, and more recently coyotes, have migrated into Cape Breton and the park, but as yet skunks and porcupines are absent.

There have been 229 species of birds recorded in or near the park, half of these only during seasonal migration. There are at least 18 species of songbirds or warblers found in the lower mixed and hardwood forests along with different species of woodpeckers, nuthatches, and grouse, while less common species, such as the common yellowthroat, greater yellowlegs, and the gray-cheeked thrush, frequent the higher regions. The park also sustains hawks such as red-tailed and sharp shinned hawks, owls such as great horned and barred owls and bald eagles. Cape Breton accounts for 75 per cent of the breeding population of bald eagles in Nova Scotia. Sea birds such as Arctic and common terns, black guillemots, great and double-crested cormorants, ospreys, scoters, among others are also found here in small numbers.

Atlantic salmon, whose numbers have greatly decreased, spawn in most of the park's major rivers, which are protected breeding habitats for this species.

There are twenty-eight designated hiking trails in Cape Breton Highlands National Park, including coastal to river valley trails, mountain top and highland plateau trails, ranging in length anywhere from 0.4 kilometres (0.2 miles)

to 25.8 kilometres (16 miles) return. I managed to hike almost the complete trail system in 1993 and 1994 and highlight here what I found to be the most outstanding trails in order of appearance from the east boundary of the park near Ingonish to the west boundary near Chéticamp.

Clyburn Valley Trail

Starting in the lovely Clyburn Valley just outside Ingonish Centre, this trail follows the west bank of Clyburn Brook for a return distance of 9.2 kilometres (5.7 miles). My only visit to this trail was in late October 1993, on an overcast morning following a night of heavy rain and gusting winds. Autumn colours were at their peak and still intact, even after the battering of the night before.

The trail is wide and flat, affording an impressive view of Clyburn Brook and its valley amid the surrounding mountain ridges. The path crossed under archways of leafy splendour carpeted by richly hued leaves, and I crossed a number of small brooks before coming to the old emergency shelter on the banks of Clyburn Brook. The river which had flowed peacefully below the shelter now boiled wildly over the rocks in the distance. The trail ends at the shelter so I retraced my steps after a thoroughly pleasant hiking experience in a scenically splendid area that offers a relaxing outing to anyone willing to take the time.

Franey Trail

Franey trail is a steep but scenic loop that climbs to the top of Franey Mountain, with its attendant fire tower, returning via the fire tower access road for a total distance of 6.4 kilometres (4 miles).

Leaving the Clyburn Valley Trail in late afternoon, I climbed through a mixed forest of hardwoods and softwoods, before reaching a ridge below Franey, where I got my first panoramic views of Clyburn Valley and its river stretching westward. From there the trail grew steeper until, finally, I reached the summit and its unmanned fire tower.

I made my way along a side path to the very edge of the sheer face of Franey, looming over Clyburn Valley almost 366 metres (1,200 feet) below. This is not part of the original trail and is potentially dangerous, but the views from that knife-edged precipice are some of the most sensational in the park. In the dizzying depths below me, the Clyburn Valley and its ribbon of river lay in a wide trough, extending from the coastal lowlands with views of Middle Head and the more distant Cape Smokey into the misty western highlands. The magnificent panorama of the Clyburn Valley was robed in burnished oranges, yellows, reds, and golden rusts of autumn, even more pronounced in the light of the setting sun.

I photographed from Franey until the sun disappeared behind a cloud bank, the winds increased, and the temperature plummeted.

Noteworthy along this trail was tiny MacDougall Lake, nestled among the surrounding hills and reflecting a western sky reduced to a cold blue afterglow. It was too dark to photograph so I trudged to my car in the falling darkness and drove off in search of a hot meal.

For anyone planning to hike in the park, the trail up Franey Mountain is one you can't afford to miss!

Warren Lake

Warren Lake, a fair-sized lake set among hardwood hills within sight of the highland mountains, is not far from Ingonish. There is a looping 8.5 kilometre (5.3 mile) trail around the lake starting from either the entrance to Broad Cove campground or Warren Lake's picnic area.

My most distinctive memory of Warren Lake comes from an experience I had on the first evening when I decided to explore the lake trail, leaving the picnic area and heading along the lake shore through the hardwoods. It was an easy stroll, with a breeze wafting in off the lake.

Exquisite patches of bunchberries adorned the trail, their white blossoms at the apex of their short lives, and a pair of loons bobbed soundlessly on tiny wavelets in a shallow inlet. At the western head of the lake the land becomes low and swampy, populated by spruce and balsam fir. All along the trail, as on almost every other hiking trail in Cape Breton I've been, traces of moose were plentiful but I wondered why I so seldom saw one.

Pondering this mystery I broke into a clearing near a footbridge crossing Warren Brook, where just in front of me was a young female moose standing stone-still, gazing fixedly toward the lake. She was completely unperturbed by my presence. I approached her, speaking softly, until I was just a few metres away when, without warning, she suddenly ran at me. I quickly stumbled backwards to avoid her charge, and when I regained my footing she was again standing silently, looking out over the lake, seemingly lost in a deep trance, and I was completely forgotten. Unnerved, I turned away but before crossing the bridge my curiosity got the better of me, so I backtracked down the path. She was still there, unmovable as a statue. Can moose sleep standing up? Whatever the reason for her strange behaviour, I didn't want to be on the receiving end of another charge, so I continued on my way.

The ironic thing about this incident was that for the first time in years, I had set out on a hike without taking my camera equipment. "The light looks terrible for sunset," I thought. "I'll probably never see anything worth photographing."

Coastal Trail

This trail follows the rugged granite shoreline between Black Brook and Halfway Brook just outside Neils Harbour, for a return distance of 11 kilometres (6.8 miles). I found the trail nearest Black Brook the most scenic and interesting part of the whole trail. At Squeakers Hole, for example, the stone bluffs display colours of orange, pink, white, and grey crisscrossed with strange patterns formed in the molten granite eons ago. The trail area nearest Black Brook is the highest and most indented shoreline of the Coastal Trail, with sweeping views from the high vantage points.

The morning I arrived in late June 1994, the lobster season was in full swing. There were

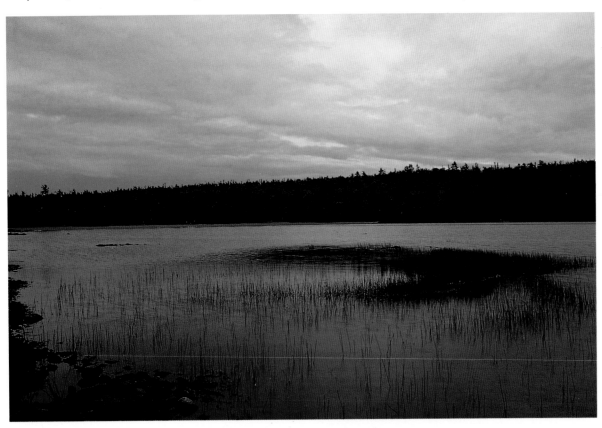

Purple dusk falls over Warren Lake.

already half a dozen or more boats out before sunrise, motoring tirelessly up and down the coast, retrieving and resetting their traps.

That morning I left my car at the Black Brook trail head and started out, before sunrise, flashlight in hand. Just past Squeakers Hole I came upon a vantage point overlooking a black silhouetted coastline of hills, narrow coves, and coastal bluffs. The dawn colours were a palette of neon hues ranging from deep orange to yellow to mauve, with the western sky in shades of magenta and blue; a waning moon was setting over the bluff of Squeakers Hole, while tiny silhouettes of boats scurried to and fro upon the painted sea.

Further down the trail, I came upon a small cove tucked between two granite bluffs with a shoreline of various sized cobble stones where waves splashed against beach stones that looked like giant nuggets of gold.

Continuing on, I passed along the edge of a spruce forest, photographing yet another patch of bunchberry blossoms, these pearl-dropped in sparkling dew. I was picking my way carefully across another small cove when I suddenly noticed that the beach stones at my feet were clothed in velvety patches of gray and green lichens, each one with a distinctive pattern. Some suggested faces while others were abstracts of oval splashes of colour, splattered randomly upon the rocks. I spent a long while absorbed in the spell cast by my surroundings, for I had never photographed beach stones like these before: strange and wonderful worlds of designs created by nature.

A morning sun backlights a jagged coast along the Coastal Trail near Squeakers Hole.

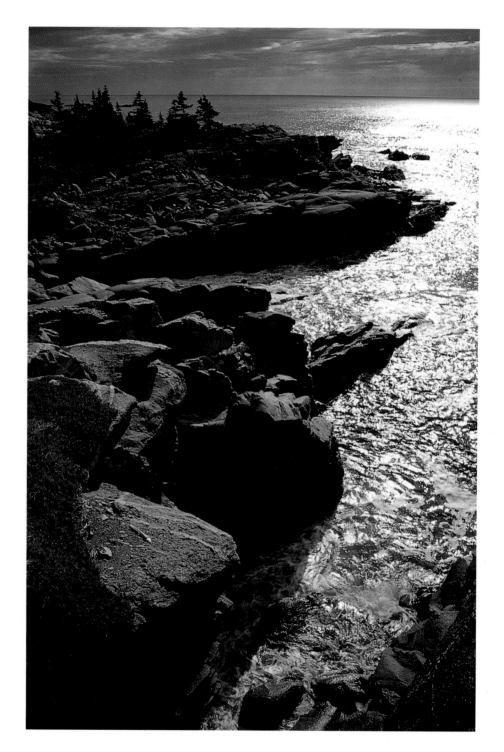

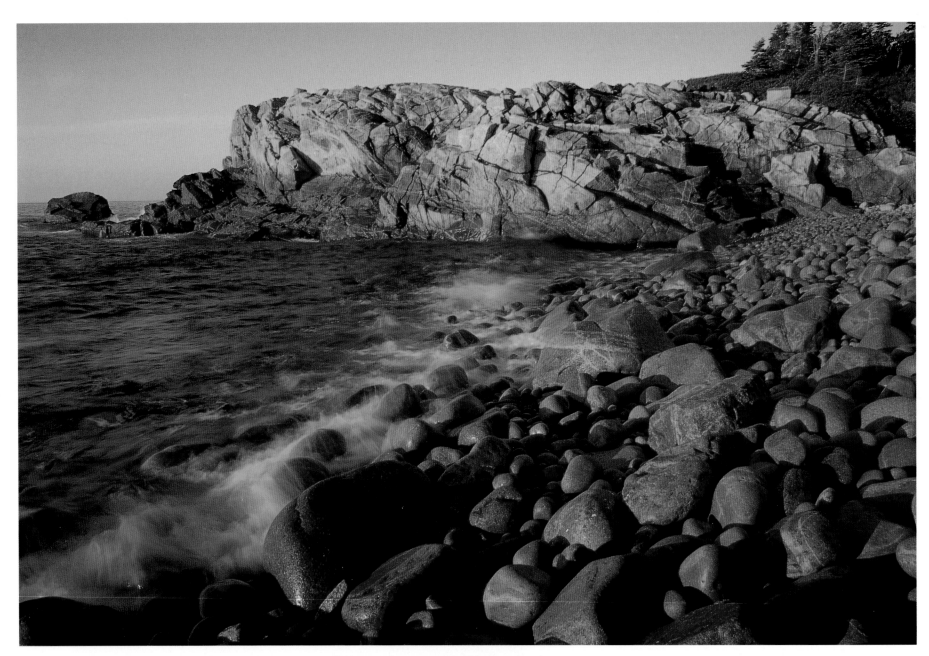

*Waves wash against a cobblestone beach at sunrise
along the Coastal Trail.*

Lake of Islands Trail

This is the longest trail in the park at 25.8 kilometres (16 miles) return, travelling along the windswept top of the highlands plateau and ending at Lake of Islands primitive campsite.

The trail was once a fire access road and ascends gradually, making it an easy climb. My only trip to Lake of Islands began around noon on July 4, 1994, an easy date to remember for someone who hikes weeks on end, losing track of time as easily as fog evaporates.

The day was bright and promising with clear blue skies peppered with white, cottonball clouds, as I crossed the small bridge over Mary Ann Brook which, further on, plunges over Mary Ann Falls, a popular park attraction and picnic area.

The trail slowly climbed higher above a hodgepodge of mixed forest into open barrens of wet bogs, ponds and lakes, and clusters of tangled black spruce. But just over a rise, a distant horizon suddenly opened before me. Down below, in a small depression between highland hills, nestled Branch Pond, a blue sapphire jewel with sand beaches rimming its ends, which I photographed at leisure.

By the time I reached Halfway Lake, tucked beneath a low hill ridge, evening was approaching, and the fluffy clouds had abandoned the sky, leaving it as sterile and bleak as the land below. The sweeping barrens and bogs with their stinted vegetation filled me with feelings of loneliness and desolation, which I couldn't shake off.

Climbing one last hill I encountered a weather-beaten trail sign announcing Lake of Islands less than a kilometre away. With renewed vigour I descended down the other side of the hill, glimpsing a silver flash of lake through the trees, and arrived at a campsite of plywood platforms that looked damp even in this driest of seasons.

A subsequent search revealed a side path with a small cabin furnished with a dilapidated stove and table and two bunks with foam mats. Home, Sweet Home!

I rested, comfortably, on one of the bunks until sunset when I ventured out again, eventually stumbling upon the headwaters of Warren Brook and passed it, up along the lake, where at the water's edge I found my photographic subject of the day: a mass of spindly black spruce, curving out over the lake shore as formidable as a fortress wall, stark against a twilight of glowing blue, magenta, and pink.

Back at the cabin I ate a typical cold supper by flashlight—a normal occurrence whenever I'm camping and photographing, trying to squeeze out the last drops of daylight with my camera.

Four thirty in the morning came much too quickly, and the eastern sky displayed the purple and pink pre-glow of dawn and a small sliver of crescent moon hanging low over the forest, reflecting its faint light in the still water of Warren Brook.

Gradually the moon faded as the eastern sky evolved into pink, orange, and yellow clouds that heightened to a crescendo of flaming hues reflecting in the placid waters of Warren Brook.

As I dallied along the brook, I observed a number of sandpipers, greater yellowlegs, with their long narrow beaks and matchstick legs, stalking for prey in the shallows along the shore, their voices the only sounds in the silence of the still morning.

I bid farewell to Lake of Islands around 10:00 A.M. as blue skies turned gradually overcast. The journey back was mostly downhill, a lazy descent from the plateau, and uneventful except for one instance when I stopped to photograph a spruce grouse and her eight chicks foraging for food along the trail.

Mary Ann Falls

One of the most popular spots in the park is Mary Ann Falls, not far from the Warren Lake area just past the Lake of Islands access road. Mary Ann Falls is composed of two stages: a small waterfall flowing into a pool under the road bridge, then tumbling down 8 metres (26 feet) over a rock-face that bottoms out as Mary Ann Brook. There are two trails past the falls which follow along the top edge of the sheer bluffs on either side of the brook, and a third with steps down to bottom of the falls.

To get the best pictures of Mary Ann Falls I had to cross the brook at the bottom of this path, hopping from rock to rock and, praying I wouldn't fall in, submerging my camera gear in the process.

I used the jumbled cobblestones as a foreground to give depth to the photograph of the falls as the background. Cinnamon ferns growing near the water were dynamic subjects to incorporate into my waterfall shots, as well as being attractive subjects in their own right.

Other than this unsanctioned access, the next best place to view Mary Ann Falls is from the vantage point at the top of the bluff trails, that starts at the bridge over the falls and ends at the edge of a cliff where one can look back up the brook to the falls.

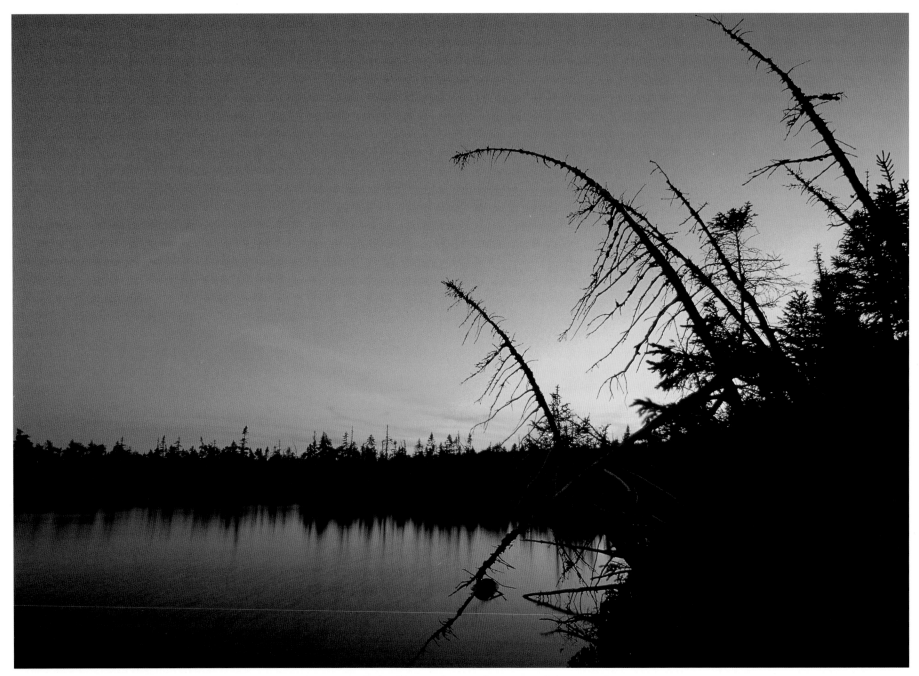

Against twilight skies, tuckamored spruce curl out over the edge of Lake of Islands.

Beulach Ban Falls

Situated in Aspy Valley, not far from the small village of Cape North, Beulach Ban Falls—16 to 23 metres (50 to 75 feet)—is one of the most superlative waterfalls in Nova Scotia by virtue of its supple grace as it spills down over its rock-face.

My favourite time to visit Beulach Ban Falls is during the peak of fall colours, when vibrant autumn foliage surrounds the perimeters and colourfully litters the dark rock-face of the falls. In photography, this combination presents a fascinating study in long exposures of moving water and leaves with some striking effects, provided one has low light levels, slow film, and a camera supported by a tripod. But whether an avid outdoor photographer or someone who simply enjoys the beautiful aspects of nature—waterfalls for me being one of the most charming—Beulach Ban Falls is a place to visit, over and over again.

MacIntosh Brook Trail

Situated just a few kilometres past the Lone Shieling heading towards Pleasant Bay, MacIntosh Brook Trail starts from MacIntosh Brook campground. This is a 2.8 kilometre (1.7 mile) return trail following the flat banks of MacIntosh Brook through a pleasant forest of mostly mature hardwoods. The trail crosses the brook three times before ending at a shallow pool that lies beneath a waterfall tumbling down from a steep hillside.

My most notable visit there was one afternoon in early June 1993, when I decided to explore a hardwood hillside west of the trail. Like the Lone Shieling area not far away, most of the hardwoods were sugar maples, beech, and yellow birch, though not as old or as big.

As I submerged myself in the leafy world of young beech trees, I was overwhelmed by the dazzling display of their lime-green extravagance. There are simply no other species of trees with more vibrant greens in spring. In the overcast light of the forest each leaf seemed illuminated by a life energy of its own, a divine expression of individual life.

The MacIntosh Brook Trail and surrounding forest has its own distinctive beauty in every season, but for me nothing compares to visiting it when the forest is resplendently alive, under the magical spell of spring.

Fishing Cove Trail

Leaving Pleasant Bay behind and travelling up and along the top of MacKenzies Mountain brings you to the Fishing Cove Trail turn-off and parking lot. Fishing Cove Trail is the park's second longest trail at a return distance of 16 kilometres (10 miles). This trail follows Fishing Cove River down from MacKenzies Mountain, twisting through the rugged forested highlands to where it empties into the picturesque Fishing Cove with its small cobble beach and old abandoned fields where a few campsites are available for use.

Fishing Cove was first settled in 1865 by a Scottish settler named Kenneth McRae who owned a fish company. There was even a lobster cannery established in the tiny hamlet in 1890, but the cove was abandoned in 1913 after the last of four families left this isolated niche in the coastal highlands. Over the years, Chéticamp farmers used the cove to summer pasture their horses but the only reminders of past settlement are the deserted fields on the hillsides of the river, which are slowly being overtaken by the forest.

My only visit to Fishing Cove took place on a cool sunny June 20, 1994. I followed the trail along Fishing Cove River down through the highlands, amongst a mixture of various hardwoods and softwoods that at sea level gives way to the gorgeous hardwoods typical of most of Cape Breton.

Within moments I emerged into a big open field overlooking the grand vista that is Fishing Cove. Thirty metres or so below coursed the widening river, pooling behind a cobblestone barrier beach, from which it funnelled through a narrow bottleneck and into the waiting waters of the Gulf of St. Lawrence.

I chose a campsite between a stand of white spruce and a jagged hill that rose above the field and over the precipitous edge of the sea. That evening I set out to see if I could round the hill and perhaps discover an outstanding view-point looking down the coast.

The theory was easy but the reality impossible. The path came to an end within 50 metres at the edge of an infringing wall of white spruce and the large rock rubble of the hill's talus slope. I tried scrambling over the latter and prying my way through the former but my progress was so slow I feared not making it back in time to photograph Fishing Cove under the choicest light near sunset so I retraced my steps to the cove.

There, the panoramic views of the rounded mountains and lower hillsides, the blue shades of the evening sky colouring the river and its pool, and the glowing band of light upon the waters of the cove and the gulf combined to

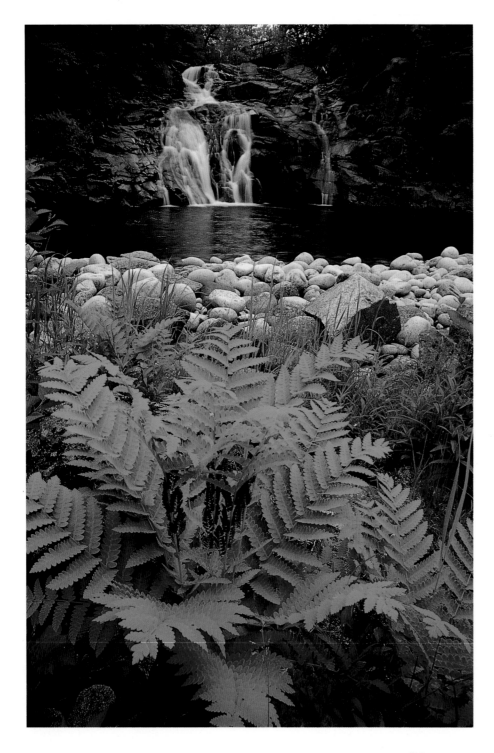

create a spectacular setting. There, I made my way down along the river and out to the barrier beach, which proved to be one of the most beautiful spots in Fishing Cove.

Before me in the crystal waters of the pool was mirrored the surrounding mountains and hills ablaze with the sun's amber radiance. Over the top of the eastern highlands a waxing full moon slowly ascended, captured in the royal blue tones of the watery world. If only such light could last for hours and hours.... As I stood watching, an orange-red sun submerged into the Gulf of St. Lawrence, extinguishing its brassy sunbeams on the water as the fiery disk sank below the horizon.

When the western sky behind me began evolving into an afterglow of glorious incandescent colours, I photographed with my widest angle lens sweeping views of Fishing Cove's cobble beach and dark bluffs against the Crayola colours of the sky and sea.

It was almost pitch-black in the eastern sky by the time I returned to the field, but unable to resist this last vestige of twilight, I captured the towering hillock next to my campsite as it rose up in a black silhouette, reminiscent of a miniature volcanic cone against the cobalt blue water of the cove.

I ate my late supper under the silvery glow of the moon, watching the stars twinkle in the heavens while contemplating the wilderness around me. Fishing Cove had turned out to be more beautiful than I had expected, revealing itself as one of the most splendid areas for scenic photography in the park.

Interrupted ferns beneath Mary Ann Falls.

Skyline Trail

Situated along the top edge of French Mountain is Skyline Trail. This is a 7 kilometre (4.3 mile) looping trail providing magnificent scenic viewpoints overlooking the Cabot Trail twisting up French Mountain from the Gulf of St. Lawrence.

My first visit along the Skyline Trail occurred on the sunny evening of June 25, 1994. Leaving Skyline's parking lot, I passed through a nondescript woods of spruce, fir, and white birch along the edge of a headland cliff. The perspective that opened up from the cliff's edge caught me by surprise. Down below, the Cabot Trail was a winding ribbon of asphalt carved into the lofty side of French Mountain, flanked by a deep ravine between the avalanching sides of the mountain and the equally precipitous ridge I was on. While taking pictures of the steep-sided mountains, ravines, and highway below, occasional matchbox cars twisted up the road, reminding me of a child's electric car and roadway display.

As I made my way along the ridge and then down the path of the tapering headland, I was suddenly buffeted by a wall of wind so forceful that it startled me. Scant seconds before there had hardly been a breeze. Here the headland ridge of cliffs plunged over 300 metres (984 feet) straight down into the sea, battered by gale-force winds off the blustery Gulf of St. Lawrence. A person caught in a storm could be sent tumbling to their death in such extreme conditions.

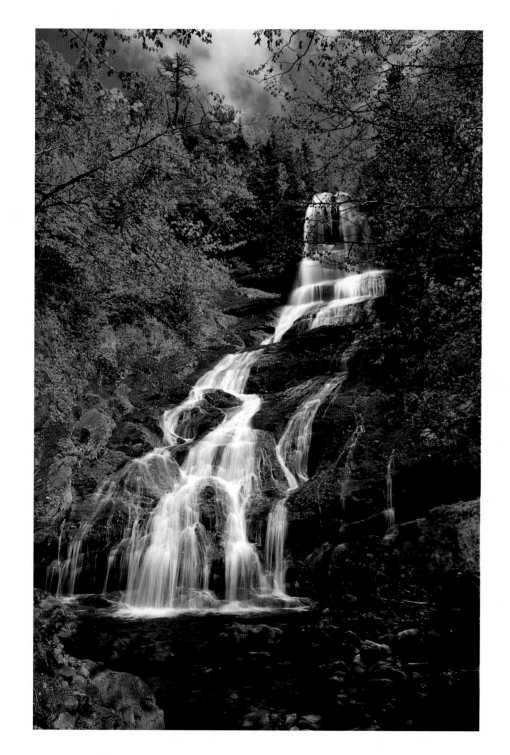

Beulach Ban Falls in late spring.

With the wind a loud rushing in my ears, I walked as close to the end of the point as I dared, looking south along the coast to Chéticamp, a tiny cluster of buildings on the horizon, its most dominant feature the huge St. Peter's Church with its spire soaring high above the town.

I had come here in hopes of finding a sunset casting its illustrious colours over the land and sea, but once again the weather had other plans; a band of charcoal clouds aborted the sunlight and nixed my enthusiasm for photography.

Trous de Saumons (Salmon Pools) Trail

This is a 13 kilometre (8.1 mile) return trail along the tapering banks of the Chéticamp River valley, consisting of a series of three salmon pools popular with sports fishermen. The trail begins in the Roberts Brook campground, near both the Chéticamp Information Centre and the entrance to L'Acadien Trail.

The late afternoon sun was a sparkling orb in the sky on June 19, 1994 as I climbed up a small knoll before descending to a flat traverse along an inlet of the Chéticamp River, which at the time was not much more than a trickle of water.

The path finally reached the main river, emerging into a clearing on its western bank with a splendid view. Across the Chéticamp River's boulder-strewn shores broods the craggy face of a mountain bluff, complemented by the rounded crests of green mountains along the horizon.

The landscape beckoned, but the afternoon light was too flat for my photographic tastes, so I continued on in hope of returning later in the evening. A sign post announced my arrival at First Pool, some 4 kilometres from the trail's start.

Unlike my first visit to First Pool, when whirling patterns of white foam had caught my attention, there was now only a faint smattering of foam drifting in the river. Still, the mountains skirting the river and the forest along the trail were haloed in bold relief by a blinding back-lighting sun, a light eminently worthy of my camera.

Cape Breton Highlands National Park, as well as being Nova Scotia's largest park, is also endowed with the most varied and spectacular landforms in the province. Its landscapes, ranging from soaring mountains rising out of the sea, to its highland plateau rolling down into glacier-carved, hardwood canyons, and coastal lowlands, represent the largest protected wilderness area in the Maritime Provinces. All of these features, plus the wealth of its flora and fauna, make the park a pristine wilderness to be unforgettably experienced by even the most jaded traveller.

The lush greens of spring dominate the forest along the MacIntosh Brook Trail.

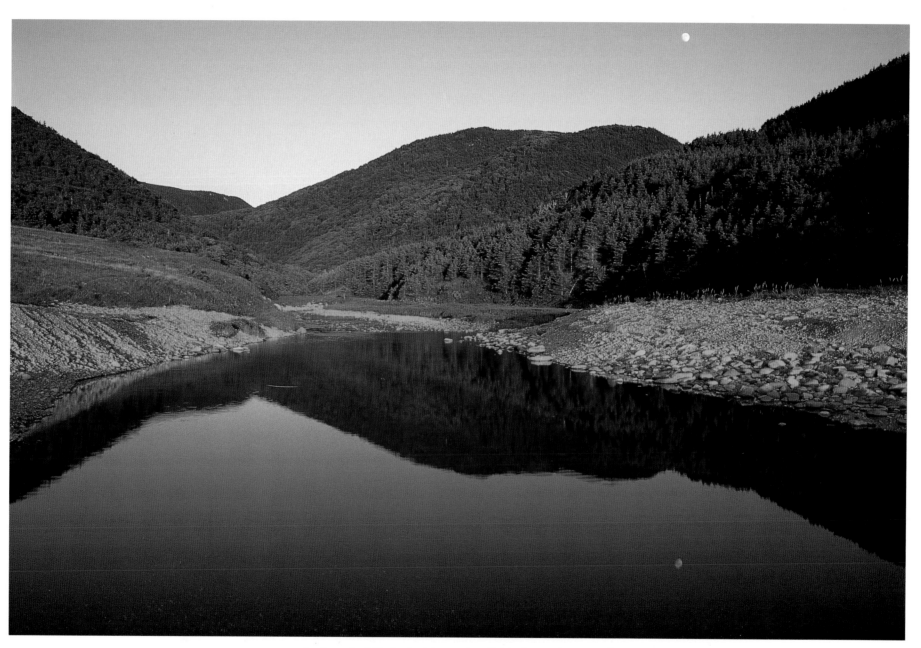

Against the hills bathed in evening light, the pooling mouth
of Fishing Cove River reflects a rising moon at Fishing Cove.

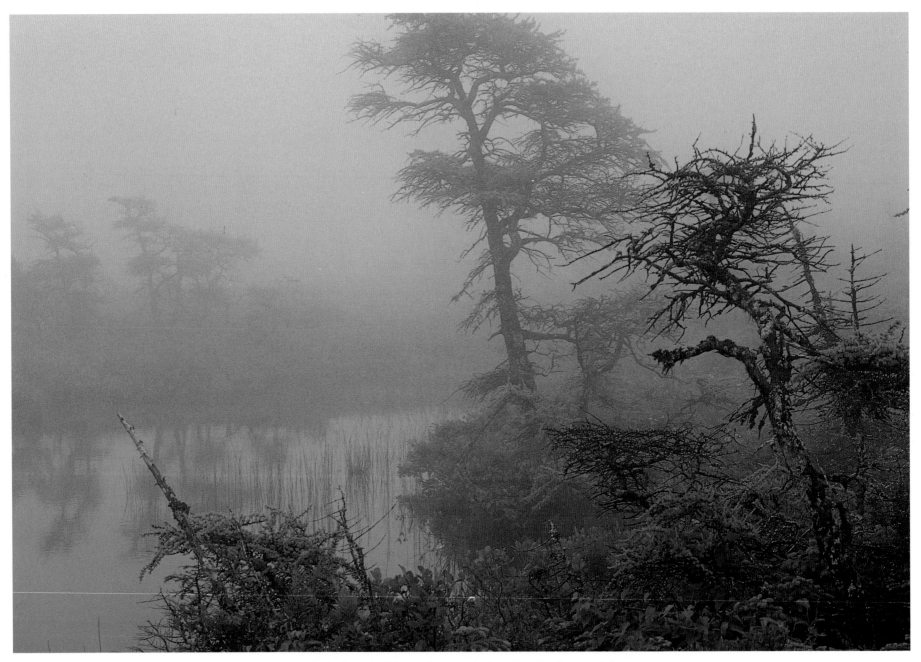

*A thick shroud of fog veils a pond along Bog Trail, one of the
park's shortest and most visited trails atop the highland plateau.*

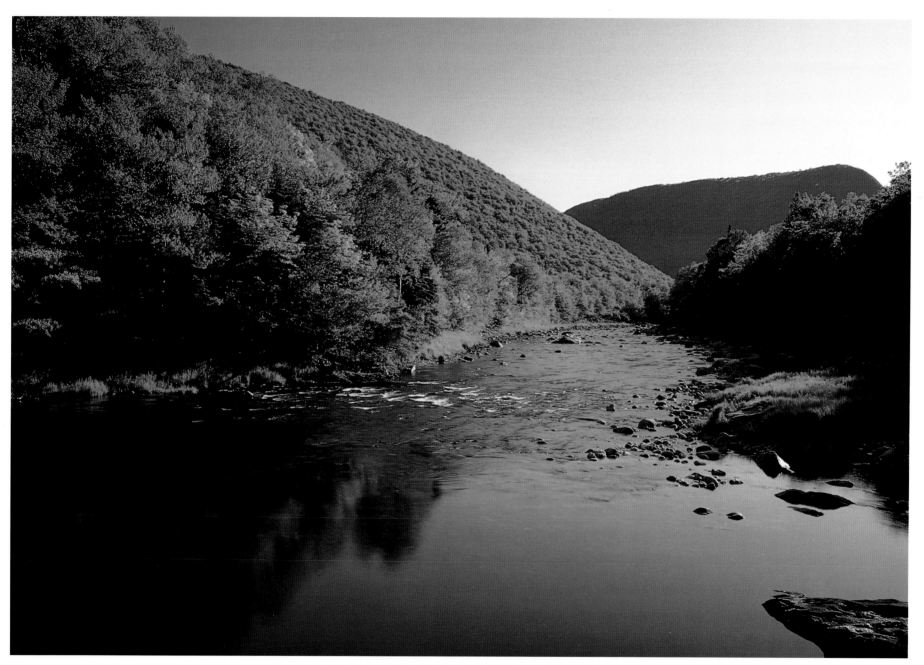

At the edge of First Pool looking down the Chéticamp River
along the Salmon Pools Trail.

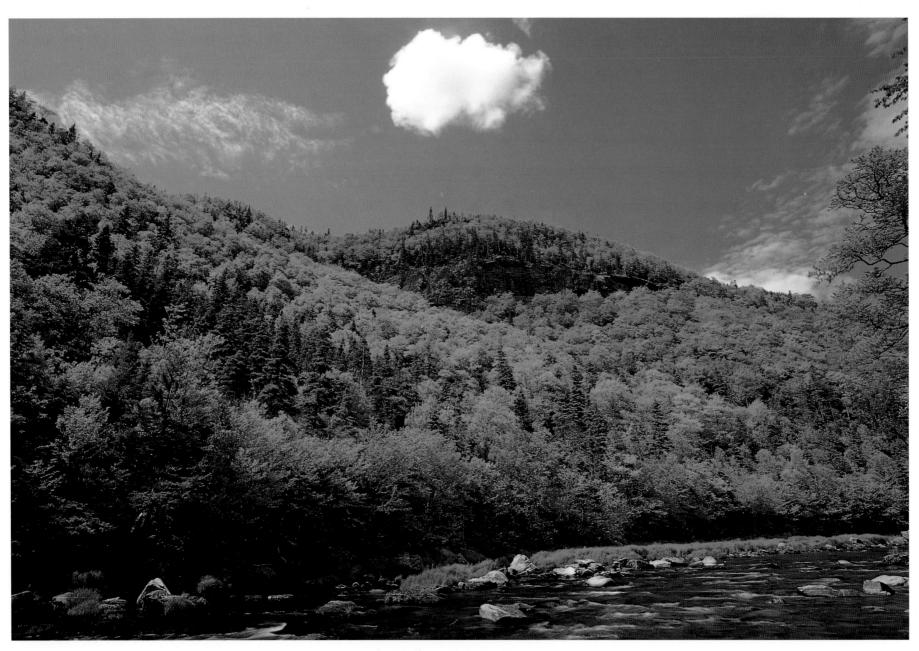

*The Northeast Margaree River just
above First Fork Brook.*

Northeast Margaree River

This is a wilderness region on the upper reaches of the Northeast Margaree River, situated roughly north of Kingross and Big Intervale near Margaree Valley in Cape Breton. This is a land of precipitous highland escarpments flanking both sides of the river, of numerous side canyons coursing with brooks and waterfalls, and mantled with mature mixed and hardwood forests, including some rare old-growth hardwood stands that may never have been touched.

This area, like some other areas of the highlands, offers relict species of Arctic alpine plants and Cordilleran distinct plants (plants characteristic of boreal deciduous forests common on the Pacific coast or in the Rocky Mountains) that grow in dark, moist places and on the north face of cliffs or rock walls. Some examples of the irregular plants found here are western rattlesnake plantain, common bladder-fern, sweet cicely, and northern bedstraw.

The hardwood forests and rock rubble (talus) slopes of the district are particularly favourable to small mammals, supporting fourteen of the seventeen insectivores and rodents known to exist in Cape Breton such as weasels, southern bog lemming, and the more Arctic alpine relict species such as rock vole and Gaspé shrew.

Large mammals such as moose, white-tailed deer, black bear, and coyotes, frequent the territory, but the steep slopes of the highlands limit their occurrences. For bird-watchers this place presents a wide diversity of various warblers, nuthatches, and woodpeckers. The Northeast Margaree River also remains as one of the most important salmon producing areas left in Nova Scotia.

It is because of these varied qualities that this wilderness area of 6,191 hectares (15,297 acres) is recommended for protection under the new provincial Proposed Systems Plan for Parks and Protected Areas.

Second Fork Brook

My first experience in exploring the wilds of the Northeast Margaree River occurred around mid-June 1993. I arrived after dark at the end of the dirt road past Kingross, having driven there with the intention of bunking down for the night in my car, hoping to catch an early start the next morning.

After a long night curled up in my too-thin sleeping bag trying to keep warm against a surprisingly bitter cold, daylight finally broke. After confirming my directions with the nearest local resident, I set out for my destination, Second Fork Brook, some 4 kilometres or more up-river, known for its remnant old-growth forest and a waterfall of local renown.

The path, which kept a respectful distance from the river, became more precipitous and difficult to hike, while growing fainter with each passing step. Just as it disappeared altogether, I became aware of a brook tumultuously rushing into the river hundreds of metres away. This was First Fork Brook, which I would have to find a way to cross to get to Second Fork Brook.

Although the brook was quite narrow except for its slightly wider mouth, it flung itself violently down over a low hill, dashing

over and between large rocks into the Northeast
Margaree River in a chorus of crashing water.
I finally found a place to cross that required two
leaps to slippery rocks in the brook separated by
angry foaming waters.

Failing to find a path, I hiked along the flat
stony river's edge, observing clusters of blue
violets growing near tiny pools along the shore.
The new greens of spring were freshly minted on
the surrounding hardwood clothed highlands
towering above the river. The sky above was a
deep blue, not yet paled by the haze that often
comes with summer, with only an occasional
cloud sailing across the blue dome of sky.

The river here was broad and shallow,
broken by various sized rocks slicing the water
into ripples of foam. Tall, lush, green grasses
grew in the flat margins of the shore, com-
plementing the greens of the hardwoods and
the spotted patches of darker conifers on the
mountains ridging the river.

I was forced to scale the river's banks and
travel along the sloping hillsides until I found
another stretch of river where I could descend to
walk along its broader and drier shores. I had
been told the hike to Second Fork Brook would
be tough but I didn't realize just how tough. I
was soon drenched in perspiration, but after
struggling along I rounded a sharp bend and
spotted a small, sandy-bottom brook the colour
of light brown molasses gently merging with the
river not far ahead. This had to be Second Fork
Brook, if my map was reliable.

*A beautiful fern meadow near the mouth of
Second Fork Brook.*

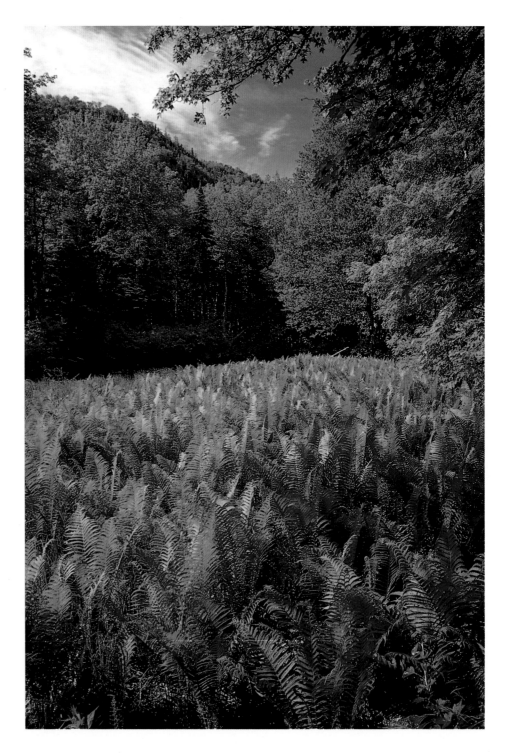

The mouth of the brook bottomed out into a luxurious swathe of the most gorgeous ferns I had ever seen and this sudden treasure (I learned later they were ostrich ferns) was a cause for unexpected amazement and delight. I lingered to photograph this lovely spectacle under a high backlighting sun.

Following the brook upstream, I ducked under the cooling canopy of the first trees and was immediately transported into another realm belonging to a time long past. This was a forest of wide, open spaces littered by ancient fallen or still-standing trunks, shade-tolerant young saplings and ferns of different species, while stately sugar maples reached their wide grey trunks and spreading branches into the sky. There could be no doubt I had found portions of the old-growth forest that was known to survive at Second Fork Brook without possibly ever having experienced the sting of an axe.

Walking under this domed, living sanctuary was exciting and uplifting. I always experience a bitter sweetness whenever I visit such old forests because they are so enchantingly different from the forest we have come to know, and because, sadly, they constitute less than 1 per cent of the forests left in Nova Scotia that are over 100 years old, let alone the true or mature old-growth forests whose ages are 150 years and up. I felt like an honoured guest, privileged just to be there.

The old sugar maple grove gave way to a more mixed forest of spruce and fir as the hillside grew steeper. Before long I detected the sounds of roaring water issuing from up ahead. I made my way down to the brook's edge and easily jumped to the top of a huge, flat boulder wedged in midstream, the water forking around, crashing downhill a few metres below.

Directly upstream, past two tall intertwining yellow birch trees isolated on the bank's stony shoulder, was the waterfall I had come in search of, Second Fork Brook Falls, only 25 or 30 metres away. It was one of the most distinctive waterfalls I had ever seen. Second Fork Brook Falls came sliding down a solid, bare rock-face, sloped at a 45 degree angle, about 14 metres from the top to bottom, with the water forming a small pool at its base before flowing out into Second Fork Brook.

Just as I was taking my first picture of the brook and background waterfall, the sunlight was suddenly blotted out. Turning around I looked up to see an extensive cloud front from the west swallowing up the sun in its advance across the sky. This was an unforeseen and unwelcome event.

Just moments before I had been confident of photographing the waterfall sparkling under brilliant sunshine, and now the sky was capped in a grey ceiling of clouds. Wrestling with my disappointment, I did take a few good shots of this enchanting place before starting back.

It was now late afternoon, but I stopped along my way to photograph again elegant beds of ostrich ferns now modelled under the soft, pearly sheen of the sky above. Gently retreating from the edge of the fern beds so as not to disturb such unblemished examples of creation, I continued on towards the Northeast Margaree River. Just before Second Fork Brook joined the main river I passed a remnant trunk of an old yellow birch, some 60 centimetres in circumference, curving out over the brook.

I stopped to photograph this grizzled relict, speculating on the endless cycles of time it had endured: could it have been a tiny seedling in the 1600s when the first French settlers arrived on the shores of Nova Scotia?

Now realizing that unless I stopped photographing I just might be spending an unpleasant night in the woods, I packed my camera gear away and took the quickest route out, although I did pause (half-cursing myself for it) to photograph the blue violets I had ignored on my way in.

Four or five hours later, in the last light of evening, near where the path runs into the field, I froze in my tracks. Through the trees ahead, just off the path, I spotted a large black form, which I alarmingly took for a black bear facing in my direction. I made a cautious retreat back up the path and then stopped to see my unwelcome companion.

It was not a bear but a large bull moose, partially hidden behind the trees. On noticing me, he made a loud snort and crashed away through the woods. After seeing no wildlife all day except for birds, I hadn't expected to encounter either a bear or a moose so close to civilization, but of course moose, like deer, do frequent old fields.

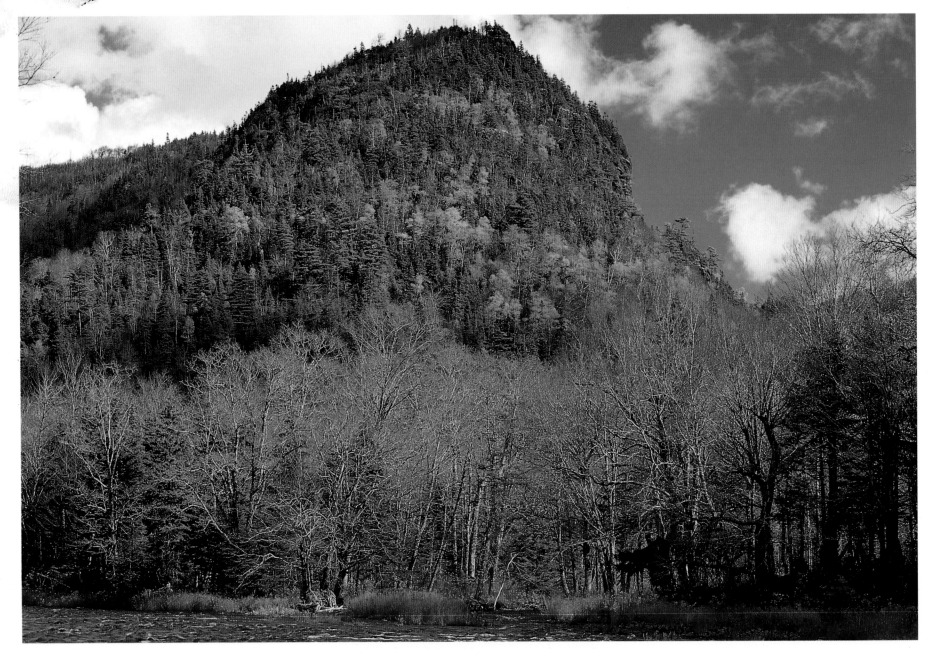

*Hardwood meadows and mountain at the mouth
of Second Fork Brook.*

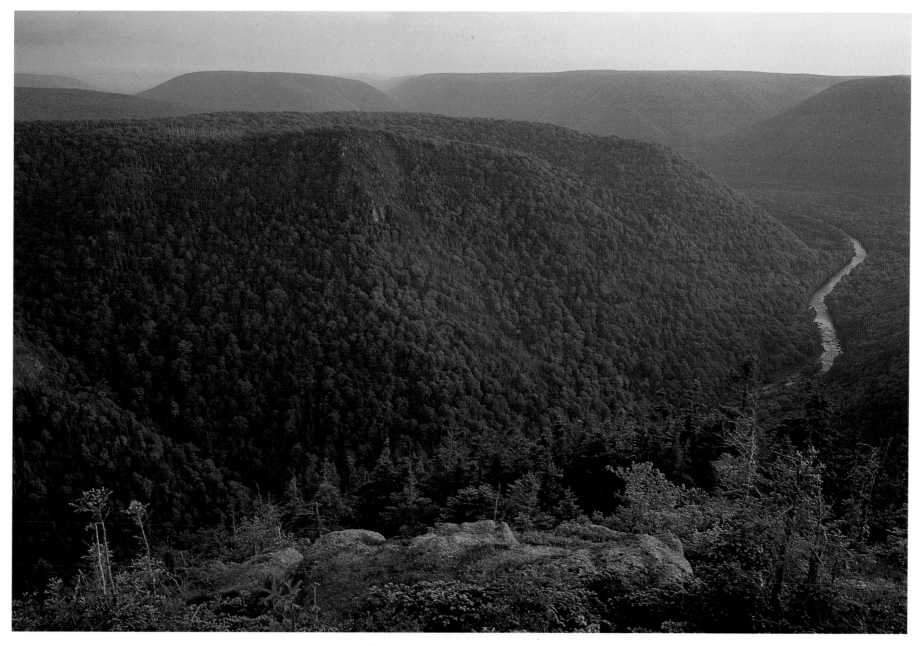

*A view of highlands and the Northeast Margaree River
bathed in purple twilight from atop Cape Clear.*

Cape Clear

Cape Clear is a locally famous mountain look-off, (accessible by car via logging roads), high above the Northeast Margaree River overlooking First Fork Brook. It is acclaimed for its fabulous scenic views as seen from atop its sheer and plunging summit.

After having heard about the high drama of Cape Clear from a number of different sources in my research of the area, I set out for it in the early evening, the day after my first hike to Second Fork Brook in June 1993. The weather had cleared, and I was filled with the anticipation of capturing on film some proof for these glowing reports.

Following the directions given me at a tourist home where I was staying in Northeast Margaree, I headed out for Margaree Valley a few kilometres away. Shortly, I turned right onto Fielding Road, a dirt road which travels up to the top of the highlands plateau. Once on top, Fielding Road turns into a well-maintained logging road called, appropriately enough, Highland Road, running in a north-south direction.

Turning left, I travelled north, passing old clear-cuts and small logging side roads, until I turned left onto Second Fork Brook Road. Picking my way around the larger rocks that littered the road, I followed the small signs pointing the way to Cape Clear, and within ten minutes or so I arrived at the road's end.

I chose one of a number of paths to the windswept barren on the summit where I could now survey the highlands in a wide-ranging

A moss-clad spruce straddles spinulose wood ferns.

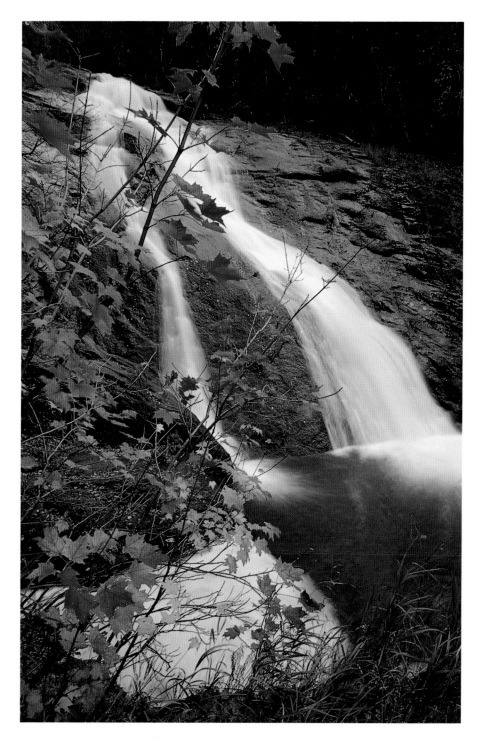

panorama with the Northeast Margaree River carving its route through them, along a broken escarpment of cliffs and steep hills far below.

I carefully approached the brink of the ledge and peered over. I was overcome by a spine-tingling sensation of space plunging straight down to a tiny brook meandering along the bottom of a deep mountain canyon that threaded its way toward the eastern horizon.

My map of the area shows Cape Clear to be 457 metres (1,500 feet) high, and as I gaped over the miniaturized squiggle that was First Fork Brook far beneath my feet, I was awestruck by the sheer height of my viewpoint. My expectations had been too modest; the landscapes that swept out around, before, and below were far more exciting than I could have imagined.

I photographed these grand landforms tinted orange from the setting sun, before a series of low-flying clouds materialized out of the south-east as if from thin air. A number of times I was shrouded in swirling fog as the clouds scraped the top of the cape, moving on as swiftly as they arrived, leaving me, off and on, in clear sunlight. Most of the clouds flew well below me, dashing by with a velocity I could scarcely believe, chasing each other upstream along the valley of the Northeast Margaree River between its high escarpment walls.

As the sinking sun touched the horizon, its light burned the evaporating wisps of clouds to varying hues of orange yellow, pink, and magenta, while I madly tried to capture on film the unfolding events as best I could.

Colourful sugar maple saplings frame the waterfall at Second Fork Brook.

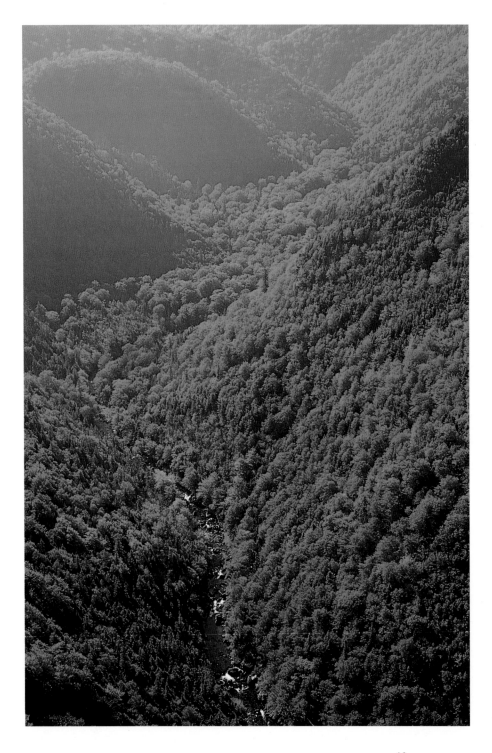

Moments after the sun disappeared below the horizon the clouds vanished as mysteriously as they had arrived. So climaxed a memorial visit to Cape Clear, whetting my desire to return at a later date.

Turner Brook Falls

The amiable guide who had given me directions from Kingross to Turner Brook Falls hadn't mentioned that the brook split into two branches but it did, just past an impressive bridge constructed of thick wire cables and railway ties. I was faced with a tough decision as to which branch led to the falls.

With some trepidation, I headed out along the left-hand fork, assuming it to be the main course as it ascended uphill in a most abrupt fashion. After fording the brook's treacherously slippery rocks far too many times, I climbed the right bank to hike as best I could along the sides of the bordering hills.

The undergrowth was profuse with young hardwood saplings that kept slapping at my camera's lens cap, knocking it off so often I had to keep a constant eye on where it landed, as well as where I might land if I took a nasty spill down the hillsides. Despite my many retrievals, I lost three lens caps to those grasping tendrils.

By this time the sky was a bright grey umbrella of light, ideal for photographing the fall colours and the thin ribbon of Turner Brook, cascading below through its sluice-way between the hillsides. I began to fear that I had taken the wrong branch when the brook's margins began to broaden, and eclipsing its soft

Far below Cape Clear, First Fork Brook twists through morning Highland mists.

melodies I detected loud waters wafting down through the trees from up ahead.

A short distance along, a small clearing came into view where a willowy silver fountain poured over a cliff, dispensing its velvety threads into a waiting pool. For the next half hour I photographed the waterfall from various angles around the pool, taking my time and resting up for the return hike.

Initiating a slow retreat down Turner Brook, I stopped to photograph the falls from a sapling-choked hillside, where I framed it with big yellow leaves of sugar maples, and again as a silvery white speck over a foreground of mossy rocks and rotting tree trunks that had crashed down into the brook.

While wrestling my way through the under-growth of striped and sugar maple saplings, I was compelled again and again to photograph the golden amber foliage of the large sugar maples which accentuated the bare branches of the surrounding trees.

My last shots that day were of Turner Brook itself, which I had ignored because of my urgency to find the falls. Now I saw it as a lithesome series of waterfalls ranging from a 1/2 metre to 2 metres in height, tumbling down over rock ledges into tiny pitch-black pools. This interconnecting chain of waterfalls and pools, surrounded by emerald mossy banks, still-green ferns, and the yellows, oranges, ambers, and rusting hues of autumn, capped my photographic efforts of the Turner Brook area that brilliant fall day.

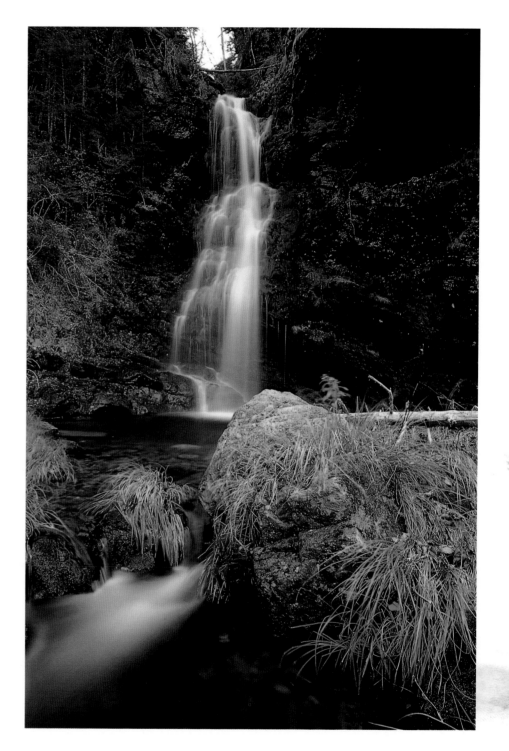

Turner Brook Falls.

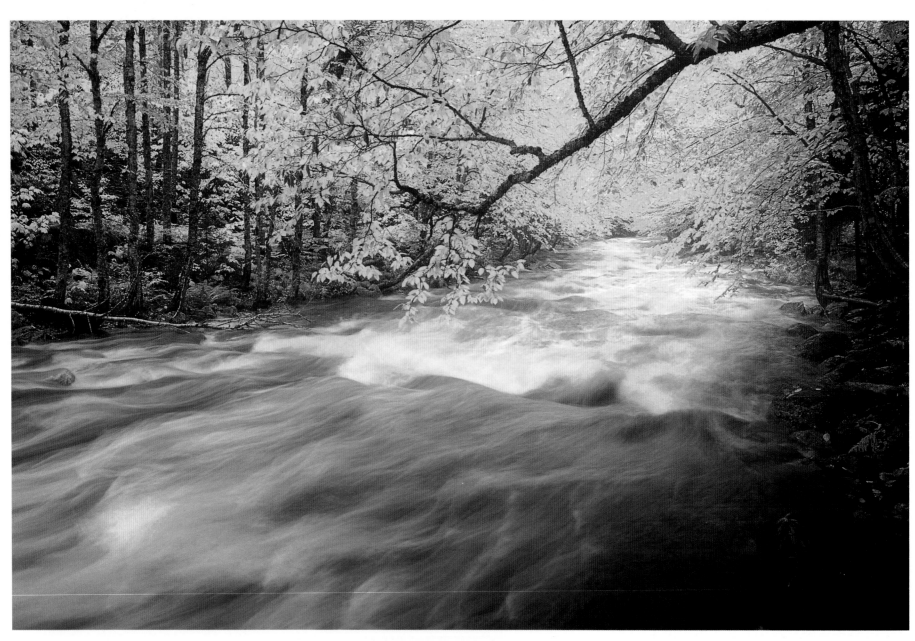

A turbulent, rain-swollen North River.

North River

Already the site of a small provincial picnic park—one of the prettiest in the province—North River Provincial Park, north of Baddeck off the Cabot Trail in Cape Breton, is now also one of the 31 candidate areas under the province's Protected Areas Plan that would see the park's roughly 600 hectares expanded to take in almost the whole length of North River plus areas of its tributary branches, an area totaling 4,334 hectares (10,705 acres).

To reach this unheralded park one exits the Cabot Trail at North River Bridge for 5 kilometres westward along a dirt road which ends just inside the park's entrance. Beginning at the parking lot and picnic area, is an 18 kilometre (11 mile) return hiking trail which flanks North River along the bottom of its sometimes steep canyon hills before it eventually reaches North River Falls.

The first part of the trail is an old road that leads to a former community of seven families which existed in the 1880s, descendants of earlier Scottish settlers. The only trace left of these people is a small area with a few low stone walls and foundations overgrown with stands of white spruce.

Near here, North River narrows considerably and splits into West, Middle, and East Branches. The hills begin to close in and the trail gets rougher as it follows first the Middle Branch and then along the East Branch.

The forests are mainly hardwoods of red maple, striped maple, and white birch with some mixed softwoods of white spruce, hemlock, and white pine, except for some fine examples of near old-growth hardwoods such as sugar maple, beech, and yellow birch along the East Branch. It is here that I have found the most luxuriant growth of bracken, cinnamon, and many other kinds of ferns as well as wildflowers such as bunchberry, blue-bead lily, starflower, spring-beauty, and stemless lady's slipper to name but a few.

The area's rock talus slopes and its sheltered valley bottom of rich soil and vegetation provide an excellent home for small mammals such as weasels, southern bog lemmings, and species such as Gaspé shrew and rock vole which are normally distributed in more northerly or high altitude regions; large mammals are less frequently seen here. Its mature hardwood stands ensure that North River is ideally suited for many species of songbirds, nuthatches, and woodpeckers.

The trail crosses the river several times, once via a crude log bridge, and further on via another more elaborate walkway built from two-by-fours. It was near this bridge one miserable October afternoon that I and a friend photographed the river and its surrounding autumn foliage. The rain had been sporadic when we started out but by the time we arrived at the bridge it was a torrential downpour.

We each shot a few frames, wiping off our lenses and view-finders before and after each shot, wondering if it was really worth it standing there soaked to the skin, trying to get a decent exposure of the frenzied river at the bottom of a murky canyon. What will nature photographers not do to get a shot?

Strangely, when the slides came back from the lab the river looked like it had been photographed at high noon with a bright sun filtering down through a thin haze. It was bizarre. The long camera exposure obliterated any trace of the deluge that was falling. They turned out to be some of my best shots.

From the last bridge over the river it is a short twenty-minute walk to North River Falls, an unforgettable avalanche of two white water plumes bouncing 32 metres (105 feet) over the jagged cliff face. Photographing the falls is an absolute must, but it requires lots of lens cleaning tissue. Fine spray blows down-river constantly and will turn one's treasured pictures of North River Falls into fuzzy, out of focus images.

When photographing the falls, another pitfall to avoid is taking a camera meter reading which includes the white water, especially on a sunny day; it will overpower the camera's light meter every time, resulting in underexposure. I have lost more than one slide to underexposure because of it. This, despite my faith in my camera's meter, would take into account the areas of black rock, green trees, and deep blue sky which I expected to more than offset the influence of the shining waters. It didn't.

Next to a rest bench at the bottom of the falls is a short side trail weaving up the sides of the surrounding hills, cresting atop a ridge 335 metres, (1,100 feet) in elevation. This can be a tough climb but it is well worth the effort. There is a splendid view looking down and across to North River Falls backdropped with the grand sweep of the Cape Breton Highlands in the distance above it.

North River is a beautiful area gifted with a pristine wilderness that recommends it for further park protection. It is easily accessible but offers plenty of solitude. From the first flush of spring with its living carpets of wildflowers to the flaming hues of autumn embracing the hills and mountains, North River remains one of my favourite places to return to year after year; it claims a rugged beauty that never grows stale or fails to inspire.

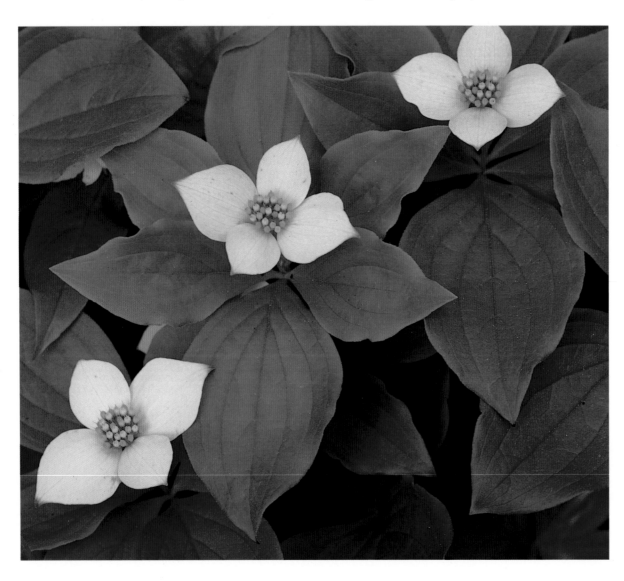

Left: A trio of bunchberry blossoms.

Facing page: North River Falls.

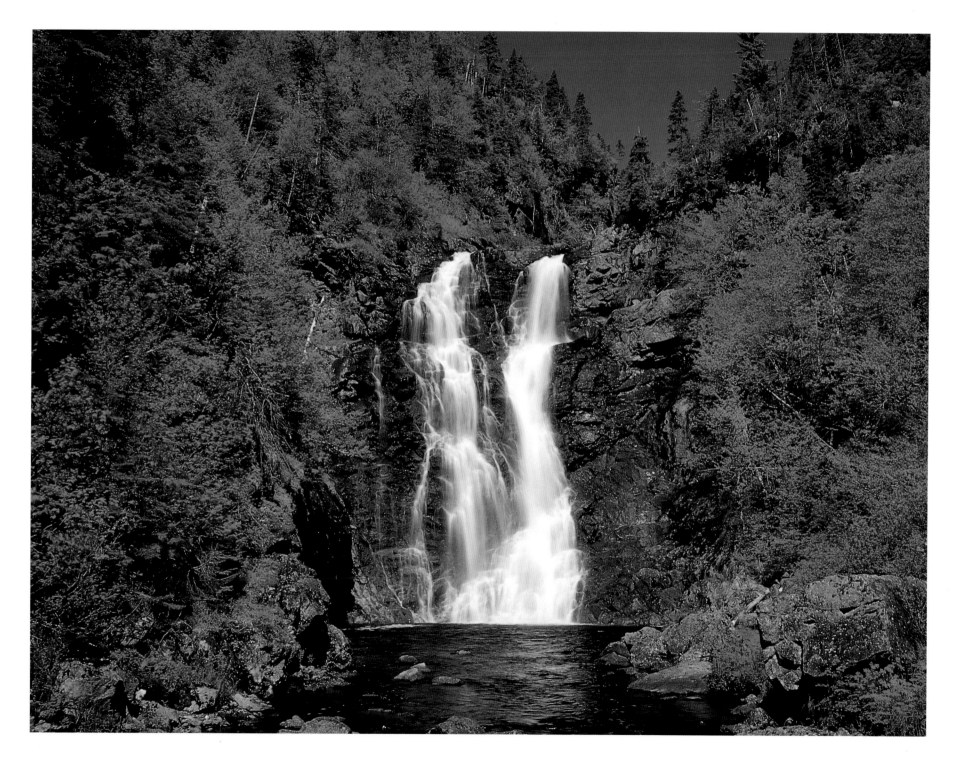

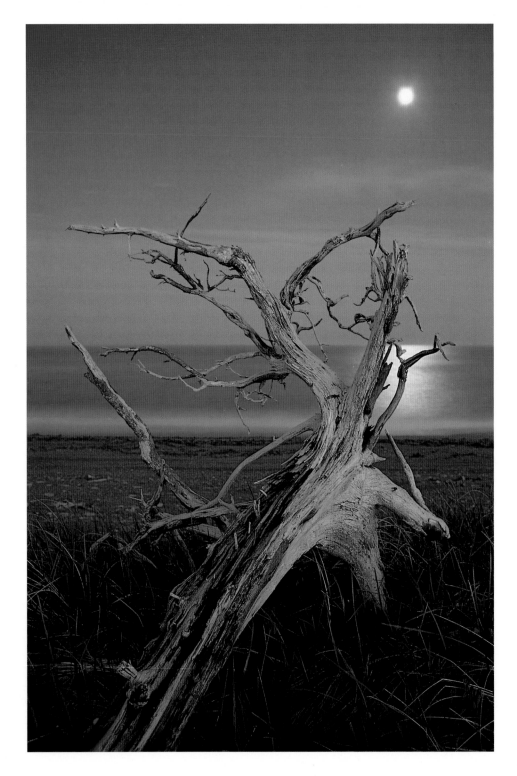

Gabarus-Fourchu Bay Coast

This is an austere but lovely coastal wilderness area in eastern Cape Breton County, just outside the small fishing village of Gabarus, stretching from Rams Head to Belfry Gut in Fourchu Bay. It is, deservedly, another candidate for permanent protection under the Proposed Systems Plan for Parks and Protected Areas, which would involve 4, 413 hectares (10,904 acres) of public land.

The characteristics of this region are low hills and flat coastal areas indented with coves, swamps, bogs, lakes, sluggish rivers, and streams wandering through an almost impenetrable forest of white and black spruce and balsam fir. Barachois ponds, lakes, and lagoons (coastal bodies of water with a mixture of fresh and salt water) created by barrier beaches of sand are also a predominant feature of most of the coast, making it practically impossible to explore the interior on foot.

As far as wildlife is concerned, this area's greatest significance lies in it being a crucial wilderness for migratory waterfowl and shore-birds. The offshore islands from Fourchu Bay south to Framboise Cove are important breeding colonies for sea birds such as black guillemots, common eiders, cormorants, and gulls. Green Island just offshore from Cape Gabarus, is the most southerly nesting ground of black-legged kittiwakes as well as the only one known to exist in the Maritimes.

For hikers there are two approaches to this coastal wilderness: one from Gabarus Village and one from the opposite end of the coast at Belfry Gut off Highway 327. I made four separate excursions to explore this lengthy coastline between June and July 1993.

From Gabarus, I took the dirt road that leads to the local cemetery on the eastern outskirts of the village, parked my car and on foot continued straight along an old cart-track used mainly by hikers and recreational vehicles. This track skirts Harris Lake and crosses its outlet stream and marsh on a large pole walk-way. From here it leads to the eastern end of Harris Beach, a crescent cobblestone beach and a small swamp bordered by the beach and woods. I noticed that ATV (all-terrain vehicle) tracks had torn up parts of the swamp, giving me concern over the tracks I saw following old trails into Harris Lake. What kind of damage might they have inflicted in that sensitive ecosystem bordering the lake?

From the end of Harris Beach the cart-track follows the edge of a dense coastal forest of white spruce along a rocky shore to Gull Cove, with its abandoned fields and the remains of tumble-down stone walls, fading reminders of a small settlement that once existed here.

My first visit to Gull Cove was one evening when the sun was tinting the bluff of Cape Gabarus in pale orange. Before I arrived at the cove I had shot very little film, but there I raced around to utilize painterly light spilling out upon the land.

On my retreat back along the coast, I spied a tall pyramid-shaped rock which stood out distinctively from among its fellow reef rocks. I constantly altered my camera-on-tripod position so that the sun would touch down exactly over the pointed tip of the rock and rattled off seven or eight bracketed exposures

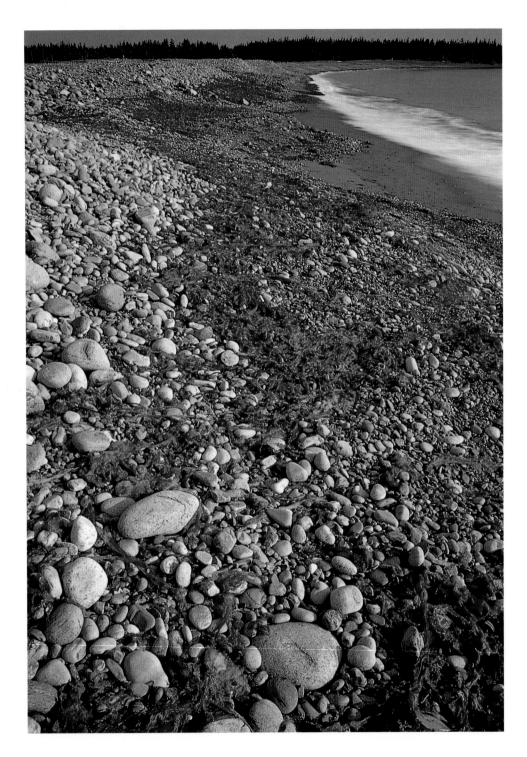

during the climactic moment when it was perfectly perched over the tip of the rock (like dotting an I) before it was so rudely plucked from sight beneath the horizon. The show was over almost before it began, but I knew it was in the bag.

Past Gull Cove is the grassy hilltop of Cape Gabarus with its broad view of Gabarus Bay and Green Island. My most unforgettable memory of this place occurred one morning an hour after sunrise. From the windblown field at the top of Cape Gabarus as I was surveying the panoramic views of the coastline, the sun momentarily slipped through a chink in the clouds. Directly to the east below me, past a wide strip of spruce forest, Green Island's silhouetted hump was caught suspended between a sparkling sea of diamonds and a storm-black sky. Taken by surprise, I barely had time to set up and fumble off two or three shots before this dramatic scenario was lost to me forever.

On the edge of a stand of spruce framing the beach at Hilliards Point I was fascinated by a small cluster of dead trees, their bone-white wood glaring so brilliantly in the sun they hurt my eyes. Small stands of dead spruce are a common occurrence along the coasts of Nova Scotia, but for me they are intriguing subjects for exploring the graphic designs found in nature, limited only by the boundaries of my imagination.

Belfry Lake, the largest lake in the entire chain of barachois lakes stretching north to Gabarus, is perfect for canoeing or kayaking,

Cobblestones and seaweed at Harris Beach on Gabarus Bay.

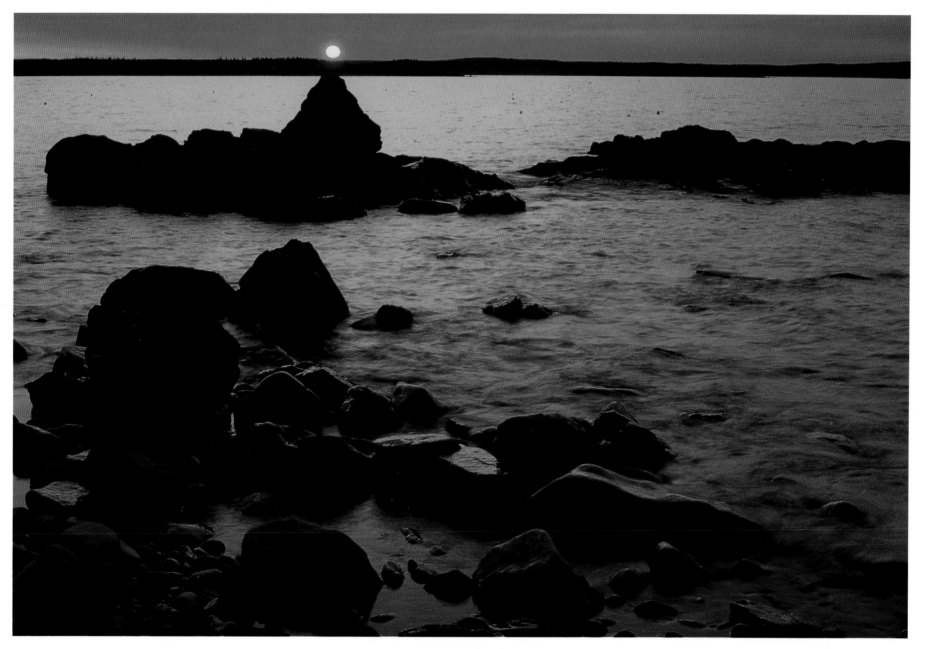

Sundown near Gull Cove Beach.

having three large islands and various smaller ones, and is sheltered from the ocean although its waters are influenced by the ocean tides via a shallow channel called Belfry Gut.

One evening on my first visit to Belfry Beach I discovered large driftwood stumps, battered relics of former Atlantic storms, in the tall marram grass of the beach. Their pale forms shone starkly in the sunlight against a sky filled with seething black clouds. I could not have hoped for better light. I managed to photograph a few of these marvellous sculptures before the sun disappeared.

Later, after shooting a series of wave pictures from a rocky headland at the end of the beach, I retraced my steps hoping to photograph the driftwood against the clear twilight sky. The compositions I wanted didn't materialize and I decided I'd have to pack it in for the day when I felt the pull of something over my shoulder. There, perched over the top of a driftwood trunk, was a softly glowing full moon, casting a sheen of light on the calm Atlantic Ocean. I had only ever dreamed of finding this kind of picture.

Consequently, it was quite dark when I returned to Belfry Gut. At low tide an ordinary pair of rubber boots will get you across this narrow channel, but at high tide it is much deeper. Once you are across this last obstacle (or first, depending on which end of the coast you start from) you are only a few metres from the dirt road, which leads back to the main highway.

In my brief visits along this coast I thankfully have seen no serious damage done to its environment. Like other candidate areas, Gabarus is only protected from new develop-ment and resource extractions such as lumbering or mining; its beaches and wetland eco-systems cry out for protection in the form of a total ban on ATVs, dirt bikes, or any other form of recreational vehicles within its borders. Once damaged they may never recover, not to mention the disruption to the sea birds and waterfowl that live, nest, or migrate through this prime breeding territory.

From Rams Head near Gabarus, stretching nearly 25 kilometres (15.6 miles) to Belfry Gut in Fourchu Bay, there exists a grand wilderness coast that deserves our respect and thoughtful protection. Visitors are rewarded with an invigorating wild setting but should leave their dirt bikes and ATVs at home. For wilderness, once destroyed, can never be replaced.

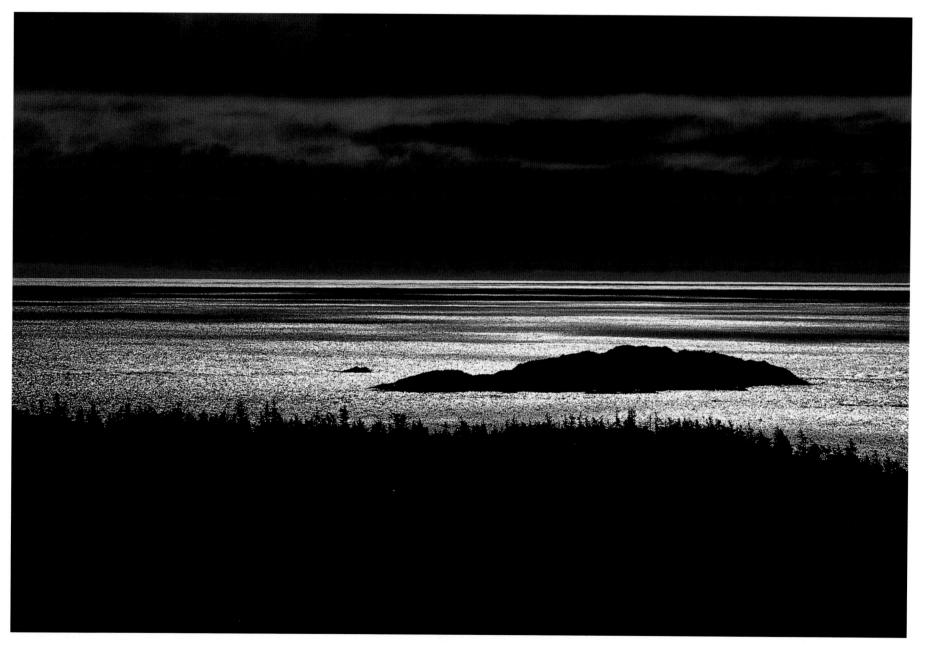

Green Island set amid the silvery waters of Gabarus Bay.

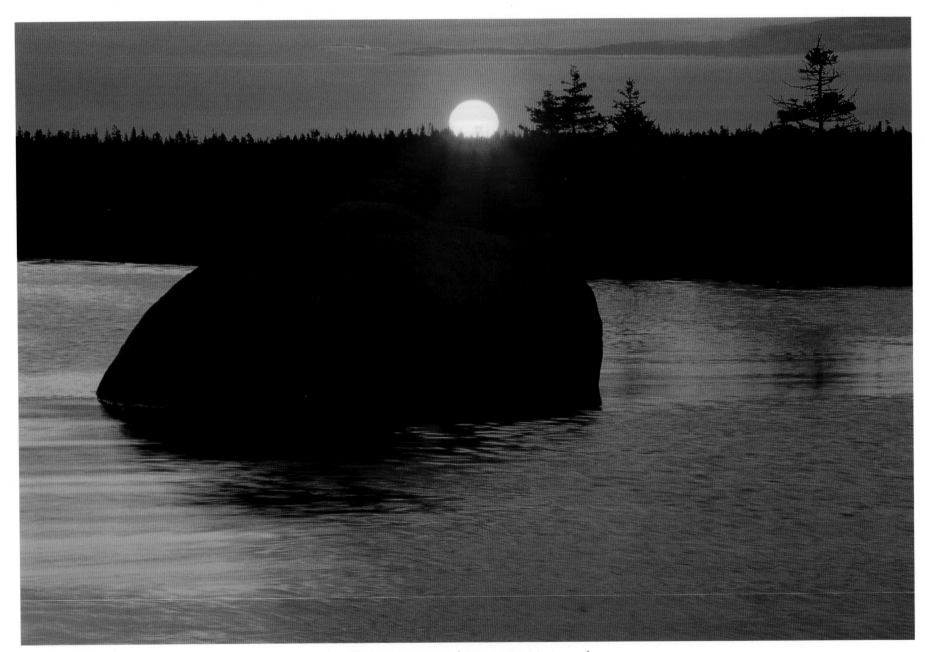

*The sun rises over a large erratic rising out of
the waters of Dover Bay.*

Canso Coastal Barrens

Although topographically speaking this area of granite knolls rising to 200 metres (656 feet) and coastal heath barrens stretches from New Harbour Cove to Cape Canso in Guysborough County, the most significant wilderness area lies along the coast from Lower Whitehead to Little Dover. It is one of Nova Scotia's most unspoiled coastal wilderness areas and is another designated Candidate Protected Area encompassing 8,501 hectares (21,006 acres) within its proposed boundaries.

It has an indented coastline of coves, headlands, and islands, with dozens of inland lakes of all sizes and shapes, and where there is enough soil, stands of black spruce and balsam fir grow. The vegetation on the barrens is mainly huckleberry, sheep laurel, Labrador tea, brackens, lichens, cinnamon ferns, and alder bushes. The area is not a great wildlife habitat, but along the coast and especially on the islands are good breeding grounds for double-crested cormorants, great blue herons, Arctic terns, common terns, common eiders, and gulls.

I came to this wilderness coast on my way back from Gabarus in late June 1993. I drove into the small fishing village of Little Dover a half hour before sunset, coming to the very end of the main road which dead-ended in a tiny cove off of Dover Bay. That night (like many other trips out photographing) I slept in my car so that I'd be on location at first light.

As a colourful dawn broke over the cove, I was already walking along its shoreline searching for photographs where the cove's still waters mirrored an orange band of eastern sky and clouds. My search ended when I positioned a rising sun over a massive boulder partially submerged in the shallow orange and blue waters of the cove.

Further along Dover Bay I noticed a tree that had been tossed upon the shore with bark clinging to its roots while its trunk and branches were smooth and bare. It looked like a flower wilting upon the rocks, the ruddy light infusing the rich hues of rocks, and the wood in warm golden tones.

Skirting the Louse Harbour coastline (an ugly name for such a pleasant place), I found many photogenic subjects for my camera such as the glacial erratics peppered along the shore, abandoned lobster traps on the margins of a barachois pond, views of Louse Harbour with its islands and coastal fringe of dark conifers, and panoramic views of the barrens rising from the shore with their patchwork masses of green ferns.

The path I was following was blocked at a secluded sand beach by a formidable barrier of spruce and fir; regretting not being able to proceed further, I retraced my route until I noticed a bold splash of colour through the trees. This I found to be a granite cliff face about 5 metres high, covered in vivid emerald-green moss from one end of the cliff to the other. I had never found anything quite like this before and, needless to say, I shot a lot of film before I felt I'd done it justice. Even with the sun high in the sky the woods were so shaded that I required exposures of many seconds, but I didn't have to contend with glaring spots of sunlight dotting the forest floor and ruining the pictures.

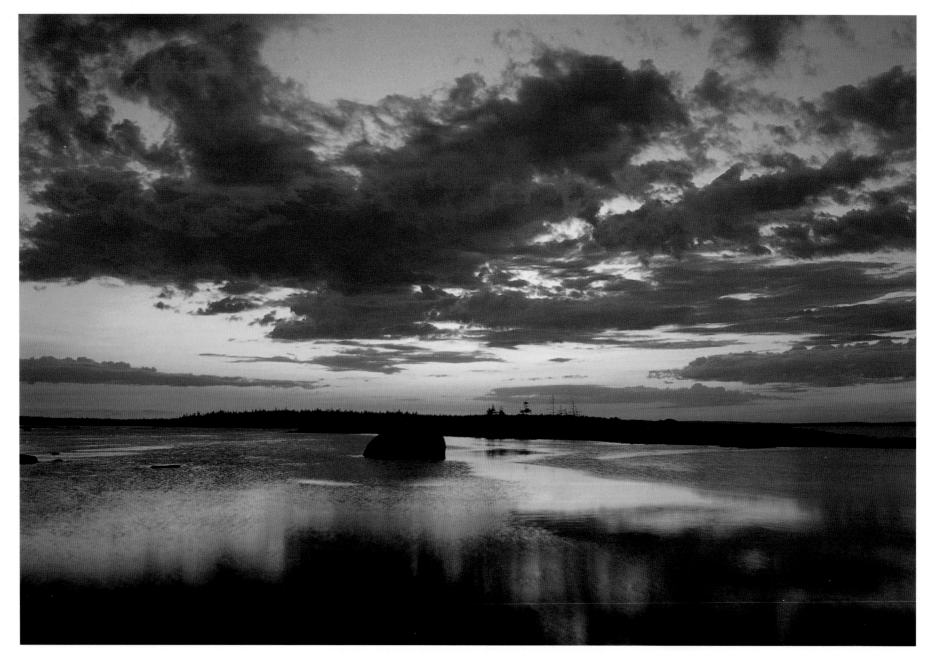

Dawn breaks over a remote cove off Dover Harbour.

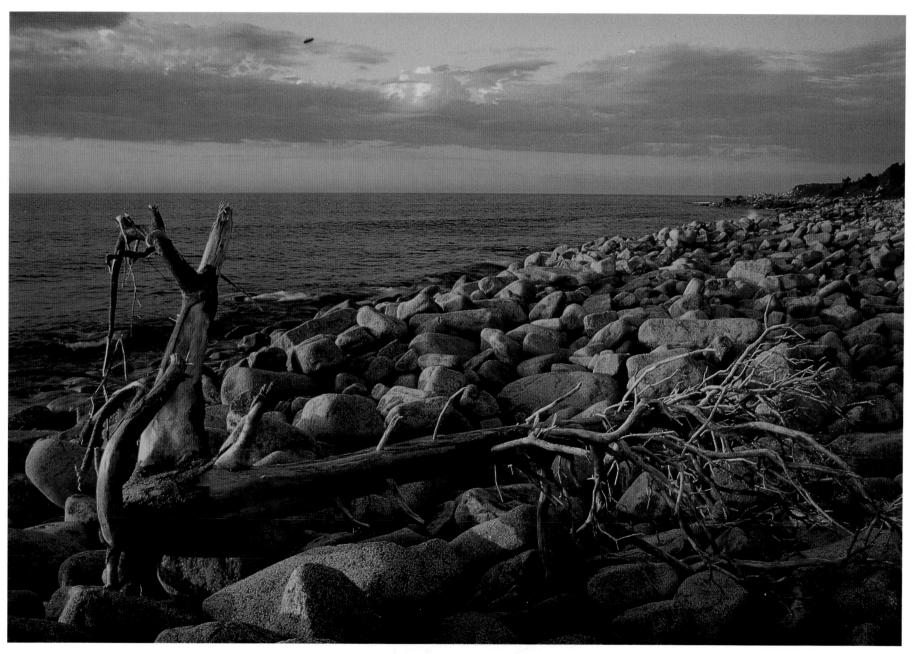

*Sunrise highlights a driftwood trunk tossed upon
the rocky shoreline of Dover Bay.*

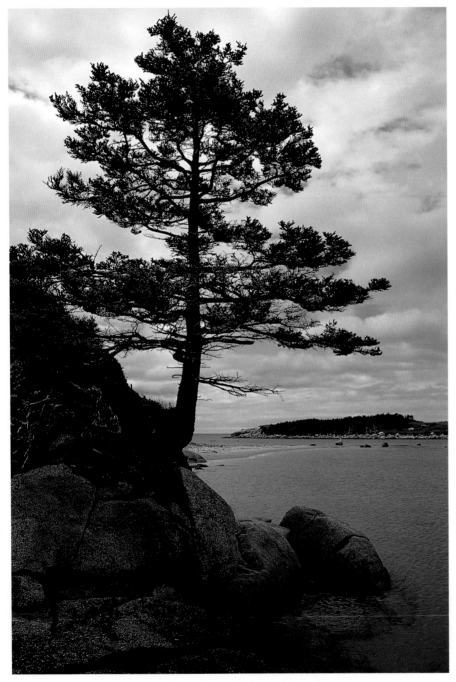

A solitary spruce clings to the rocks on Dover Island.

Finding the coastline impassable resulted in my returning a few weeks later to explore the coast from seaward, with a local fisherman, Darren Nicholson, who was also a photo enthusiast.

We left the public wharf in Darren's 5 m (18 foot) outboard, passing Grassy Island directly across from Canso, which is now a National Historic Site, and Glasgow Harbour, with its small islands of bare granite, and through a long passage into Dover Bay, where I recognized the coast which I had hiked along just a few weeks before.

On the far side of Dover Island we came to Sand Cove which shelters an alluring sand beach. I was eager to go ashore so we beached the boat and I set off with my camera to photograph the area. The beach was pristine with only a few pieces of driftwood and the mummified remains of a small flatfish poking through the sand. Here was a delightful strand of beach, as unspoiled and hidden from the world of man as much now as it had been centuries ago. I loved the feeling of being on such a secluded wilderness beach along one of Nova Scotia's most remote coastlines.

Crane Cove further down the coast opened into wide barrens, and invitingly had a fisherman's camp at the end of a small inlet. I decided to hike the coastline as far as I could before nightfall and to camp overnight at Crane Cove. Darren left, promising to be back around noon the next day.

The heath barrens along the Atlantic coast are typified by thick shrubbery, ferns, and alders, interspersed with bare rock surfaces, mosses, and lichen-spotted glacial rock leftovers. I knew from experience how difficult it is

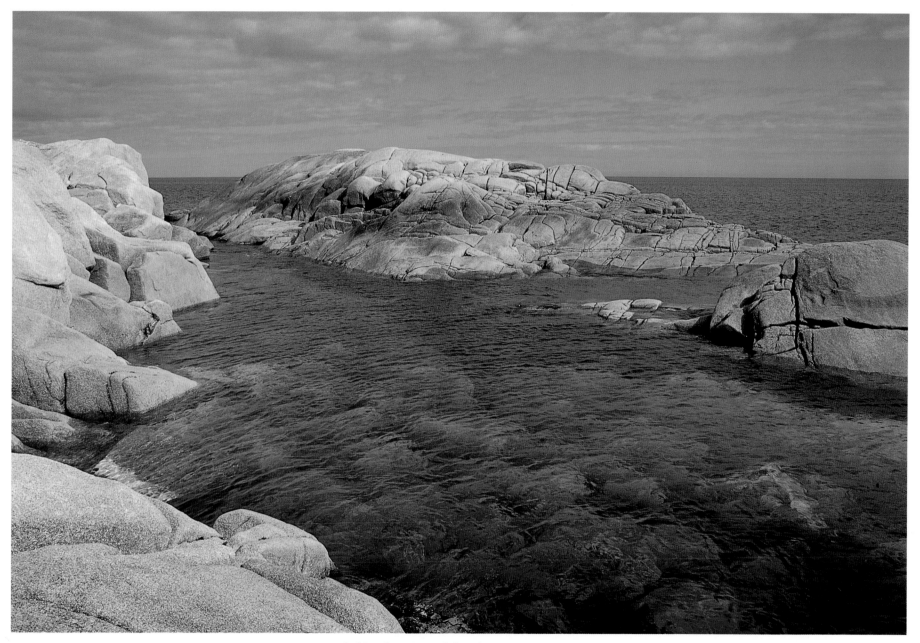

A baldrock section of shoreline near Crane Cove.

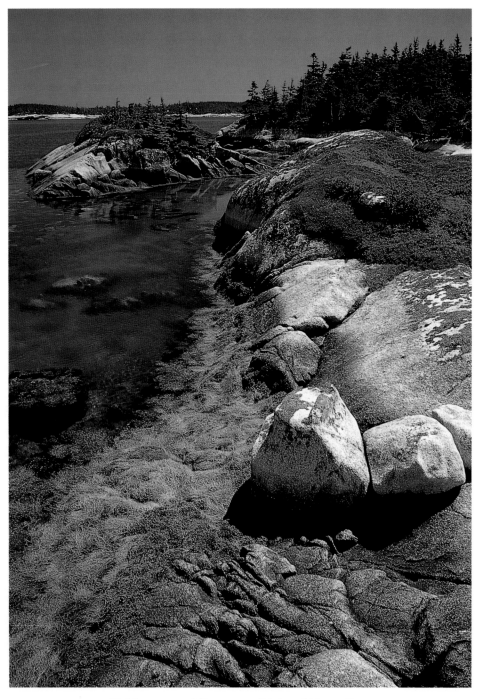

Golden seaweed lines a small inlet of Crane Cove.

to hike any distance through that kind of terrain, so, like nature, I took the path of least resistance, following the shoreline along the water's edge and only crossing the barrens when I couldn't manoeuvre around small bluffs, huge rocks, or other obstacles.

That afternoon, hiking along the wilderness shoreline and exploring its nameless coves was one of the most exciting days I have ever spent photographing. The hiking was easy and all my cares and responsibilities were miles away; I felt free, my only task to enjoy the unspoiled beauty and do what I love most to do—take pictures.

Rocks with their different shapes, colours, and textures have always held a special fascination for me photographically, especially glacial erratics. This was a rock lover's paradise. Every few feet (or metres if you prefer) along the coast I photographed an interesting rock formation. The most memorable one was a large granite slab at the mouth of a nameless cove. It was fractured into sections, with most of the fissures sprouting leafy green plants, while the rock itself was speckled in eye-catching gold and orange lichen.

A short distance away, a line of huge granite rocks stretched towards a forested island just offshore as though someone had begun building a causeway to it. I photographed the natural causeway and a cluster of pink wild peas that added a dash of colour to the somber landscape.

It was close to evening before I started back to camp. The sun, which had been in and out of the clouds all afternoon, finally broke through one last time, flooding the coastline in a warm orange hue. I managed to take only a few pictures before the evening sunlight I had been anticipating all day disappeared in less than two

minutes. Back at the camp I had something to eat, while above my head stretched the haloed band of the Milky Way, flowing like patterns of frost across the window pane of the sky. Elsewhere, individual stars shone like sparkling diamonds randomly tossed by the hand of God. I sat there for a long time, meditating, my eyes scanning the skies, admiring the handiwork of the firmament, before I turned in for the night.

Darren arrived shortly after twelve that next afternoon, dropping me off again on open shoreline that I had not explored earlier because of dense woods. During my explorations, I stumbled upon a hidden inlet with its own tiny island, a granite knoll shaped like a pyramid,

capped with a clump of dwarfed spruce trees and mosses. Lining the margins of the inlet were swaths of gold seaweed, while the inlet water reflected various shades of green contrasted against the dark blue of the surrounding Atlantic Ocean. With such dynamic scenery before me I didn't stop until I felt I had left no erratic (or is that stone?) unturned.

Once again on board, we skirted the coast-line past Whitehead Island, made our way carefully through the channel and rounded a point: the vast Atlantic Ocean was before us, stretching to the horizon, its unabated swelling waves wilder than those of the sheltered inner coast just behind us.

The Canso Barrens coast is one of Nova Scotia's prime wilderness areas, essentially the same unsullied, wild landscape as it has been for thousands of years. This stark and beautifully somber region needs our support if it is to be retained for its irreplaceable wilderness values. It is an heirloom that should be preserved.

Hardy survivors cleft in golden granite (left); wild pea blossoms (centre); and buttercup and orange blossoms of Sedum rosea (right), all near Raspberry Cove.

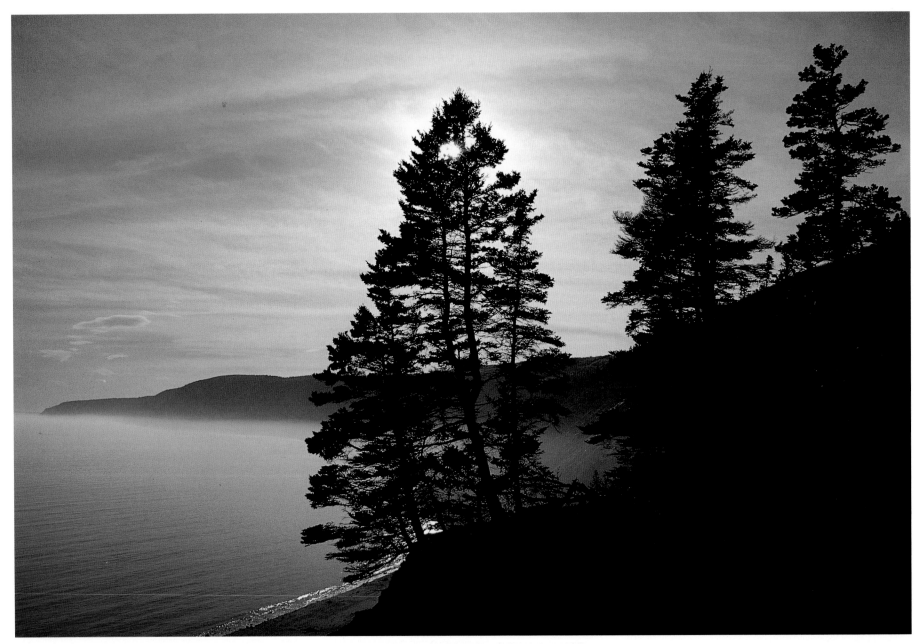

A late afternoon mist contours the receding outline
of Cape Chignecto.

Cape Chignecto

Cape Chignecto, Nova Scotia's newest and largest provincial park, stretches from the outskirts of West Advocate along the Bay of Fundy coast to Halibut Head, just past Spicers Cove, 11 kilometres southwest of Apple River in northern Nova Scotia.

This is one of the province's most remote coastlines and incorporates many of its outstanding natural features. These include ancient rock formations 400 to 900 million years old; sheer 185 metre (607 foot) high coastal cliffs whose bases are washed by the world's highest tides; fascinating sea-stacks, "keyholes," and other such formations; small sea caves and isolated coves as well as rocky beaches, some of which are raised beaches and wave-formed terraces now 35 metres (115 feet) above sea level, remnants from the last ice age.

Up from the coastline, the land is cut with deep narrow valleys and ravines whose streams and occasional waterfalls flow along primeval fault lines, passing through remnant stands of immature old-growth red spruce and yellow birch sometimes sheltering rare plants, mosses, and lichens. For example, Cape Chignecto is the only known location for white snakeroot in Nova Scotia, and the most northern occurrence found of a rare lichen (*Parmelina aurulenta*) in North America.

Due in part to these distinctions of natural history, in 1990 the provincial Department of Natural Resources acquired 5,930 hectares (14,653 acres) of land at Cape Chignecto, 4,252 hectares (10,507 acres) for the proposed Cape Chignecto Provincial Park that is slated (among others) to have a coastal hiking trail along the park's entire 23 kilometres (14 miles) of jagged, spectacular coastline.

The wildlife of Cape Chignecto is typical of other areas in Nova Scotia with moose, deer, black bears, coyotes, harbour seals, and other smaller mammals. Although not abundant, there are small numbers of waterfowl present such as black guillemots, mallards, cormorants, and loons as well as more numerous songbirds, nuthatches, woodpeckers, grouse, owls, hawks, and even a few bald eagles. The most noteworthy visitor to Cape Chignecto is the rare eastern bluebird, which is sometimes found nesting in the area.

Here, the forests are predominantly mixed varieties of red spruce, balsam fir, red maple, sugar maple, white and yellow birch. In a few areas, such as at McGahey Brook, are older red spruce stands remnant of the once pre-eminent forest cover of the region, where its mixed stands of spruce and birch are 100 to 150 years old.

There is one regrettable distinction between the landscape of Cape Chignecto and the other wilderness areas I describe in this book: large areas of Cape Chignecto were lumbered between the 1870s and when the land was acquired for the park.

Although there is little evidence of the logging done decades ago, the modern methods of clear-cutting are visible in sections of the park area as well as outside its boundaries. Although these clear-cuts inflict disfiguring gashes upon parts of the interior landscape, they are thankfully not visible nearer the coastline, which still retains its pristine nature.

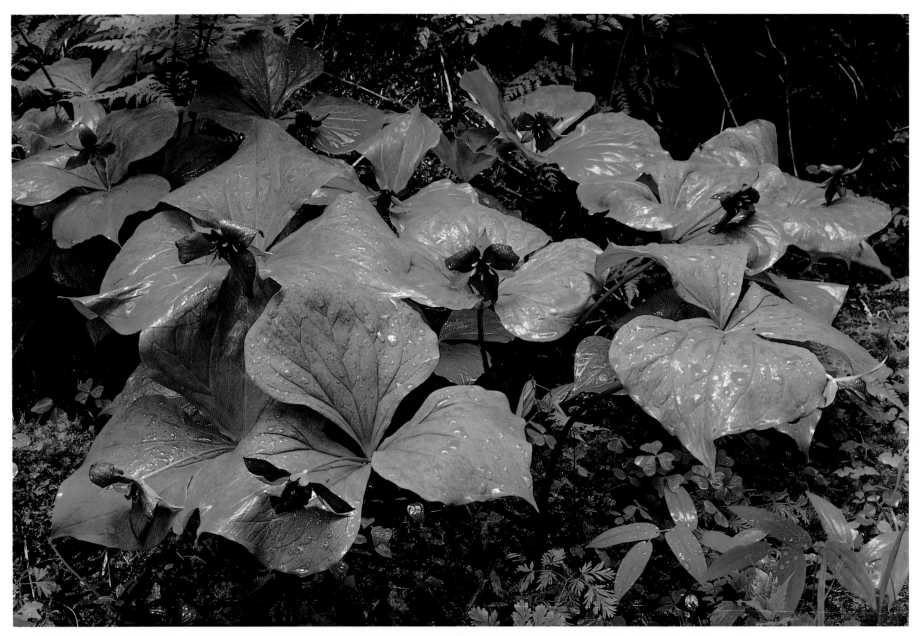

Ageing rain-freshened red trilliums along the upper reaches
of McGahey Brook.

My starting point for exploring the area began at Red Rocks, the distinctive red sandstone fingers of rock that poke above the stony beach in Advocate Bay, on the western boundary of West Advocate. These tide-smoothed rocks, the only sandstone formations for miles around, are a popular place for sunbathing and swimming and are easily accessed by a dirt road with a small parking area. Red Rocks is a starting point for hiking further up the beaches or coastline beyond.

McGahey Brook

McGahey Brook is 1.5 kilometres northwest of Red Rocks. It is a shallow, Y-shaped brook tumbling down from the surrounding hills through two narrow canyons that finally merge over a low coastal bank into the waters of Advocate Bay. Some of the best examples of what remains of Cape Chignecto's original red spruce dominated forest are found here.

After long ignoring McGahey Brook for other more remote areas of Cape Chignecto, one afternoon in early August 1994 I took the easier right-hand branch, where along its mouth, as I later learned, a sawmill had operated around the turn of the century.

I followed the brook past an annoying barrier of overgrowing spruce to an open mixed woods with wet, low areas rich in different species of ferns and distinctive clusters of lion's-foot (*Prenanthes alba*) plants with their large spreading trio of green and silvery leaves.

Not far upstream the spruce and balsam fir grew larger and, to my delight, I found large open spaces flooded with light and filled with multitudes of ferns surrounding large yellow birches, red maples, and impressively straight,

towering spruce and fir. These hillside glades were a pleasant diversion after being submerged under the somber shade along the brook's banks.

I was suddenly aware that the afternoon had somehow slipped away and sunset was bearing down. I made my way along the hillside through the tall ferns and the thick-trunked trees in search of other photogenic subjects. Nothing stood out except a pair of white birch trees whose bark was peeling off in curling strips down the length of their trunks. After a series of long time exposures I packed my camera gear away and hurried down to the brook and back out along its winding course, believing I had made my first and last trip along McGahey Brook.

A few months later, a copy of the 1904 Geological Survey map of Cape Chignecto came into my hands, showing not only the mill but three separate waterfalls: a 3.4 metre waterfall further up the branch I'd explored plus two higher falls halfway up the other branch.

Moreover, Mill Brook, the next brook down the beach, possessed two waterfalls as well, one 12 metres near its mouth and an even higher one—15 metres— further up its course.

As a photographer, one of whose favourite subjects is waterfalls, I knew I'd have to return come the proverbial hell or high water.

—◦—

I returned to McGahey Brook with high expectations in mid-June 1995, just after a full-force gale had huffed itself out but the rain had kept up.

As I approached the upper limits of where I

had been the summer before, splashes of blue through the trees revealed a wet glade with dozens of blue violets growing in lovely profusion—the largest concentration I ever remembered seeing.

Just past a minor offshoot of McGahey Brook, the banks reared up in a definite slope for the first time, and a few hundred metres away I discovered two gorgeous tassels of water, only a few centimetres in width, sliding down the side of a 10 metre bedrock ridge on the opposite bank of the brook.

The first rivulet flowed past a white-blossomed hobblebush—which drew my attention because of its showy flowers—while the other knifed smoothly down over worn grey rock and multicoloured mosses, bottoming out as a white wedge of water into McGahey Brook.

The brook now was trapped between the walls of the rising ravine, where its glassy-eyed presence was transformed into a roaring monster, thrashing over ledges, boulders, and debris from the nearby hilltops.

I climbed the adjacent hillside, following the brook's run towards the top, to where McGahey Brook comes flying down a sloping summit out of the forest. But there was no miraculous turn of events; there simply were no waterfalls.

Wet and exhausted, I headed back down the brook. Happily, just past the flowering hobble-bush I sighted the wine-red blossoms and glinting leaves of a tightly clustered array of a dozen red trillium wildflowers. To witness this many red trilliums growing together was phenomenal, as they usually grow solely or with only two or three loosely spaced, and their blooming season was over in other parts of the province.

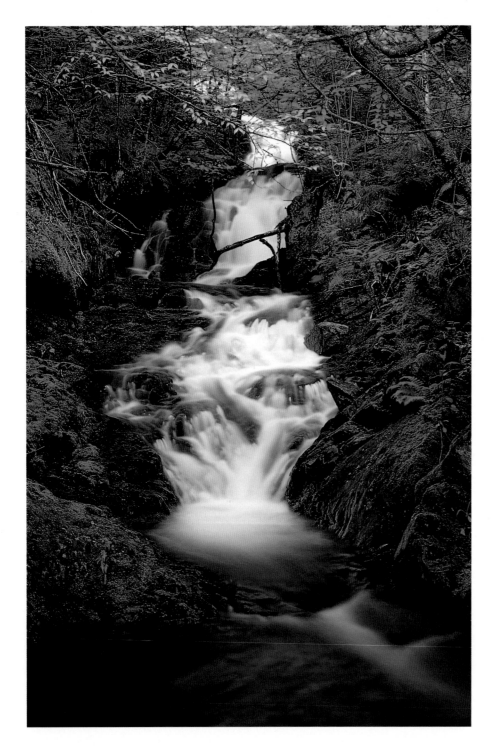

Mill Brook

Mill Brook lies roughly 3 kilometres northwest of Red Rocks, down the beach past McGahey Brook. Just before Mill Brook, the beach narrows into a jumble of seaweed-covered boulders that have crashed down from the bluffs, leaving only a few metres of shoreline to manoeuvre around to the sheltered cove into which Mill Brook empties.

That next morning, delayed by the rain, I dashed down the beach, hoping I could make it around the boulders before the tide came rushing in, but even in my rubber boots, I couldn't get around. Cautiously, I managed to climb my way to the top of the seaweed-slicked rocks and drop down into the cove with its pebbled beach, lined by high cliffs and receding hills beyond. The shallow waters of Mill Brook flooded across the beach and not far away a waterfall dashed down between two lower bluffs.

The map had shown a 12 metre (40 foot) falls at the base of Mill Brook and, for once, it was right. Maybe there really was a 15 metre (50 foot) waterfall after all.

Passing what I concluded were traces of the old sawmill operation, I continued up the brook until, rounding a corner, there unexpectedly appeared before me one of the most beautiful forest ravines I have ever seen: Mill Brook was transformed into a still pool of glass, enclosed by mossy rock walls several metres high. Small clusters of ornate and willowy ferns edged the pool, while a skeletal tree rested its top in the peaceful water.

Eventually I caught sight through the trees—

Mill Brook's most dominant waterfall.

which had gotten much larger—of a small pool of water being fed, to my disappointment, by a brook merely bubbling down over a rocky hillside. Nice, as they say, but no cigar.

I continued uphill through the trees, where a short distance away, Mill Brook splashed down over loose stones and small rock ledges from a split-course waterfall several metres high; in the distance a much higher waterfall dropped out of my line of sight.

There actually were other waterfalls on Mill Brook.

I photographed the lower falls from bottom to top but my intuition took me up past the bigger falls, where to my satisfaction I discovered a third falls even more exquisitely wrought by the hands of nature.

Fashioned from two water courses, it cascaded silver and white over a bedrock edge into a fathomless pool. I photographed the waterfall and the moss-lined chute of tumbling water below its pool, aware that ominous black clouds were threatening to obscure the sun.

Glancing upstream, (I shouldn't have been surprised but I was) I spied another waterfall—the most imposing of all! Its waters came surging down 15.2 metres (50 feet) in a series of bouncing steps over a steep hillside directly ahead, its summit just barely visible through the lush leaves of the enclosing hardwoods.

I photographed the falls from its base pool and picked my way up along its edge until I came to where Mill Brook first drops over the top. From this vantage point I could view the hills surrounding Mill Brook more clearly, some of their crowns (according to my map) reaching about 274 metres (900 feet) high, reminiscent of Cape Breton's Highland mountains.

My worst fear was being stranded in the cove for a long wet night waiting out the hours for the next low tide. But as I focused my camera on the scene before me, I became mesmerized by the patter of the rain (which had just begun) as it broke the pool's still surface. My vision changed and I imagined a lithesome unicorn coming gracefully down to drink, while on the top of the mossy bank among the trees, a family of tiny trolls were congregated, curiously looking down upon me. It must be in special places and at moments like this that artists find the inspiration to paint works of wonder and fantasy. After taking my last shots, requiring two or more minutes of exposure in the growing gloom, I hurried through the woods along the brook's banks and into the cove where to my great relief I found the tide at maximum low.

Refugee Cove

Seven kilometres from Red Rocks, past Mill Brook and a shoreline rimmed by cliffs and boxed-in coves, lies Refugee Cove, the largest cove on this side of Cape Chignecto.

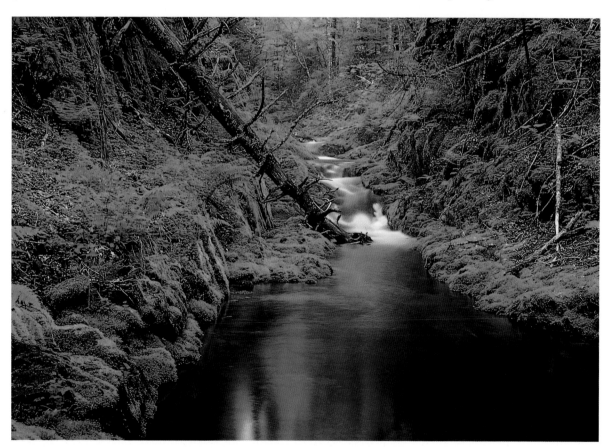

In a moss-draped ravine Mill Brook empties into a pooling still water.

According to legend, in 1755–56 a group of Acadian refugees from Belleisle in Annapolis Valley escaped the expulsion of their people by the British and made their way to safety at Refugee Cove—hence its name.

My first hike here occurred during the first week of October 1993. I decided to take the most direct route—straight down the shoreline from Red Rocks—a daunting challenge given the vertical cliffs, jutting bluffs, and headlands hemming in the coastline beyond the beach at Mill Brook.

After waiting out the rain for two days, I finally set out for Refugee Cove, on a sparkling sunny morning, allowing myself time to walk around the edge of the boulders at the entrance to the cove at Mill Brook, before the tide turned.

Half a kilometre or so from Mill Brook I arrived at Arch Brook, a thin string of water flowing down from a high bluff, the last brook marked on the map before Refugee Cove.

Arch Gulch, just beyond, is a shallow alcove sliced out of the side of a cliff; its overhanging roof, I mused, would provide a temporary shelter during a rainstorm or a watery prison during high tides.

Near here I happily stumbled upon one of my favourite subjects found sporadically in nature–sea-stacks. Two tall and crazily slanting sea-stacks were standing in close proximity, hugging the shoreline.

The tallest and most slender sea-stack, perhaps 15 metres (50 feet) in height, had the most pronounced tilt and was topped with a few small bushes. The other was thick and shorter, crowned by one skinny spruce tree sticking like a feather out of its sloping summit.

I photographed them despite the flat light.

I had to skirt a jutting headland with an archway tunnelled just above my head, and here, as well as two or three places on my way to Refugee Cove, the waves were beaching only a few metres away and this near maximum low tide! The confined shoreline made me nervous: I was walled in by hills, bluffs, and vertical cliffs, with a few indented coves on my right and the incoming tides of the mighty Bay of Fundy to my left. The biggest coves could provide an escape route from the world's highest tides but most were little more than niches in the cliffs that would fill with water at high tide.

I hiked along the coast at a brisk pace, hoping to see Refugee Cove around each bend and becoming more and more anxious, until with relief I cornered another headland and came upon a terraced gravel beach amply spaced between two high ridges. Refugee Cove at last, and none too soon for my peace of mind.

I learned later that the small brook-fed pond behind the beach was the remnant millpond for a sawmill constructed in 1939 that operated for only a few years. A foot path along the brook led to a large concrete block, hollow and lined with bricks—the old wood-burning oven used to generate steam for the mill.

The hills framing the cove's boundaries were arrayed in a mixture of conifers and hardwoods, displaying their fall coats of red and orange. To the west, a sheared orange rock-face striped with diagonal veins of jade green rock plunged to the beach, where a gravel spit reached out to Refugee Cove's most singular landmark, a tall pyramid sea-stack 20 metres (65 feet) or so in height, poised like a sentry about the cove's entrance.

Although the sun that evening hid behind the headland ridge (rather than over the cove), its colours spilled into the cove, silhouetting the peaked sea-stack, the headland and the distant land of Isle Haute rising fortresslike out of the sea: black shapes outlined against the tangerine-coloured sky and waters of a serene Bay of Fundy.

With the tide in retreat, I made my way out of the cove along the shoreline to the west, where from the top of a ledge I photographed the silhouette of French Lookout not far away, a sheer-cliff headland rising vertically from the shore. French Lookout, like Refugee Cove, got its name from the French refugees who kept watch for English ships from its top and from where they signalled their compatriots across the Bay of Fundy on the mainland. It is along this section of the Cape Chignecto coast that the cliffs and headlands are the tallest and sheerest, rising 185 metres (607 feet) from the shoreline.

After a cold meal by flashlight, and several hours enjoying the overhead theatre of stars, I climbed into the warm cocoon of my sleeping bag and fell asleep, listening to the soft sighing of the wind and the slapping of the waves on the beach.

The next day turned out to be quite windy, with waves crashing onshore. This was not good. I was planning on leaving around noon and the strong winds and waves would definitely inhibit my progress.

I left at what should have been low tide, but when I came upon the first high bluff the waves were already washing its sheer face. What was wrong with my timing? To cross, I had to time the incoming waves, my back pressed against the rock wall. This was the most frightening

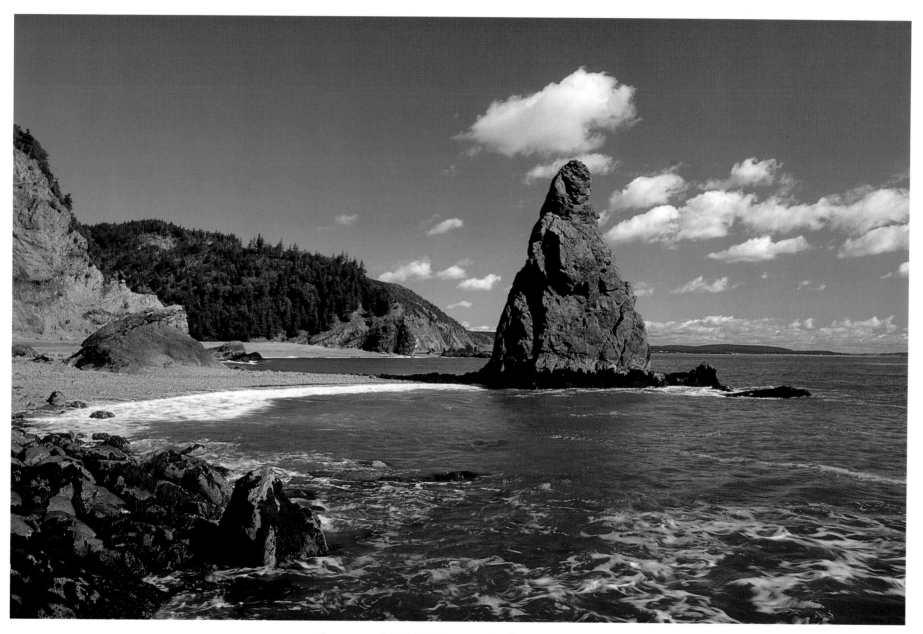

The sea-stack "Old Sal" is one of Refugee Cove's most
prominent landmarks.

spot, but there were narrow protruding areas of big boulders or low rock ridges where I ran between incoming waves or scrambled around rocks I could no longer pass in front of.

Dreading each bend of the shore, it was with great relief that I eventually approached Mill Brook, even though the tide was rising up the sides of its huge boulders. I had to climb across their tops to get to the beach on the other side, but at least I was home free.

Although I absolutely do not recommend it, anyone insisting on hiking the shoreline to Refugee Cove from Mill Brook should leave as soon as possible before low tide, making sure they have the correct tide times and the correct time. (I discovered, too late, that my watch was twenty minutes slow!) I followed the low tide times listed for Parrsboro, while, as the local fishermen will tell you, the local tide times are closer to those of Saint John across the Bay of Fundy, a one-hour difference. When I left Refugee Cove by a watch twenty minutes slow and using Parrsboro tide time, I had actually left about fifty minutes after low tide!

Coastal Cruise to Cape Chignecto

In mid-July 1994, I arranged for a local fisherman, Jerry Fields from West Advocate, to take me and two friends, John Webb and Hubert Boudreau, on a sightseeing cruise along the coastline of Cape Chignecto from Advocate Harbour to Spicers Cove and back. I wanted to get an intimate look at the entire rugged coast of Cape Chignecto; a coastal wilderness very few people have ever seen.

We set out at 8:30 on a cloudless sunny morning on the retreating tide from the pier at Advocate Harbour in Jerry's Cape Islander boat. It would be an all-day trip because we would not be able to return until high tide later in the evening. Low tide in this part of the province leaves boats sitting dry on muddy bottoms.

There was not a breath of air and the seas were as smooth as glass, a rare occurrence in the Bay of Fundy. We passed in quick succession a distant and familiar Red Rocks, McGahey and Mill Brooks, before we began to hug the shoreline. We had front row seats for a close-up view of the reefs and rocks, the cliffs, bluffs, and coves only a few metres away. We passed the two sea-stacks I had photographed on my hike to Refugee Cove, camouflaged against the cliffs above Arch Rock.

We idled awhile at Refugee Cove, taking pictures of the cove's various features including its tall sea-stack partially submerged by water. This sea-stack, locally called "Old Sal," was fashioned from a jade green rock; the whole coastline of Cape Chignecto is composed of mixtures of green, grey or black rock (although the predominant colour is a reddish or orange brown) making for colourful rock formations in many areas.

All along the coast we were met with an array of imposing headlands and sea-cliffs, some of which are the sheerest and tallest coastal cliffs to be found in mainland Nova Scotia. Nearing the tip of Cape Chignecto we came to Devils Slide Cove, one of the cape's most distinctive landmarks. Locals call it Devils Slide because it is simply an indentation in the rock as though a giant (maybe Glooscap?) had cleanly sliced a rectangular chunk of bedrock out of the cliff. Bordering on Devils Slide is the

tip of Cape Chignecto's massive headland, the most westward extension of the Cobequid Mountains.

Rounding the cape we came into view of its far side, markedly different from the previous shoreline. Although presenting a rough and convoluted wilderness landscape, the land abruptly starts to bottom out, losing its dramatic elevations.

After a lunch of fresh cooked lobster we resumed our journey along the shoreline, passing in succession Big Bald Rock Brook and its namesake Big Bald Rock, a smooth bump of headland rock overshadowing the shoreline. Jerry's familiarity with the names of the coves, brooks, and other coastal landmarks was invaluable in identifying landmarks as we sailed along.

Not far up the shore we crossed the entrance to Keyhole Brook with its dual waterfall, emerging from a densely wooded valley with peculiar grassy areas, possibly traces of past logging activities in the nineteenth or early twentieth century.

Nearby, we spotted eight or nine harbour seals sunning themselves on a reef, diving and swimming about while keeping a wary eye on our proceedings. After a few unsuccessful attempts at photographing them we moved on.

Two more sea-stacks rose up from the edge of a small cove at Carey Brook, one was quite massive and tall with a clump of trees at its top while the other was short and skinny with only a single lanky spruce tree clinging to its pointy tip. Carey Brook itself was a boxed-in beach at whose shallow head was flung a high wall of driftwood debris. Its most distinctive feature was a towering coastal bluff that dropped down

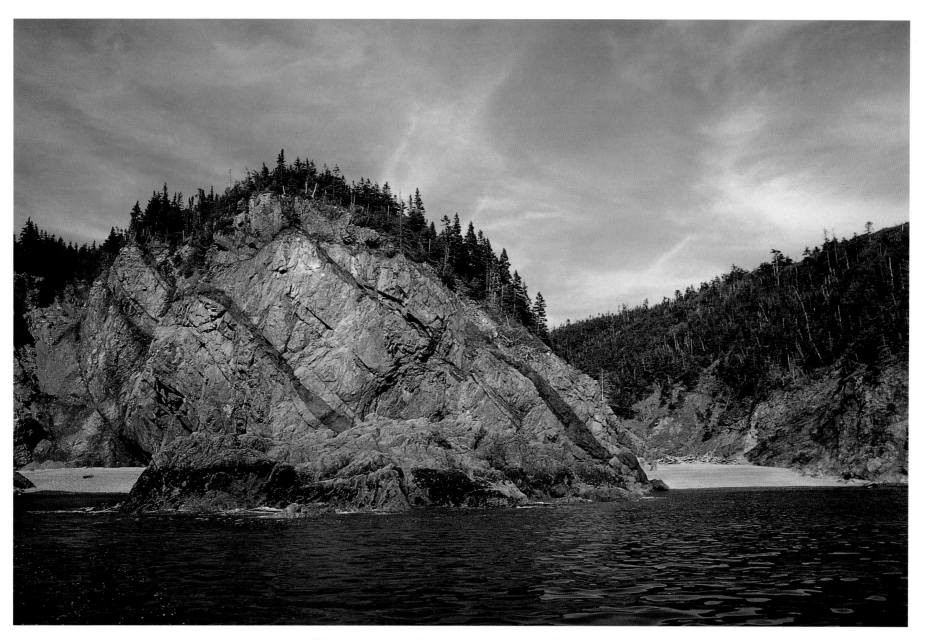

*The cragged, irregular coast near Carey Brook is typical
of most of Cape Chignecto.*

to the beach, its rock-face highlighted by two long diagonal veins of green rock.

Just around the first minor headland past Eatonville Harbour we coasted by some of the most outstanding natural features that this coastline has to offer—a coastal "garden" of sea-stacks. The closest was a straight spire of solitary rock 10 metres (33 feet) high, while in the background was a trio of sea-stacks of impressive stature called the Three Sisters. Two are roughly the same size and height, 12 metres (40 feet) or more, but the third is shorter, shaped like a skinny finger pointing upward. There were a few smaller stacks and other stacks in progress being sculpted from the hard volcanic rock of the shoreline by the Bay of Fundy's ever surging tides. By now the tide was high as we could pass close to the outer edge of the Three Sisters, a novel experience since I had walked around them at low tide, when a friend, John Webb, and I had come in search of this particular area after hearing vague rumours of its existence.

On that occasion, we had left his car in the clearing at the end of the logging road and hiked down to Eatonville Brook along an old cart-track to the beach. John was in the lead, and after leaving the beach, managed to make his way to the top of a rock ridge to get a view of what lay down the coast. He gave a shout of exclamation, and when I hurried up behind him I could see why.

Below us, lit in a reddish orange by the setting sun, was a tall spiked spire of rock. Not far away three other ruddy coloured sea-stacks stood clustered together, outlined against the sky and coastal cliffs. The two outer sea-stacks were thick-stemmed with wide moulded heads,

one curving outward like a mushroom whose cap was missing, the other rising straight up with a flattened top. The innermost stack had a needle-shaped body tapered to a sharp pointed tip.

I am always on the lookout for sea-stacks along the Maritimes' coastlines. Their appeal is their simple yet often starkly dynamic shapes, sculpted out of the surrounding natural landscape. And here were all these sea-stacks in one small area! I was thrilled at this discovery.

There are two legends from Mi'kmaq mythology about this area. One is that the Three Sisters were Glooscap's sisters, who he turned into stone to await his return when he left for unknown lands. The second legend is that one day while Glooscap was out hunting, three dogs began chasing his moose. He turned the dogs into stone. The dogs had forced the moose to jump into the Bay of Fundy and the moose called on Glooscap to save it from drowning. This he granted by turning it into stone, now known as the island of Isle Haute.

Past the next headland, which looked like the prow of a large battleship, we came to Andersons Cove with its extended beach between two sloping hills and a small ravine with its attendant streamlet.

Andersons Cove is rimmed at either end by cliffs and a narrow strip of gravel beach, but at its centre it expands into a long sloping beach where the cliffs give way to a deeper cove with a ravine and a concealed streamlet set between low undulating hills. This cove has its own sea-stacks, too, a pair of isolated, unrelated rock columns of fair size and photogenic quality.

At the northern entrance to Andersons Cove is a jutting headland bluff called Squally Point,

claimed to be one of the best examples of an ancient raised beach that existed during the last ice age and has gradually risen to its present height of 35 metres (115 feet) above sea level.

Just around the corner from Squally Point is found a small keyhole arch worn through the bottom of a low headland bluff, which you can walk through and immediately enter into the boundary of Spicers Cove.

Spicers Cove is the largest cove along Cape Chignecto's shores and is enclosed by the highest and sheerest cliffs on this side of Cape Chignecto.

The coldest air I've ever felt was here at Spicers Cove on a sunny late afternoon in early January. Several friends and I had ended up at Spicers Cove without being really prepared for hiking. The funnelled blasts of Arctic air whipping off Chignecto Bay that afternoon plunged the wind chill unbearably low. Within moments of starting out along the beach it felt like I was wading thigh-high through the waters of the bay itself. As we hustled around Squally Point the wind instantly died. The difference was unbelievable, as though someone had shut off a giant wind fan.

Rather than continue on to Apple River, we decided to start back down the coast, stopping momentarily beneath a large overhead rock to watch nesting cormorants feed their young.

As we were nearing Keyhole Brook we saw a bald eagle quickly pass overhead as he skimmed the treetops along the cliffs, heading up the coast. This was an unexpected encounter, the first and only time I've ever seen a bald eagle at Cape Chignecto where they are not known to frequent.

As Jerry smoothly docked at his spot along

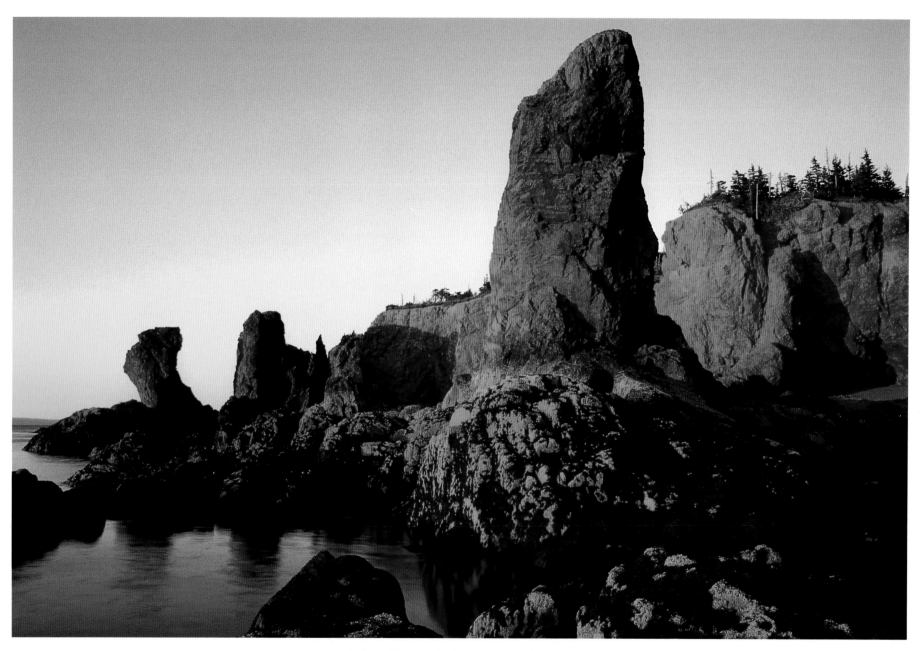

*At low tide, the distinctive sea-stacks at the
Three Sisters take on a sunset glow.*

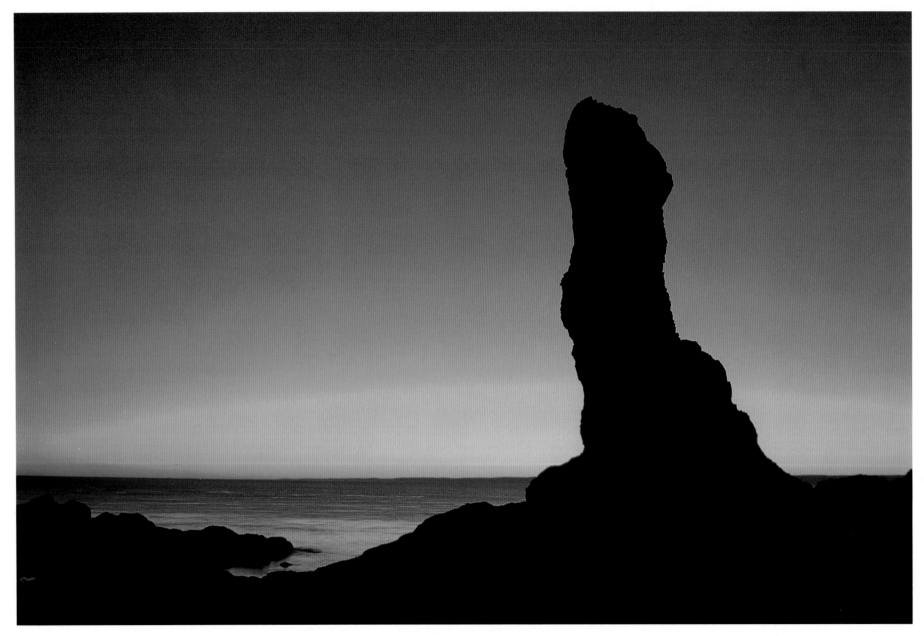

In the afterglow of twilight, a sea-stack's stark silhouette at Andersons Cove.

the wharf, cutting the engines, I realized that we had been out exactly twelve hours. It had been a thoroughly fascinating experience. We had seen first-hand the untamed shores of Cape Chignecto, a place very few people have heard of, let alone visited, a virtually unspoiled wilderness realm.

Big Bald Rock and Keyhole Brook

Three weeks later on a sunny Sunday morning I returned to camp overnight at Big Bald Rock Brook. I wanted to photograph a remarkable keyhole-shaped rock I had noticed during our coastal cruise; the arch was large enough for a person to walk through comfortably. As I drove my car along the logging road of the cape, I tried to ignore the repulsive large areas of clear-cuts on both sides.

After an afternoon of bushwhacking down the brook, I caught a glimpse of shoreline cliffs through the trees ahead. The coast at long last! What I had imagined would take a couple of hours (it's only 2 kilometres down the brook to the shore) took seven to complete. The sun was already low in the western sky; I didn't have much time to find a campsite, pitch my tent, and do some photography before sunset.

The light was melodramatic, torching the cliffs in a tangerine glow as if the rocks themselves were molten. This glorious tint of sunlight, which comes only in certain sunset and sunrise moments, is what some photographers call "sweet light." It painted the coast in golden tones for only a few fleeting moments until the sun slipped behind a thin layer of mist over the New Brunswick coast and its Midas touch was vanquished.

As the afterglow blossomed into its zenith of haloed glory, I captured the black silhouette of the coastal bluff with its spruce trees leaning over the waters of the bay below.

As the crow flies, Keyhole Brook was only 2 or 3 kilometres up the coast, but I knew from having seen the terrain from the boat that the hiking would be extremely rough. The forest was composed of dense stands of spruce and fir with lots of deadfalls and areas of tuckamore, not to mention the deep ravines I would have to cross.

I struck out for Keyhole Brook the next morning, making my way through a wet area with patches of large cinnamon ferns, smaller conifers and dead wood, shortly coming onto the top of Big Bald Rock, a humped rock headland crouched 20 metres above the water, its contours showing the effects of glacial gouging from the last ice age.

From there was a marvellous view of the upper coastline stretching off into the distance with New Brunswick providing a coastal backdrop.

After crowbarring my way through an horrific wall of tuckamore, in a small clearing surrounded mostly by red maples I came upon a sight unique to me. Swarming around a clump of tall blossoming purple-pink Canada thistles were more butterflies than I had ever seen in one place! About a dozen orange and black fritillary or silver-spot butterflies vied for space on four interconnected blossoms. Once sated by nectar they would fly off to rest before returning to the blossoms.

Three rolls of film later, I moved on, privileged to have enjoyed this extraordinary spectacle of silver-spot butterflies.

Late that afternoon I had passed through several ravines and into the borders of an expansive old clear-cut. So far the hike had been tough, but it was a picnic to what I was facing: barricades of tangled spruce and fir, and open spaces with a dense cover of ferns camouflaging potholes and hollows and littered with tree stumps and brush. I had to test where to place my foot with every step I took.

It was in a section of clear-cut like this that I took a nasty spill after my foot slid down into a concealed hole. My tripod went flying and the contents of my knapsack followed.

I lay there in agony, afraid I had broken my ankle in this god-forsaken place, but I soon realized it was simply a bad twist. I hobbled about, picking up my food and equipment.

With everything secured (or so I believed), I set out again. I wasn't to discover until hours later at Keyhole Brook that my 20 mm lens was missing, concealed somewhere among the masses of ferns.

Soon I crossed into the thickest section of tuckamore stands I had yet encountered in the clear-cut. It was now almost two hours since I had first ventured across this wasteland and tears of frustration and exhaustion began welling in my eyes: I had hardly advanced more than half a kilometre!

It was a great relief when, about forty-five minutes later, I finally busted through that snarling brush to find—a path! most likely formed by moose and deer, leading up a hill and down to another streamlet.

The hill fell away into a deep chasm and across it I could see a high ridge extending

inland. This had to be Keyhole Brook and not a moment too soon!

I followed the brook until it dropped as a waterfall over the edge of a cliff in two separated branches to the beach about 6 metres below. Standing on the edge of the cliff, I looked down into the sunlit cove of Keyhole Brook. It was low tide and off to my right was the distinctly slotted keyhole formation of rock I had come to see. Twenty minutes to sundown; history had repeated itself.

Dumping my camping gear, I rushed about searching for the best pictures I could take in the last moments of sunlight left. It was then I realized my 20 mm lens was missing. But my challenge now was to find a safe and easy way down to the beach, a task I decided to leave for another day. Stretching out in my tent, I relished the soft mattress of mosses that cushioned my weary body as I listened to the soothing sounds of the brook and waterfalls swishing their way over the cliff. Two owls called to each other in the stillness as in peaceful contemplation. I drifted off to sleep.

I spent most of the next day resting. As late afternoon turned into evening with the tide in withdrawal, I dug my nylon rope I had brought from my backpack and searched for the best support to lower myself to the beach, choosing the largest rock I could find. I was alarmed to learn from the small print on the package that the rope would only support 63 kilograms, not enough for my muscular build (just kidding).

To compensate, I tripled the rope and slung it around the rock, but it reached only halfway down the cliff! I started to despair. Had I come all this way, pitted myself against the heinous tuckamores, sacrificed an expensive camera

lens, and almost broken an ankle to be defeated by a 6 metre cliff!

Serendipitously, I noticed something camouflaged in the grass and when I pulled the knotted end, out came a thick rope about 3 metres long, strong enough for an elephant. I couldn't believe my eyes! Had someone years before used this rope to get down to the beach?

The sun was now racing for the horizon; it was do or die. I knew if an accident should happen that left me unable to climb, I would drown with the incoming tide.

I started down, hugging the rock-face, supporting my weight on various footholds to lessen the strain on the rope, one hand clutching my tripod. Suddenly a large rock I had brushed against broke free, struck me on the knee, and went crashing down to the beach; I followed more slowly until my feet touched solid ground. Finally I could do what I had come here to do.

I photographed clusters of smooth stones draped in coats of neon green sea algae; the orange rock cliffs etched in bands of green, grey, or black stone folded together hundreds of millions of years ago. I photographed the sea arch from every perspective in the golden light of the setting sun, the most dramatic setting from inside the arch looking through its hole across the Bay of Fundy to the New Brunswick coast.

As the twilight grew dim, I scaled my way back up the cliff without incident, untying the rope from the rock support, leaving no trace of my presence there.

I look forward to exploring this marvellously scenic coast in more detail, but I intend to wait until the promised Coastal Hiking Trail from West Advocate along the coast to Spicers Cove

is open. My days of bushwhacking through tuckamores, clear-cuts, and steep ravines are over. But when that coastal trail is open, you can be sure that I'll be one of the first ones on it!

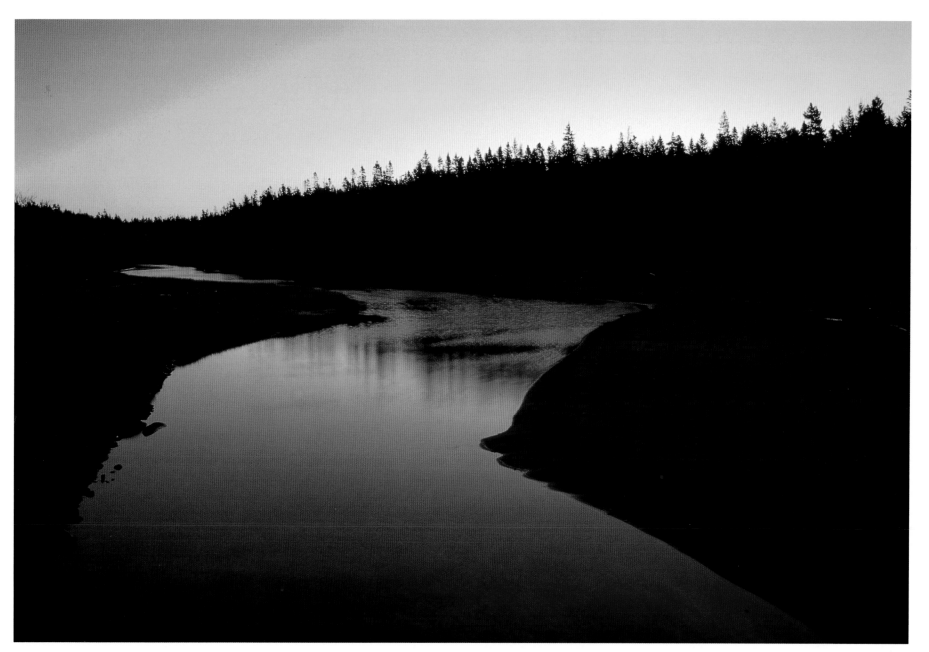

Dawn's colours spill over into Spicers Cove Brook.

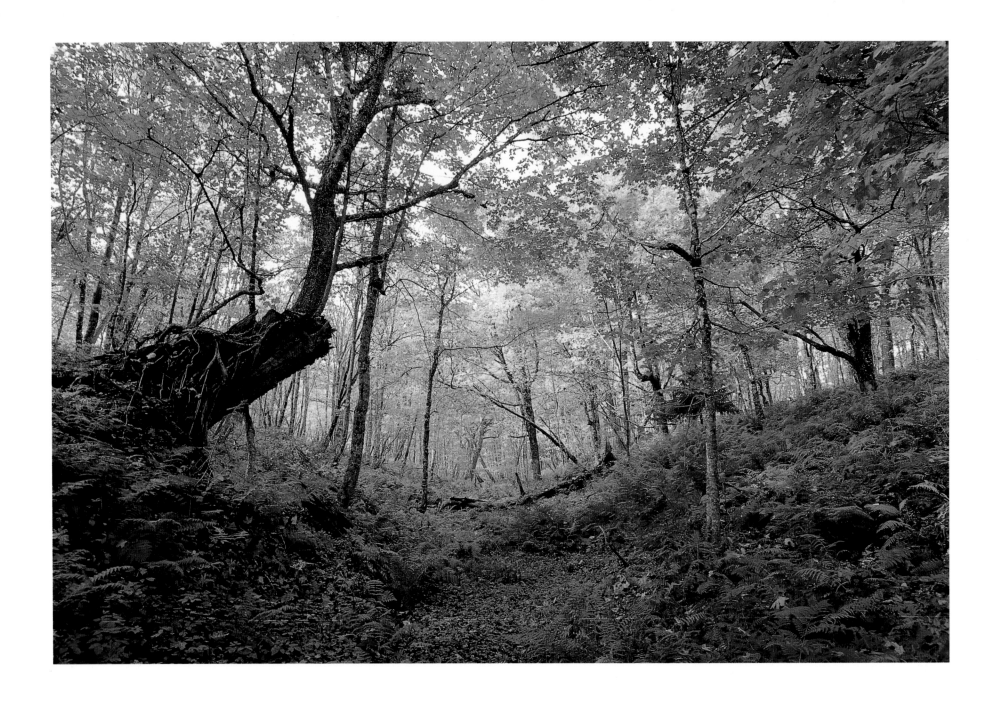

Cape Split

Situated at the tip of Blomidon Peninsula and extending out into the Minas Channel, Cape Split is a long narrow cape with many interesting and unusual features. For much of its length its cliffs are sheer drops over 76 metres (250 feet) with sweeping panoramas of the Minas Channel, Bay of Fundy, and facing coastlines which can be especially beautiful during sunset when the sun sinks over the outer reaches of the Bay of Fundy. There are also imposing displays of the powerful currents and tidal movements around the sea-stacks and pinnacles at the tip of Cape Split, as well as an old-growth hardwood forest cloaking the outer end of the cape and supporting a multitude of bird species.

All of these attractions can be explored via an easily accessible hiking trail out to the tip of Cape Split (16 kilometres or 10 miles return) from the small parking lot at the end of the dirt road in the community of Scots Bay.

Starting from the parking lot, the trail begins as a footpath skirting the edge of a field, and then widens out to a well-worn logging road through a forest of white spruce. The trail climbs gradually, passing several brooks, until it reaches the top of the cape and levels out. From here to the cape's end the forest is predominantly old-growth sugar maples, beech, and yellow birch, some of which are said to be over two hundred years old.

Here wildflowers grow in abundance, especially in late spring before the canopy of leaves has darkened the forest floor. Wildflowers such as spring-beauties, blue-bead lilies, blue violets, and white violets (in wet meadows or near small streams) are common. This forest is particularly noted for species of plants and flowers that are normally found in the deciduous forests much farther to the south. These Alleghanian plant species include wildflowers such as Dutchman's breeches, toothwort, and red trilliums, and a species of fern called silvery spleenwort. Strangely enough though, I have found it to be one of the most frustrating locations I've ever seen for flower photography.

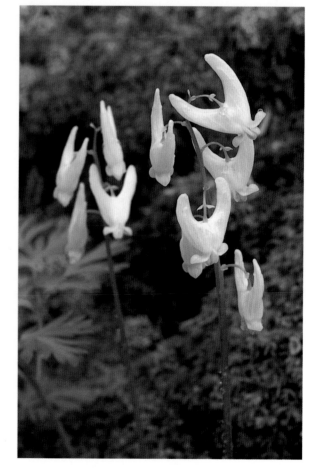

Facing page: Late September in one of Cape Split's many spacious meadows.

Right: Among other species, Dutchman's breeches grow profusely in the spring hardwood meadows of Cape Split.

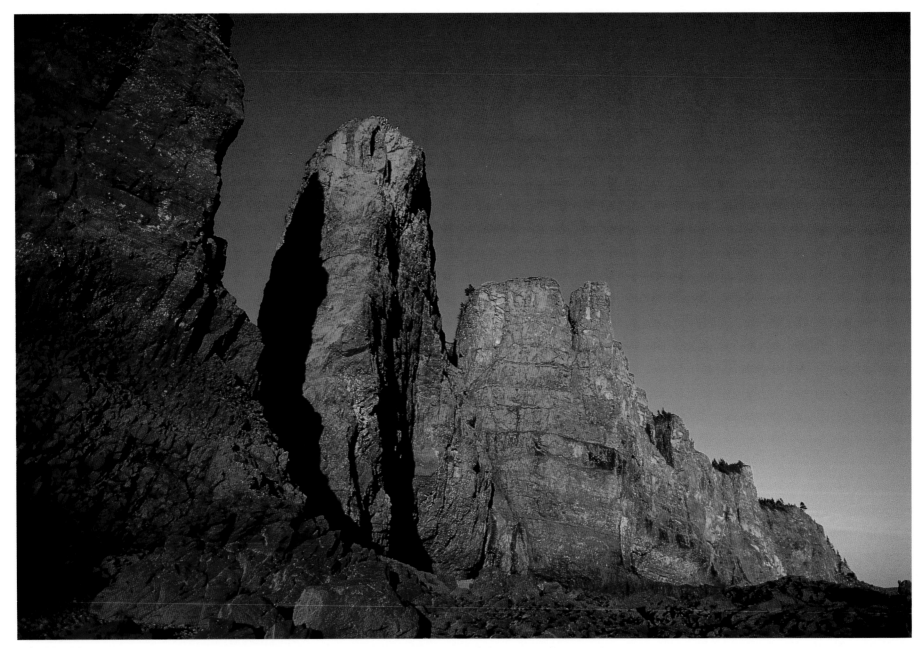

The sheer cliffs and pinnacles near the tip of Cape Split
suffused in a sunset's glow.

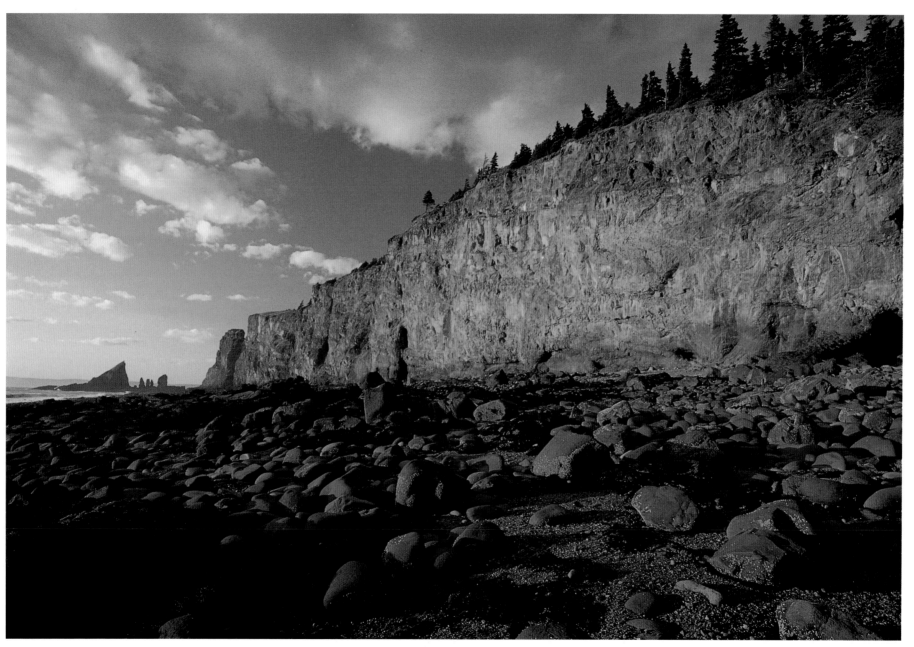

A setting sun tints the cliffs and shoreline of Cape Split.

For instance, I have struggled in vain for years to capture the delicate loveliness of red trilliums and Dutchman's breeches, which blossom from mid-May till early June. Here's why.

For woodland wildflowers the best light is cloudy skies with diffused light because harsh sunlight mixed with dark shadows is too much contrast and unflattering for flower portraits. I have often left Halifax on overcast, wet mornings, only to near Wolfville to find clear blue skies. The rest of the province could be wrapped in fog or heavy showers for days but it is clear and sunny in "the Valley." Wonderful landscapes but disastrous for most flower photography.

I've even tried photographing there just after sunrise, but twenty minutes after finding my first red trillium the sun came streaming across the forest floor creating terrible light.

The winds on Cape Split are another problem: I've shot four or five rolls of film at a time trying to capture the flowers during the split-second lulls between gusts, only to salvage a few slides.

My favourite times to visit the cape's pleasant old hardwoods and grassy meadows is in late spring and fall. In the first few weeks of June the leaves flourish, clothing the forest in a joyous riot of fluorescent green, while wildflowers carpet the forest floor. In fall, the trees, ferns, and grasses are a clashing palette of intense colours against skies of royal blue. These are the times I search out the trees with the most vibrant hues, their flaming leaves, backlit against sparkling sunlight.

Sometimes the best colours appear on overcast or wet days. The light is soft and diffused, allowing a wide range of subtle tones and hues.

The old-growth hardwood forest is populated by many different species of birds from hawks and owls to woodpeckers, chickadees, nuthatches, and warblers. This is one of the best places in Nova Scotia to observe these varied and interesting creatures.

The trail continues another 4 kilometres where it forks; one branch continuing to the end of Cape Split, the other leads down to the rocky beach at Little Split Rock Cove.

At the end of Cape Split the cliffs drop at least 76 metres (250 feet) to the shore below, and it's on these precipitous cliff ledges that great black-backed gulls and double-crested cormorants nest and tend their young. It is also on these exposed cliffs that several Arctic alpine plants are found, relicts from just after the last Ice Age. One is *Sedum rosea*, producing yellow or orange blossoms and rose-scented roots typically found on mountain ledges; another is *Saxifraga aizoon*, normally native to Arctic regions and widely grown for its whitish purple-spotted flowers.

On the shoreline off the point of Cape Split is a cluster of five remnant sea-stacks grouped in a row, the remains of a much longer cape. They consist of three short slender sea-stacks, a tall, thick one, and another towering over the others like a protective mother hen.

It is possible to visit these sea-stacks from the beach at low tide, although it is not recommended. I know from personal experience how treacherous this area can be. In late June several years ago, on an overcast day, myself and two photographer friends made our way down to Little Split Rock Cove. My friends went off towards the cape's sea-stacks while I explored the cove itself. The tide was out when my

friends left, so I became alarmed when I discovered that it was soon lapping the lower shelf of rock extending from the cliff head.

I shouted to get their attention and waved frantically, but they were too far away and too preoccupied to notice me. I managed to climb to the top of the lowest ledge and they finally saw me and started back, but the ledge on their side was too difficult a climb; they had to wade waist high around the rock, clutching their camera gear above their chests.

It was a close call—maximum high tide was still three hours away. Fortunately, they could have climbed Little Split Rock sea-stack, which is on higher ground, and waited out the long hours to low tide.

When it is safe to do so, hiking along the shoreline to Cape Split's end grants an awe-inspiring perspective to the cape. I've never failed to be impressed by the overwhelming presence of the soaring cliffs and pinnacles or the sea-stacks, particularly when sheened by the golden orange light of an evening sun. They remind me of a miniature version of the fantastic, knife-edged mountains of Chile's Patagonia region.

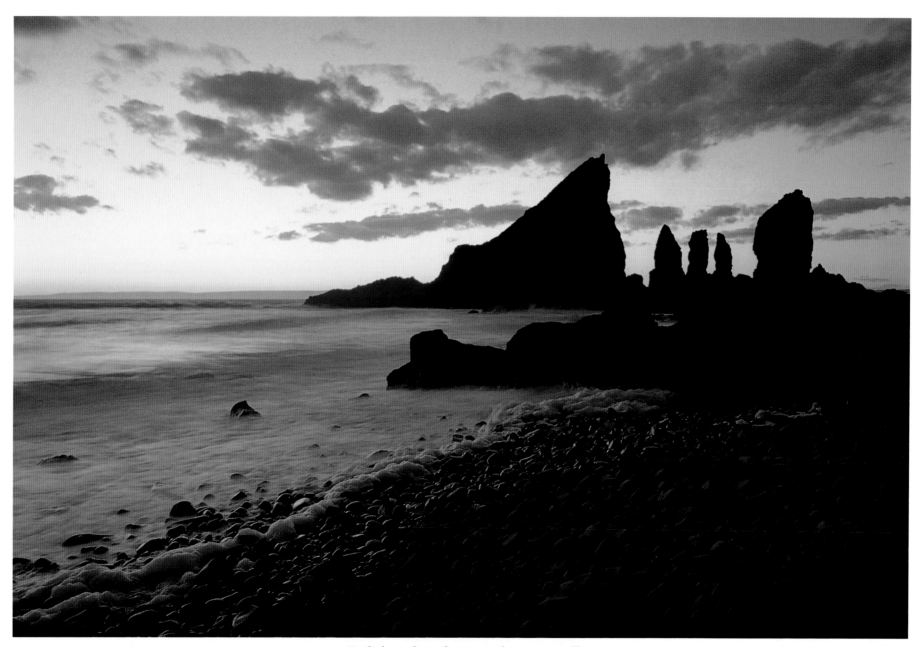

*Twilight outlines the sea-stack remnants off
Cape Split's point.*

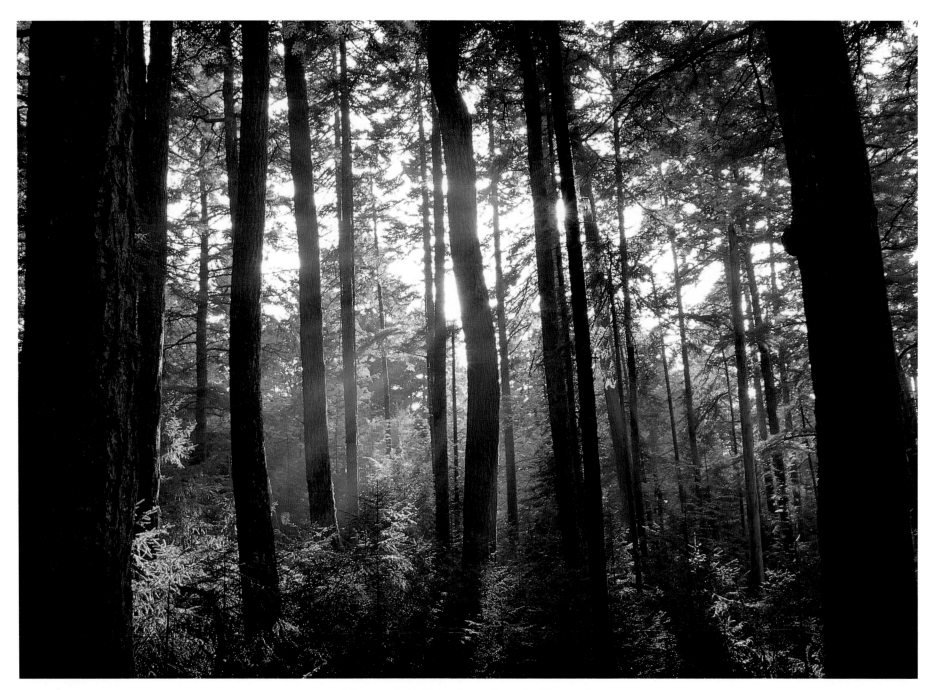

Misty sunlight filters down through old-growth
hemlocks at Panuke Lake.

Panuke Lake

Situated in West Hants County along the eastern shore of Panuke Lake just south of Blind Bay is a small nature reserve protected under Nova Scotia's Special Places Protection Act.

This reserve, owned by Bowater Mersey Paper Company of Liverpool features one of the best examples of original old-growth eastern hemlock and red spruce forests left in Nova Scotia. Although the reserve is 150 hectares (370 acres) in area, only about 40 hectares are truly virgin hemlock with some red spruce stands. The remainder is composed of the usual mixed forest of hardwoods and softwood found elsewhere in the province. But forgo any thoughts of a casual visit. Access is strictly limited and unavailable to the general public.

If you do manage to get permission to visit, you have to secure a Bowater guide to get you

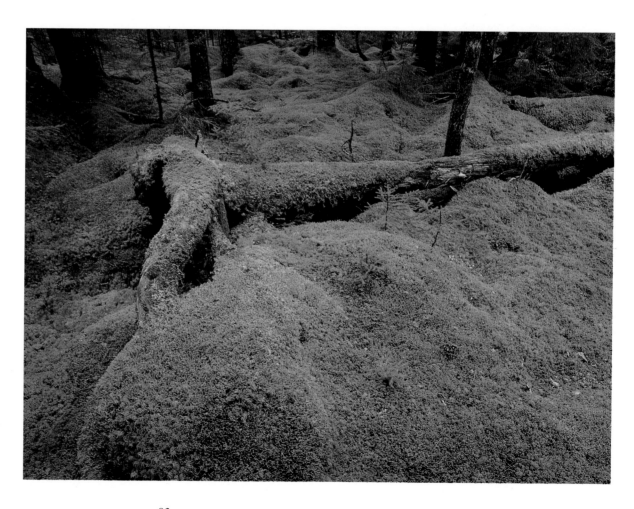

Rich thick mosses carpet large areas of the forest floor.

A hemlock varnish shelf fungus thrives in the moss of an old fallen tree.

The dusky forest floor of the reserve is ideal for supporting many different kinds of mushrooms and other fungi.

through the 12 kilometres of logging roads past a war zone of clear-cuts before you reach the reserve.

I made three trips to Panuke Lake in 1993, one in the summer, with two back to back visits later in the fall when I was allowed to go in without a guide.

On my first visit during a muggy July afternoon, my guide had trouble finding the right trail, but after much scouting around we finally found it and I set off alone through the woods to the shores of Panuke Lake. Still, I could not find the prized hemlock stands I had heard so much about, until luckily a woodsman came along and directed me to an inconspicuous, alder-choked logging road. The trail was overgrown in spots, the red markers were irregular, and I had to double back a couple of times. There weren't many hours of sunlight left when I ducked through a patch of thick underbrush upon a specious landscape overwhelmed beneath the trunks of immense hemlocks. I experienced a rush of elation and a powerful sense of awe. This was indeed the place!

The most overwhelming aspect of the reserve is the majestic size of the hemlock stands. These towering trees can reach over 25 metres (82 feet) in height and 2 metres (6.5 feet) in circumference. Beneath them, the shaded forest floor is spacious and free of underbrush, mainly because so little sunlight trickles down through the thick canopy of trees. The murky quality of the forest, its misty shafts of sunlight, and its sullen silence, lent a mysterious atmosphere to the reserve. It was as if I had crossed into a lost world where all manner of mythical creatures might still exist.

I discovered luxuriant carpets of damp mosses in such vibrant emerald greens I couldn't resist photographing them. Many colourful mushrooms, toadstools, and other fungi thrive in this subdued environment. One of my strongest impressions was of several spruce trees that had germinated on top of large boulders; in maturity their roots reached down like tentacles over the boulders. To me they symbolized the indomitable will of nature to adapt to the harsh conditions of the surrounding world.

Lake Panuke, when I arrived on its shores, stretched north and south to both horizons with boulders and driftwood scattered along the shore painted with the golden brush strokes of a setting sun. In the distance across the lake a few cottages could be seen, shattering the illusion of the lake's wilderness setting.

I was careful to leave in time to get out to the access road before dark. Although it didn't take long, the path into the reserve is so overgrown and obscure in places it would have been impossible to find even if I had had a flashlight.

I have heard that there was another old-growth stand near the reserve that survived into the early 1970s, but it has been since logged out. Whether this is true I cannot say, but how the reserve ever escaped the axe before it became protected is indeed a wonder. Visiting this tiny island wilderness in a sea of desolation was an awe-inspiring yet melancholy experience. Panuke Lake Reserve, although a precious jewel, is also a sad reminder of the splendour that was once common in the coniferous forests of Nova Scotia.

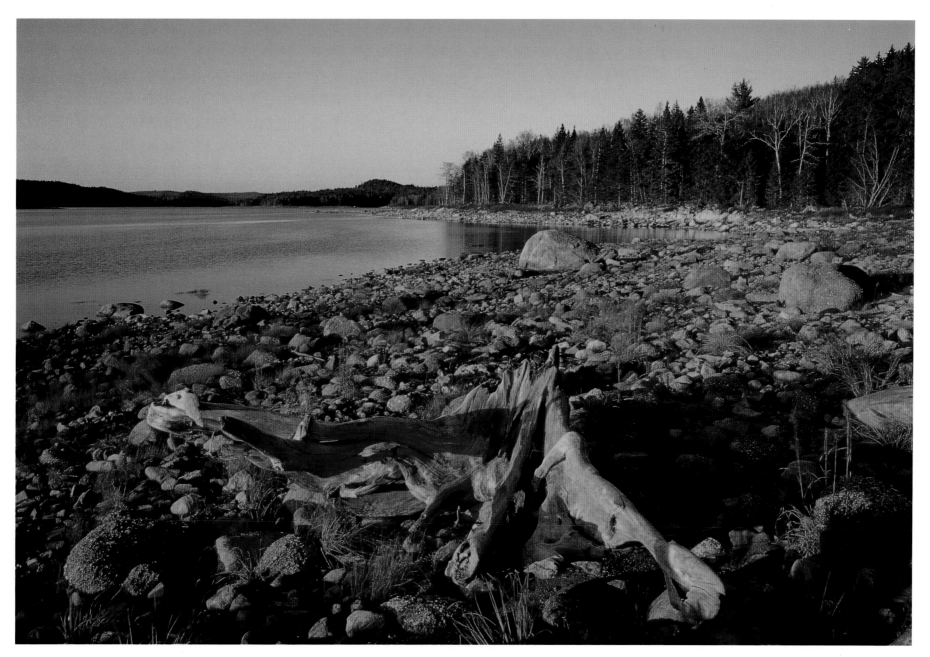

Looking north up the shoreline of Panuke Lake.

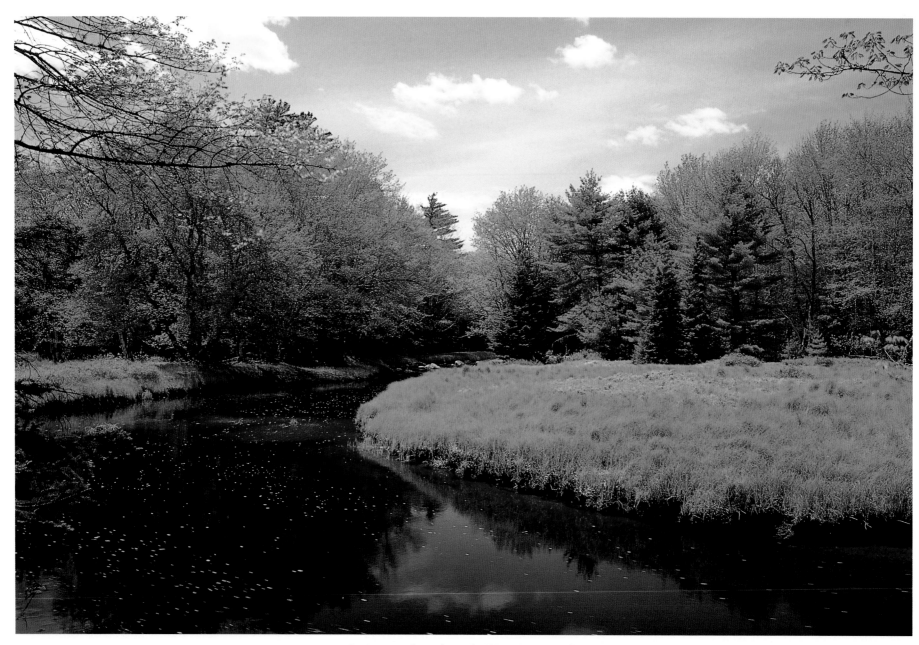

Spring meadow along the West River Trail.

Kejimkujik
National Park

Nova Scotia's second national park, established in 1968, lies 170 kilometres (106 miles) southwest of Halifax between Liverpool and Annapolis Royal on Route 8. Comprising an area of 381 square kilometres (147 square miles), the park is a landscape of gently sloping hills and lowlands interlaced with lakes and numerous rivers, streams, and still water brooks often bordered by grassy meadows and forest glades.

"Kejimkujik" is a Mi'kmaq word, which refers to the exertion of paddling across the park's largest lake, Kejimkujik Lake. This area was an important ancestral home of the Mi'kmaq, and the park has been designated a National Historic Site. Mi'kmaq history in this part of the province dates back at least four thousand years. Presently around forty settlement sites have been discovered in various areas of the park, and a number of rock carvings or petroglyphs have been found that depict Mi'kmaq legends and events.

Little remains of the original forest of Kejimkujik National Park due to logging, fires, or farming activities. Today, 75 per cent of the forest cover is mixed hardwoods and softwoods whose average age is less than one hundred years. The hardwoods consist mainly of red maple, red oak, white birch, with some yellow birch, and small numbers of sugar maples. The softwoods are mostly balsam fir, red spruce, white and red pine, and eastern hemlock. A few stands of eastern hemlock still survive as old-growth examples in the park, in particular along the Hemlocks and Hardwoods Trail, where some of the hemlocks are over three hundred years old. Solitary remnant old-growth white pines also exist along some lake shores and offshore islands, survivors from a bygone age when white pine (as well as red spruce) were a sought-after commodity in the shipbuilding trade. Beneath the forest canopy, the forest floor is stony and dominated by vegetation such as bracken ferns, huckleberry and blueberry bushes, bunchberry and sheep laurel to name a few.

Kejimkujik is home for a large variety of animals. Its most common and widely seen species is the white-tailed deer, which frequents the grassy sides of the main park roads and Kejimkujik lake shore nearby. Others include moose, bobcats, black bears, coyotes, porcupines, beavers, muskrats, and turtles.

In 1987, a new arrival was re-introduced into the park—the American marten, which was formerly found in mainland Nova Scotia but disappeared because of trapping and habitat destruction. Now nearly one hundred martens have been released in an attempt to re-establish them in their native territory.

This protected environment with its shallow lakes, bogs, marshes, and sluggish streams supports more species of reptiles and amphibians than anywhere else in Atlantic Canada. These include such rare species as the ribbon snake and the Blanding's turtle which wasn't discovered here until 1953. The nearest other population of Blanding's turtles is found in either southern New England or in southern Quebec and Ontario.

Kejimkujik is also a haven for many species of birds such as warblers, woodpeckers,

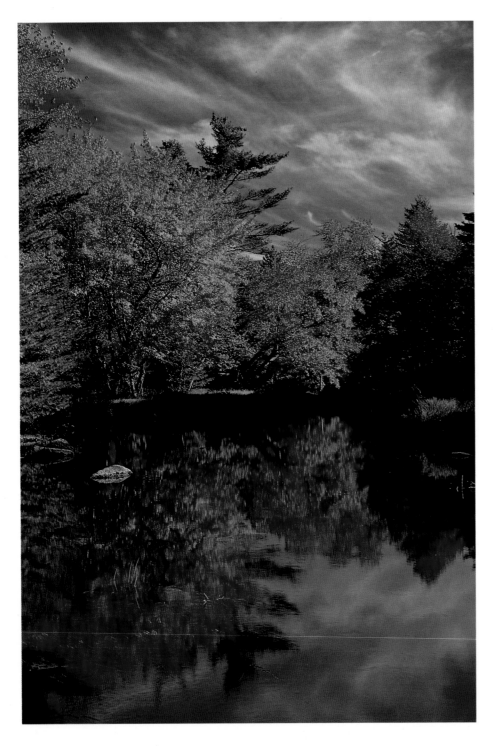

nuthatches, and grouse. Birds normally found in more southern hardwood forests such as the scarlet tanager and the great crested flycatcher are rare in Nova Scotia, but some do make their homes in the more sheltered hardwood forests of the park.

There are small numbers of waterfowl found in the park such as ospreys, black and wood ducks, and common and hooded mergansers.

Of the park's 381 kilometres, over 80 per cent is wilderness back country, accessible only by hiking trails or canoe. There are over 100 kilometres (62.5 miles) of hiking trails in the park; the longest wilderness trail is the Liberty Lake Trail. This is an extensive looping 65 kilometre (40.6 mile) trail stretching from the Big Dam Lake parking lot to the Mersey River bridge below George Lake. Extending from the Liberty Lake Trail there are a number of side trails from 6 to 20 kilometres (3.7 to 12.4 miles) return in length.

Besides these remote trails there are 14 easily accessible day hiking trails of short duration ranging from under 1 kilometre to about 6 kilometres (0.6 to 3.7 miles) return, plus 2 trails using park service roads where bicycles are permitted: McGinty Lake, a 5 kilometre (3.1 mile) return trip, and Fire Tower Road, which is a long 18 kilometre (11.2 mile) return trek.

Although I have hiked and photographed most of the trails in the park, my most memorable expedition was along the park's longest and most scenic trail. In October 1993 on Thanksgiving weekend, I spent four days backpacking the trail, from the Big Dam Lake

Autumn reflections cast their glory into the tranquil waters of Still Brook.

parking lot down to campsite no. 42 at Liberty Lake and back out again.

It was midmorning on Saturday when I left the parking lot at Big Dam Lake, loaded down like a pack mule with a huge backpack, stuffed camera vest, and a tripod with camera attached.

Stopping to rest on the bridge over Thomas Meadow Brook near the head of Big Dam Lake, I admired the thick-trunked aspens still wearing their summer greens against the red, orange, and yellow of the surrounding maples.

Later that afternoon while searching for a bridge across Still Brook, I happened upon a beautiful pooling area—an exquisite little pocket of sublime wilderness. The brook's still water reflected the glory of bluest skies and whitest clouds blending with the explosion of colour from the surrounding hardwoods still at their peak.

Among the stones lining the brook's edges I found flourishing a multitude of small plants, St. John's wort, bursting in profusions of colour from dark purple to red, orange, yellow, and green. It is in moments like this that I've often wondered how black-and-white photographers can remain unmoved by the emotional appeal of such colours. I could not imagine reducing such magnificent hues to shades of grey.

Feeling the chill of evening coming on, I hurried off to my campsite tucked beneath a grove of towering white pines just off a large inlet of Frozen Ocean Lake.

The next morning at dawn I was greeted by frosty skies and thin mists lingering over the smooth water of the lake. At its edge I

A morning sun backlights red maple leaves along the banks of Still Brook.

discovered a charming mosaic of lily pads, fallen leaves, and pine needles woven together in a floating autumn tapestry.

With the sun ascending through the pines I headed back to Still Brook, confident that was where my best pictures might be found. I was right. Mist still clung over the mirrored waters of the brook while the silvery brilliance of the sun backlit the opulent coats of large maples lining the meadow's dew-laden banks, rimming the leaves in scarlet flames.

I spent the next few hours wandering up Still Brook, wading through its thigh-high grasses and under the sun-bursting maples and oaks, photographing everything I found delightful

around me, until the mists were gone and the sun had climbed into the heavens.

My purpose for coming to Kejimkujik was to photograph the best of its wilderness splendour, so the next morning, despite a light drizzle, I set out for a day hike to Liberty Lake in search of photogenic opportunities.

After crossing the bridge at Northwest River, I heard clawing sounds coming from the woods just up ahead. Instantly I recalled that bears will claw trees to mark their territory and this put me on alert. A short distance away, a tiny baby black bear was clinging to a big aspen and looking down at me.

I would have loved to photograph the cub

but it was too dangerous: I was afraid of being attacked by its mother who was undoubtedly somewhere close by.

Little Liberty Lake where I stopped to quench my thirst, was being whipped into whitecaps under strong winds hurling across the lake, driving me off into the forest. I stopped there to take my only photograph of the morning: a still life of two mushrooms surrounded by fallen red and yellow maple leaves with a scattering of pine needles.

The best colours, I realized, were littering the ground. On my way back at Northwest River, something on the path stopped me in my tracks: a charcoal black aspen leaf beaded with pearls of crystal raindrops and encompassed by luminous yellow maple leaves. I had never really noticed a black aspen leaf before.

Personally speaking, the most alluring charm of Kejimkujik National Park is its many lazy rivers and brooks with their still water stretches bordered by perfect meadows and tall hardwoods. Here in these wilderness river glades is found a silent solitude, a refuge from the outside world.

By evening, back at my campsite, the skies were being swept clean of all but a few rebel clouds still dashing across the dwindling twilight. In the growing gloom I began to feel a sense of isolation and loneliness that was reinforced by the sound of the wind through distant trees, like the mournful sighs of restless spirits.

At sunrise, I awoke to a heavy blanket of frost that coated my tent and the frozen ground outside. I scrambled for my camera gear, and in the next few hours my most stirring moments occurred down along the marshy banks of the brook's still water, where the tall grasses were spiked with sparkling layers of crystalline frost blending with the dazzling sunlight into rainbow colours when seen through my camera's viewfinder.

The following is a random listing of the hiking trails in Kejimkujik National Park I found to be the most scenic and memorable. Although these are my favourite trails, I am aware that beauty lies in the eye of the beholder.

Mill Falls

This is one of the easiest trails to enjoy because it starts from the park's Visitors Information Centre. The trail travels along the edge of the Mersey River to Mill Falls, a set of two broad falls (4.6 and 7.6 metre elevations according to the park's map) and back for a return distance of only 1 kilometre (0.6 miles).

My favourite time to visit is during the peak of fall colours, not only to frame the waterfalls with these colours but to observe the lovely mixture of clashing hues on the surface of the calm and the faster swirling waters.

A forest still life at Little Liberty Lake.

Beech Grove

Also near the Visitors Information Centre, this is a 2.2 kilometre (1.4 mile) looping trail across the Mersey River via a bridge near the beginning of the Mill Falls Trail. It follows along a sloping hillside through a forest composed of beech trees and then back along the Mersey River.

It had showered the previous night, and as I sauntered through the rain-freshened beech groves on a June morning, the lushness of the new spring beech leaves enfolded the sky around me in a sea of glowing lime green. In the enchanting glades beneath the trees, swathes of ferns, tree seedlings, and the darker greens of various small conifers, added their sundry shades to the land in a thrilling symphony of new life bursting forth from a winter earth of drab browns and greys.

I loitered to take pictures and just commune with the spirit of this universe of reborn greens. Eventually, as I made my way up and then down the hillside, I unexpectedly found myself in the open, directly across from the cascading bottom of Mill Falls, a cruel exile after my enjoyable beech forest reverie. I was captivated by the image of calm-flowing waters above the upper falls showcasing the sharp reflections of trees and an overhead sky of scurrying clouds amid patches of powdered blue, all framed by the dark rocks and green grasses along the river's shore. As a photographer, I'm always on the look-out for remarkable water reflections that mirror the surrounding world and this fit the bill very nicely.

The bent forms of beech trees along the Beech Grove Trail.

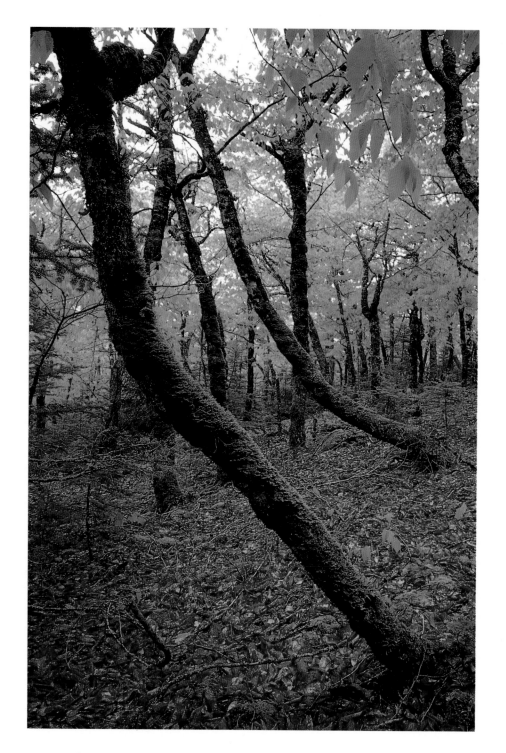

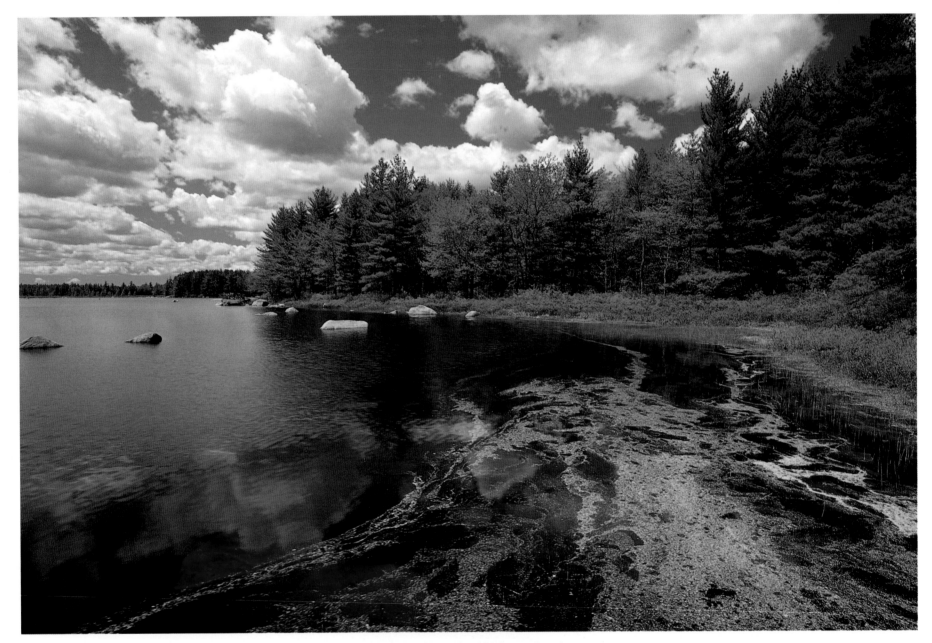

Along the shore of Pebbleloggitch Lake.

Mersey River

This is a pleasant 7 kilometre (4.3 mile) return stroll along the margins of the Mersey River, accessed from either the road to the campground at Jeremys Bay or the Slapfoot Trail across the Mersey River from Jakes Landing.

The trail passes close to the riverbank under tall stands of red maple, emerging into wide flood bank meadows that line both sides of the river. These meadows are rich with tall grasses, isolated stands of stately red maples and red oaks, and indented with occasional shallow ponds.

Autumn is the most striking time to visit the trail. Then the hardwoods are in their bright coats of red, orange, and yellow, meadow grasses are slowly bleaching blond, and the ponds are gorgeous still life canvases littered with fallen leaves.

Beyond these meadows the trail runs through a gloomy forest of mainly spruce, fir, and hemlock until it connects up to the Slapfoot Trail. Despite this small section, the Mersey River Trail, as it follows the slow-moving waters of its namesake river, is one of the most picturesque trails in Kejimkujik National Park.

Hemlocks and Hardwoods Trail

This is a 6 kilometre (3.7 mile) looping trail exceptionally noted for a special old-growth section of eastern hemlocks. It branches off Liberty Lake Trail and is well marked with trail signs.

On my first visit here in the spring of 1993, I was awed at the size and height of the hemlocks when I finally encountered them. I couldn't believe there were hemlocks of these proportions still left in Nova Scotia. Many are old-growth giants over three hundred years old, somehow having escaped the lumberyards of past generations. Their trunks are broad and massive, and their dark crowns stretching overhead are almost lost in the gloom caused by their dense canopies that blot out the sky. Only the extraordinary stands of old hemlocks at Panuke Lake have shown themselves to be more impressive.

For those seeking a remarkable example of what some of the original forests of Nova Scotia were once really like, as well as a place to enjoy solitude in nature, under the shadowed embrace of these ponderous hemlocks is the spot to be.

Rocks and water reflections along the Mersey River.

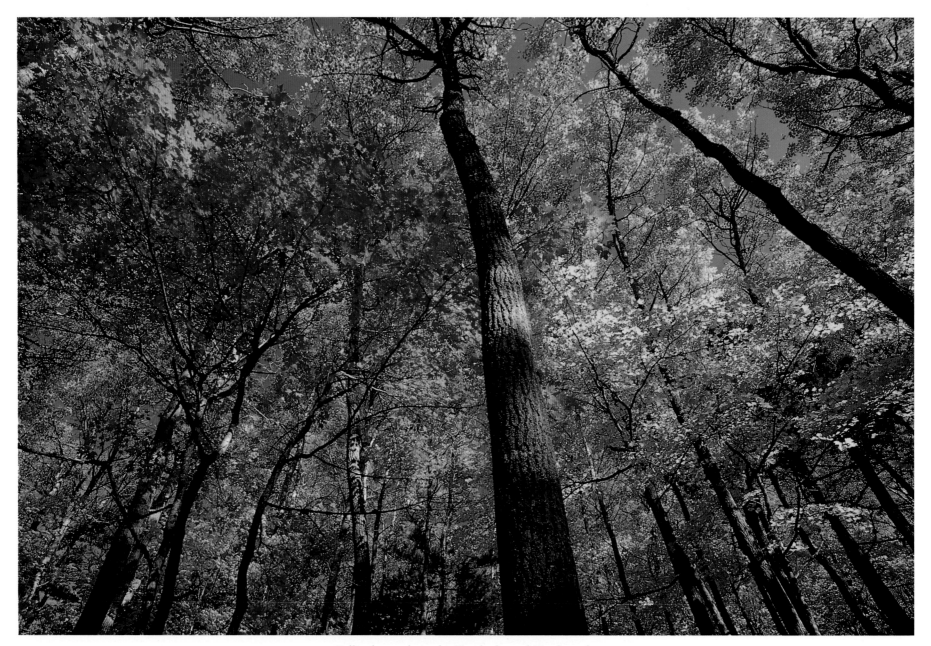

*Fall colours along the Hemlocks and Hardwoods
Trail at Kejimkujik National Park.*

Rodgers Brook

This is a short 1 kilometre (0.6 mile) circular trail, just off the main park road on the way towards Jakes Landing. From the parking lot, the trail descends to a sheltered niche where Rodgers Brook's peaceful waters are crossed by a small wooden bridge tall enough to permit canoeists to pass under. From the bridge is an eye-catching view of the brook, its grassy flood plains, and a distant hint of the Mersey River.

After crossing Rodgers Brook, you pass through a sun-blotted hemlock forest, emerging along the meadowed flood banks of the Mersey River lined with tall red maples. The path follows the flood plain along a boardwalk, then skirts the edge of the forest returning shortly to the bridge over Rodgers Brook.

This is one of my favourite places in the park come the fall for its river backdrop of meadows and savanna-like settings amid the magnificent plumage of its colourful hardwoods. The trail's quick accessibility is a benefit to photographers like myself who want to be everywhere at once during the fleeting few days of peak autumn colours.

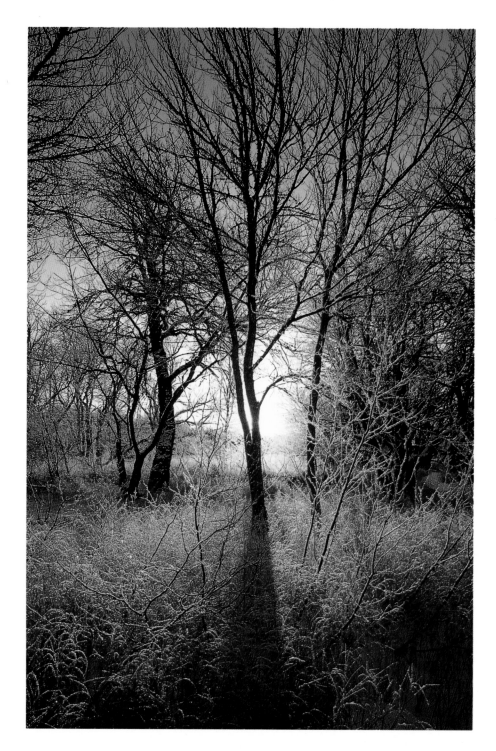

Sunrise backlights a heavy frost in molten tones along the Rodgers Brook Trail.

Slapfoot Trail

This is a 3.2 kilometre (2 mile) trail (one way) from either the Jeremys Bay campground or Jakes Landing end. My favourite section is from the bridge across the Mersey River at Jakes Landing, along the trail to near Jim Charles Point. It traverses the wet savanna flood plain of the Mersey River on a boardwalk, through a mixed wood forest, and along the edge of a large red maple and cinnamon fern meadow that borders the farther flood plain of Kejimkujik Lake.

This meadow is beautiful in the spring for its sprouting multitude of gloriously green ferns and new budding maples, and in the fall for its riotous fusion of coloured leaves and its gold, yellow, orange, and rusting brilliant burn-out of dying ferns.

Grafton Lake

This is a 1.6 kilometre (1 mile) trail oddly shaped like that of a red maple wingseed. The trail passes along parts of the shoreline of Grafton Lake, across a boardwalk over a marsh, and back through a mixed and beech forest to the parking lot.

One of the most important aspects of Grafton Lake Trail is its marsh, classified as the park's only true marsh. It can be viewed from the boardwalk, or you can climb to a small observation tower with its attendant telescope for a higher vantage.

Here, in season, you are apt to find various frogs and turtles among the marsh grasses and the masses of lily pads and their bright green smaller cousins, the watershields.

A proliferation of gnarled old tree stumps and skeletal trunks poised in the lake (the result of damming and flooding for a fish hatchery years ago) makes for both an eyesore and a conspicuous feature if you're a photographer.

Against the vivid splendour of a dawn sky and a rising sun over the lake, this watery graveyard of trees becomes beautiful silhouettes of pure black graphic forms and shapes. Even in the flatter light of day, these bone-white and reflective skeletons can render a dynamic foreground to the lake's background of forested coves.

Ironically, plans are in place to remove the dam and let the lake restore itself to its original size and contour, allowing the drowned forest to heal itself, but the marsh will drain away and the trail's future will have to be re-evaluated. Whatever transpires, the changes coming to Grafton Lake should prove interesting.

Snake Lake

I hiked this 3 kilometre (1.9 mile) return looping trail during an early October evening in 1994. The trail travels through a nondescript hardwood forest of young beech and red maples until it approaches the edge of its oddly named lake. Out of curiosity, I explored an extraneous side path, soon emerging out onto the lake shore, which I followed until I encountered a placid still water brook seeping into the lake and barring my way.

On the way back from the brook I noticed an infusion of ominous black storm clouds drifting over the treetops just across the lake. Storm clouds often add strong, emotional

drama to any landscape panorama, and these in particular had a sinister effect on the scene. My eye glued to my camera's viewfinder, I rattled off a number of quick shots.

The main trail, between Snake Lake and Kejimkujik Lake, featured a spacious meadow fitted with emerald green grasses and clusters of cinnamon ferns now tinted gold, orange, and their namesake's coloration, while elsewhere were loose stands of red maples or a few white birches whose leafy crowns betrayed the first hints of yellow. This was one of the most perfect forest glades I encountered in the park, so I spent half an hour or so photographing and savouring its paradisiacal setting.

After leaving the meadow, the trail led along a section of Kejimkujik Lake's shoreline where, as the sun began to set, I was treated to sweeping views from the lake shore's stony sands and russet-hued grasses to its reclusive offshore islands and the more distant panoramas of the lake's wooded horizons.

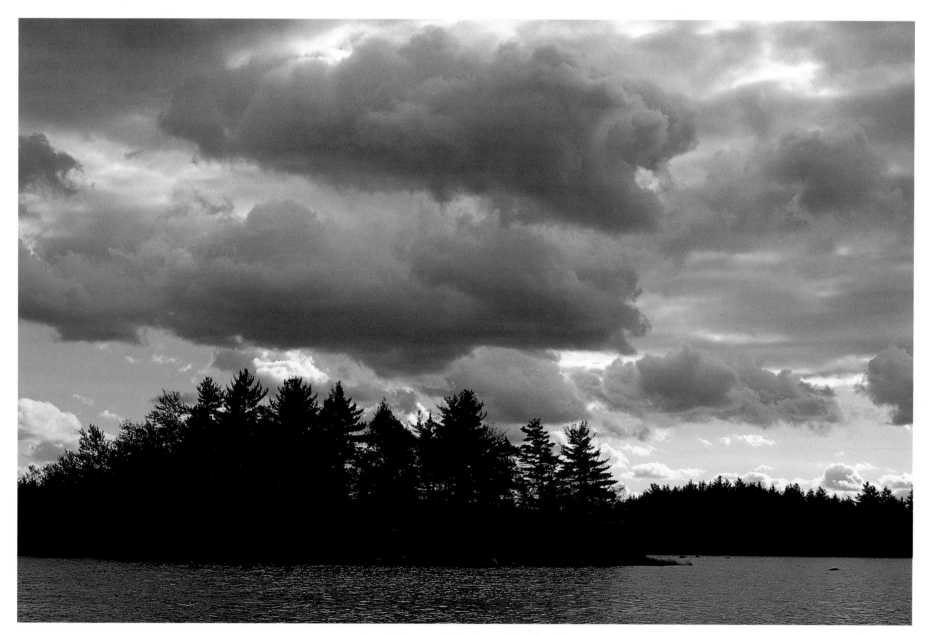

Brooding storm clouds over Snake Lake.

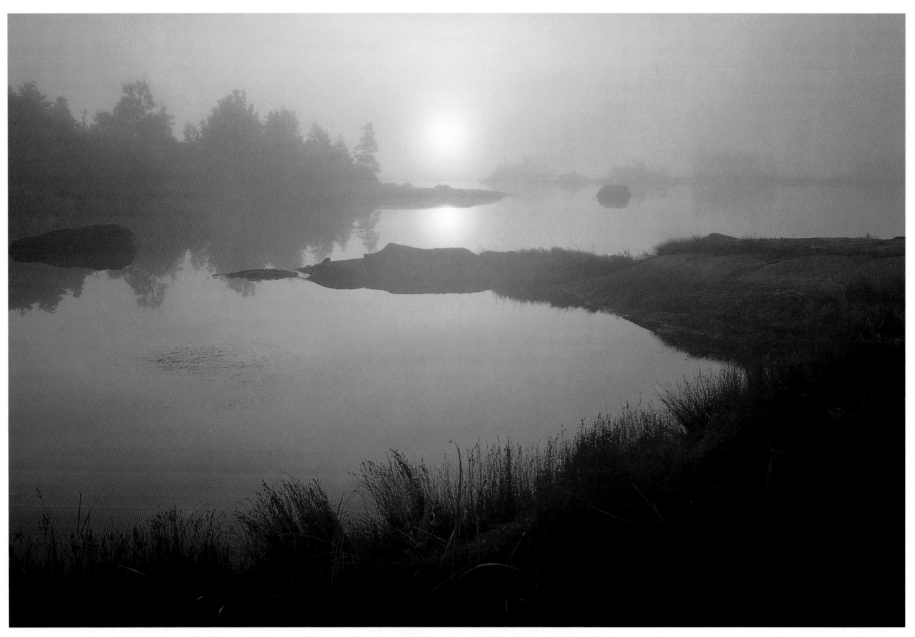

*The sun rises through the mists off Little Port Joli Basin,
Kejimkujik National Park Seaside Adjunct.*

Kejimkujik National Park Seaside Adjunct

Located on the tip of the Port Mouton peninsula off Highway 103, 25 kilometres (15.5 miles) southwest of Liverpool, the Seaside Adjunct is a small coastal wilderness boasting an impressive and varied list of natural features. These include lagoons, bays, tidal flats, white sand and cobble beaches, coastal barrens, marshes, bogs, and headlands, all packed into an area just 22 kilometres (8.5 square miles) in size. This is a recent extension (since 1988) of Kejimkujik National Park, which lies over 100 kilometres (62 miles) inland.

There are two hiking trails into the adjunct park. The longest, an 8 kilometre (5 mile) trail, follows an old road from the Baptist church at South West Port Mouton to a former primitive campsite near Black Point. The second trail begins at a designated parking lot in the community of St. Catherines River and follows an old cart-track for 3 kilometres (2 miles) to the coast at Isaacs Harbour. These two trails are unconnected, isolated by St. Catherines River Beach and its tidal inlet and lagoon.

Little Port Joli Basin and Beach

A friend and I investigated the first trail on the July 1 holiday weekend in 1992, taking the old road leading to the coast near Black Point. We caught our first glimpse of the wild and cloistered shore of the lagoon (Little Port Joli Basin) through the trees.

While my friend continued up the road, I photographed the pond area in intimate detail. The face of dawn was tinting the sky in bands of pink, orange, and yellow from a sun still hidden below the horizon. In witness, the pond was a crystal smooth glass, cool, breathless, immersed in the glory of the sky. It was a morning I will not forget.

Just a short distance around the corner from that fascinating little pond is a small bridge over the strong rushing currents of Basin Lake's narrow tidal channel, where it flows in and out of the lagoon, depending on the tide. From the bridge I became smitten with what I saw: comely little islands scattered in the lagoon, which is indented with tiny inlets and coves, saltwater ponds and marshes, glacial erratic boulders, and skinny capes sown with clusters of black spruce.

This was my first introduction to this kind of terrain, a graceful meeting between ocean shoreline with its sheltered lagoon merging into inland forest, swamps, and streams. With such an ever changing landscape I was hooked.

Hoping to catch up with my friend, I made my way through the woods down to the empty beach, breaking through the woods out onto a bluff above a tiny tidal inlet at low tide. I followed the beach a short distance until it ended in a low spruce knoll where several barkless skeleton trees jutted their roots out over low rock ledges.

Out in the tidal inlet about 15 metres away was a photogenically intriguing little island—an oblong knoll of solid granite tapered on its east end which rose to a rounded crest adorned with two curving spruce trees.

The high point of that day occurred near that little island. I had composed an image of the island with the tidal inlet decorated with

boulders in the foreground and began taking pictures, when a sudden shaft of sunlight broke, bringing my foreground of stones and tidal pool into dramatic relief against the steely blue-grey sky. I was ecstatic. I managed to get off one good frame before the sunlight ebbed away.

Further up the coast at Black Point the bedrock and erratics were covered in swatches of vivid gold and orange lichens, making interesting patterns on the rocks.

It was twilight when I got back to the car where my friend was already waiting for me with growing concern. He hadn't been impressed with what he had photographed that day, but my experience was quite different. I had discovered some of the most exceptional scenery I had ever encountered in Nova Scotia.

One early September morning in 1992, I returned to this enchanted place just after sunrise. The scenery at Little Port Joli Basin is dramatic enough, but with morning sunlight mixing with the mists off the lagoon it is breathtaking. I've been a landscape photographer for over twenty years and the best dawns and sunrises I've ever photographed have been along the shores of this lagoon.

While walking along the marsh grass of the lagoon at low tide, I happened upon an elegant

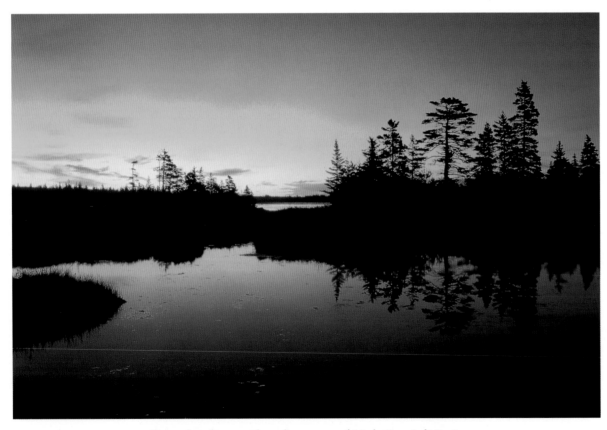
Dawn breaks over the calm waters of Little Port Joli Basin.

and graceful driftwood stump. To the right and off in the distance were wooded islands dissolving in the shifting mists. Peeking through this velvety gauze a rising orange sun reflected its glow in the still waters of the lagoon, suffusing its rays over the sky, the lagoon, and the smooth driftwood's grain.

Another of my fondest memories took place the following September in a small inlet of the lagoon not far from the tidal channel bridge. I had rushed from my tent and down the road towards the lagoon just as the first traces of dawn began to appear, wondering just where I might find the best spot to photograph. I finally settled on this particular inlet as a favourable place to start.

As I stood on the water's edge, I noticed a small rock poking through the seaweed-patterned water, while behind it a misted island stood shrouded against a blossoming dawn sky. The colours of the sky were soft shades of magenta and pink, which seemed to imbue the mists and the lagoon with warmth. As the light grew brighter and the mists dispelled, the sky and water evolved into a bold fluorescent orange encompassing the ebony silhouetted trees of the island. I lingered there with my camera before this theatre of the dawn, from its opening act of splendour to its climax of colours and light; then I took my cue and left.

Even without the fantastic sunrises, the subjects found along the lagoon of Little Port Joli Basin are many and varied, such as the hundreds of tiny "spiders' webs" blanketing the grass in areas near the lagoon's shoreline. Seen against the backlight of the morning sun, these gossamer webs are a lovely feature of the landscape. I even found the zigzagging lines of the

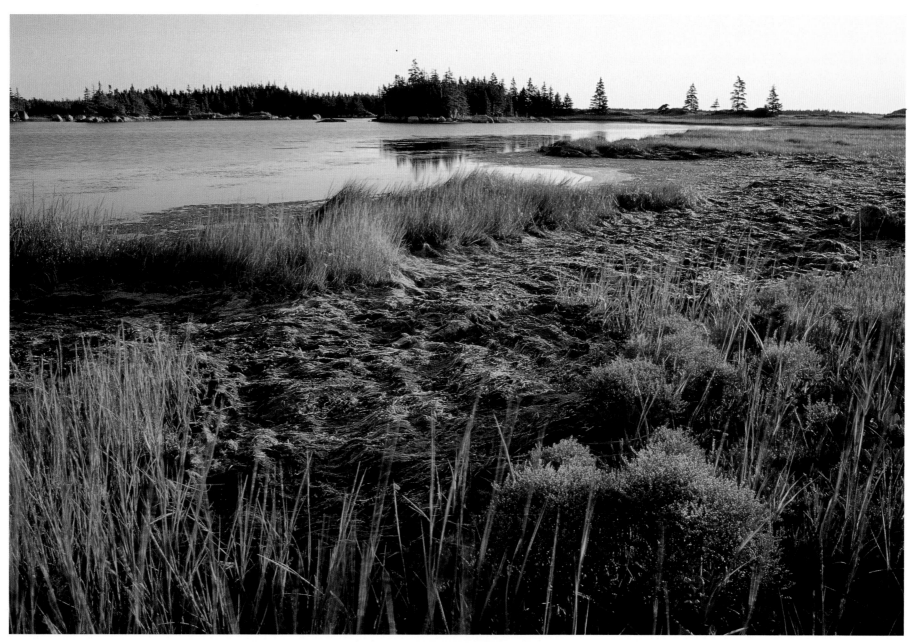

*The lagoon sheltered behind St. Catherines
River Beach.*

seaweed tossed at high tide or the lush green patterns of the marsh grass to be good subjects for my camera.

Further on the area of islands and nameless beach near Black Point, directly opposite the end of St. Catherines River Beach, is particularly inviting because of its quiet isolation (no one ever seems to be here), and its two islands, especially the smallest one, set in the midst of the lagoon's tidal inlet. This oblong wedge of granite with its twin arcing antennae of trees cuts a sharp profile. Its stark graphic shapes set against the vast panorama of sky, beach, and water remind me of a landscape painted by the Group of Seven.

Islands in all their varied forms and natures hold a strange fascination for me, but this particular tiny island is one of the most graceful and sublime I have ever seen.

The best time to observe this beach and its islands is when the sun is sinking over the lagoon behind the islands. One evening during my last camping trip to the park, I chanced upon an especially magnificent sequence to this backdrop.

Crimson clouds ribboned the sky over the lagoon while the sky itself became a deep orange absorbed into the silken waters below. The island stood etched against the flaming colours of sky and water, and out in the shallows shimmered the silhouette of a great blue heron stealthily hunting for small fish. Nearby a solitary seagull drifted unhurriedly on the water, perhaps seeking the companionship of a fellow creature. I suppose life in the wilderness can sometimes get lonely, even for seagulls.

The sand dunes at Little Port Joli Beach are higher and more impressive than those at St.

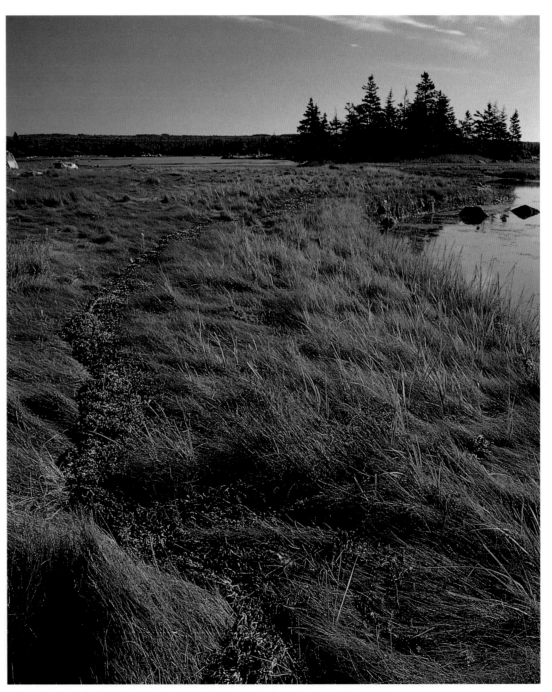

Seaweed deposited by a previous storm stretches along a section of Little Port Joli Basin's shoreline.

Catherines and the huge round erratics reminded me of doughboy marbles rolled onto the beach in several places.

The beach dunes flatten out where a tidal inlet flows into Little Port Joli Basin. When piping plover are nesting here the beach is closed. One dazzling afternoon during a camping trip to the park in mid-September I spotted twenty to thirty small plump shorebirds, likely sandpipers, feeding along the beach's intertidal edge. Under the harsh sunlight they scurried down the beach, chasing the ebb and flow of the waves, foraging as fast as their comical little legs could carry them.

I laughed while watching their swift but halting and spasmodic movements, their little heads bobbing up and down and their tiny feet making absurd and hilarious lurching motions. It was as though they had been captured on video and were stuck on fast forward mode.

I visited the St. Catherines River trail in September 1993, hoping to photograph an early sunrise somewhere near Isaacs Harbour or St. Catherines River Beach. I had left my warm bed at an obscene hour to drive to St. Catherines River and hike the 3 kilometres down to the shore. The eastern sky still seemed a bit too dark when I parked my car so I laid back for a short rest. Twenty minutes later I sat up with a jolt; the sky was so much brighter! Grabbing my photo gear I scrambled along the path as fast as my bouncing camera lenses would allow, but too soon the sun rose over the horizon and I cursed my stupidity while still almost a kilometre from the shore.

Just before St. Catherines River Beach I

found a small cove, where I became fascinated with photographing the waves lashing at the beach stones in the amber glow of sunrise. There is no other subject in landscape photography that I can shoot more film on than trying to capture the peak moments of crashing waves. I finally broke away and headed to the last bluff overlooking St. Catherines River Beach; luckily, the sun had not lost much of its golden radiance.

This lovely 3 kilometre white sand beach is renowned for supporting the densest concentration of nesting piping plovers in the Maritimes. Tragically, this stocky little bird, which resembles a sandpiper, has been on the endangered species list since 1985.

In 1972 there were thirty pairs of nesting piping plovers on this beach. By 1985, when the park was first established, their numbers had declined to eighteen or nineteen nesting pairs. Since 1992 through to the latest figures for the summer of 1995 there have been only four nesting pairs spotted each year. One small ray of hope does exist in this alarming situation—the number of nesting pairs has stabilized and may improve in the future. According to park warden Ray Farrier, the most significant damaging factors are the loss of nesting habitat to Atlantic storms combined with a natural depredation. There has been no evidence of destruction from human activity lately, but it is always cause for concern.

Although piping plovers are one of the most distinguished residents of the Seaside Adjunct, there are other visiting species of shorebirds here as well, such as the semipalmated plovers, greater and lesser yellowlegs, black-billed plovers, and five different species of sandpipers.

Many species of sea ducks or waterfowl such as cormorants, common eiders, loons, scoters, wintering harlequin ducks, and Canada geese are also present, especially in winter.

That September morning overlooking St. Catherines River Beach the solitude of early morning masked all traces of songbirds or other wildlife. The only sounds were the rustling of the wind and the distant lapping of waves. I ambled along the beach for a while before climbing one of its bordering dunes which revealed a large lagoon and its islands not far away.

Making my way through the marram (beach) grass of the dunes I noted some skeletal tree trunks on the lagoon's shore where a line of fresh seaweed had washed up with the tide. The green of the seaweed contrasted with the fall-tinged marsh grass that lined the margins of the lagoon. Looking back, I was captivated by the rippling sheen of the marram grass with its thousands of rough-edged blades reflecting the silvery sparkle of the sun as they danced to the rhythms of the wind.

Poking above this shimmering carpet were a few large driftwood trunks, mementos of past Atlantic storms. Whenever I see such remnants seemingly so far inland I get a sense of foreboding about the ocean. Trying to imagine the height of its foaming fury during such storms is truly frightening.

Much later, retracing my route, I took in the panorama of the beach, now near high tide, from the overlooking bluff. The white sand contrasted with the water, a tropical shade of aquamarine. It was as though I had been transplanted to a beach in the Bahamas—minus the palm trees.

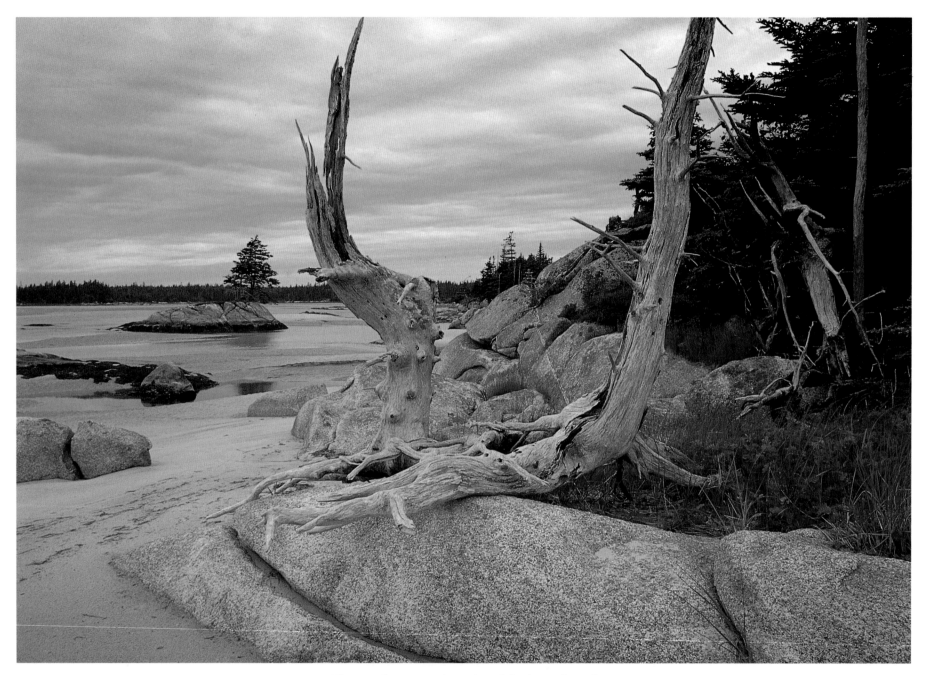

*The coastline across from the tidal inlet at the end
of St. Catherines River Beach.*

Back at Isaacs Harbour there were fifteen or more harbour seals floating offshore, only their heads bobbing out of the water, looking like little bald-headed men with whiskers and sad droopy eyes. I tried photographing the seals, but with only a 200 mm lens I couldn't bring them in close enough for a decent shot. This was one of the times I wished I owned a large telephoto lens.

That evening I elected to explore the other end of the coast towards Port Joli Head and, luckily, found an old path heading south near the coastline. Sweeping away to the west was an open expanse of coastal heath barrens with its tangles of huckleberry, blueberry, lambkill, and Labrador tea bushes, where two isolated stands of dark conifers stood out like islands on the horizon. There was a desolate beauty to this land lit by the ruddy glow of an evening sun beneath an expansive sky, reminiscent of a tundra landscape just below the treeline.

I reached the beach and came in view of the park's distant coast at Black Point. Near the edge of the shore stood two old gnarled warrior spruce, their skinny trunks and branches softened in twilight hues of pink and mauve. To the west in the afterglow of sunset, a quarter moon hung suspended near their crowns.

Charmed with these subjects, I spent the last of the evening's light there before retiring my camera and retreating along the path, opting for a short cut across the barrens to save time.

Kejimkujik National Park Seaside Adjunct encompasses some of the most beautiful coastal terrain in mainland Nova Scotia. No other park can boast the fine beaches and amazing lagoons that are found here. No other area is more important in the struggle for survival of the piping plover in Nova Scotia.

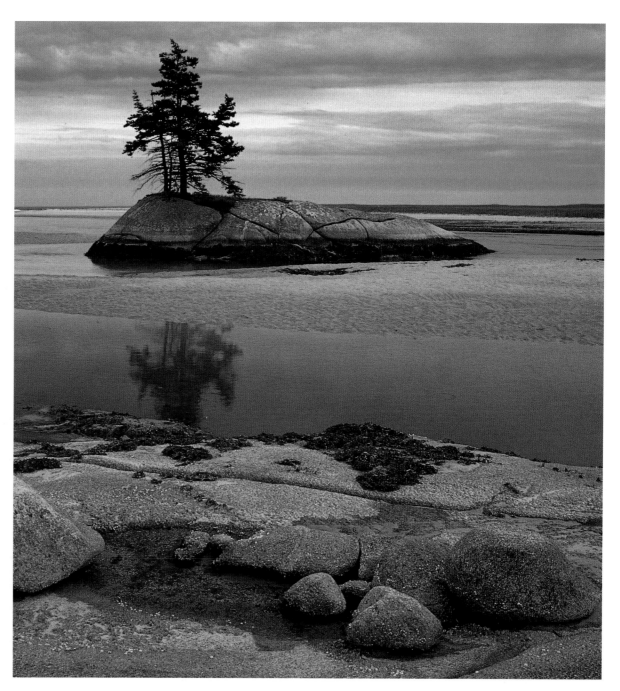

Small island and boulders amid the tidal inlet across from St. Catherines River Beach.

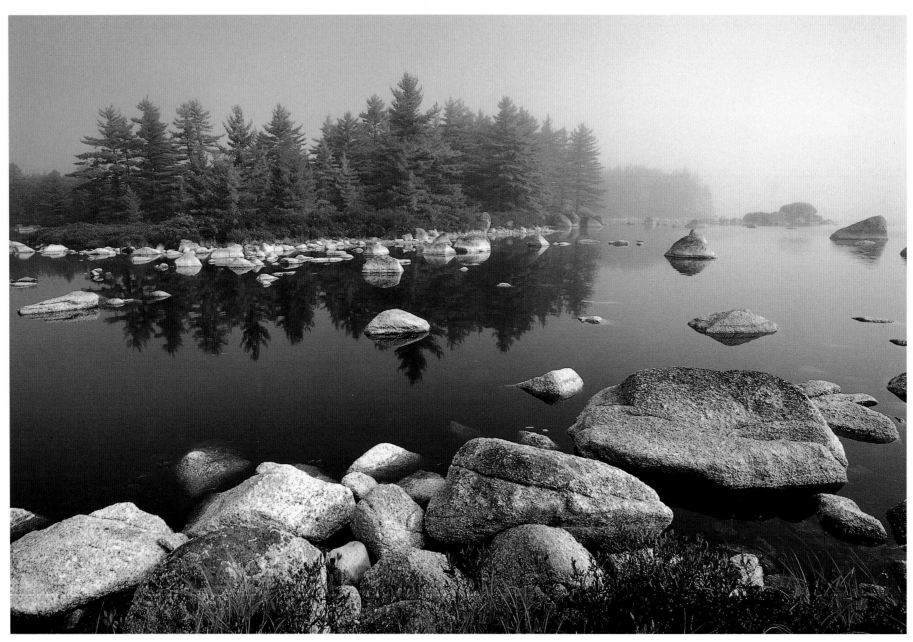

Morning fog begins to dissipate over Whitesand Lake.

The Tobeatic
Wilderness

Situated in southwestern Nova Scotia, this is the largest remaining wilderness area left in the Maritime Provinces. It borders on parts of Kejimkujik National Park, takes in most of the provincial crown land in the adjacent Tobeatic Wildlife Management Area and most of the crown land to its west, straddling Queens, Shelburne, Yarmouth and Digby Counties.

The Tobeatic wilderness is a mostly flat-lying region broken by elevated ridges or small hills interspersed with mixed forests, rocky and shallow lakes, bogs, wetlands, barrens, eskers, and glacial erratic boulders. It is an important watershed for six river systems, many streams and their outwash or flood plains. The mixed forests are patchy, scattered with dense under-lay of heath vegetation, particularly bordering their outer edges. Their main softwoods are red and black spruce, balsam fir, red and white pine, and eastern hemlock, the last two surviving in some never-harvested old-growth stands. The hardwoods include red maple, red oak, beech, white and black ash, aspens, and various species of birches.

Fortunately, 99,008 hectares (244,649 acres) of this roadless and rare wilderness are a candidate area in the provincial Proposed Systems Plan for Parks and Protected Areas. Unfortunately, the protected area would not include the "Tobeatic Finger," a corridor of crown land bordering the northwest boundary of Kejimkujik National Park in Annapolis County. This narrow strip of land roughly 4,047 hectares (10,000 acres), is an important watershed for a number of streams and rivers which flow into Kejimkujik National Park, forming a buffer zone of protection for the park.

The Tobeatic Finger not only contains some old-growth stands of white pine and eastern hemlock, it is covered by a secondary-growth forest valued by some for its lucrative timber reserves. This is the reason for the Finger's exclusion from protection.

Since 1992, one of the most active organizations trying to save all the Tobeatic wilderness has been the Tobeatic Wilderness Committee (T.W.C.), headquartered in Bear River, Nova Scotia. They have been particularly active in lobbying for the inclusion of the Tobeatic Finger in the proposed plan.

The Tobeatic's major river system, the Shelburne River, is the most remote wilderness river left in Nova Scotia, which forms much of the west, north, and east boundary of the Tobeatic Wildlife Management Area.

The river is a 53 kilometre (33 mile) long arc from its headwaters at Buckshot Lake and runs through 8 interconnected lakes until it finally empties into Lake Rossignol.

The Shelburne River has several white water stretches and low falls, but for the most part it is a lazy, slow-moving river with long stretches of still water. The most practical way to travel this river is by canoe in early spring after thawing (late April) or in the late fall (after mid-October) before freeze up. Forget summer. In the summer the water levels can drop dramatically, forcing excessive portaging along parts "canoeable" during high water seasons.

Although novice canoeists can easily handle

the still water sections of the Shelburne River, because of its exposure to strong winds on the larger lakes and the white water stretches of low falls and rapids, canoeists should have intermediate white water skills.

There are several ways to access the Shelburne River. By long and tough portages from the surrounding systems of the Sissiboo, Tusket, or Roseway Rivers or up the Shelburne River from Lake Rossignol. The simplest and most direct route is to canoe from Pebbleloggitch Lake on Kejimkujik National Park's southern border through Pebbleloggitch

Stillwater and into the Shelburne River between Granite and Irving Lakes. Those who travel this route (roughly two-thirds of the river's length) pass through an unspoiled wilderness reminiscent of the wilderness landscapes of the Canadian north.

Between Irving Lake and Lake Rossignol the river passes through Bowater Mersey land which, needless to say, is not unspoiled. From the river there are only a few signs of man's intrusion—bridges, roads, and cabins, as the river is protected by a forested buffer which even includes some stands of old-growth

hemlock. But this buffer conceals the logging operations which have been ongoing for many years.

Long before the white man dipped a paddle into the waters of the Shelburne River, the Mi'kmaq (residents here for centuries) used the river to reach the province's interior and coasts through interconnecting rivers such as the Tusket, Sissiboo, Roseway, and Mersey.

In 1993, in recognition of the Shelburne River's great wilderness legacy and outdoor recreational values, the entire river was nominated to the Canadian Heritage Rivers Systems. For those wanting to canoe the Shelburne River, a Management Area Permit (free) is required, available from the provincial Department of Natural Resources, 552 Main St., Milton, Nova Scotia.

The Tobeatic wilderness also supports a wide and varied number of wildlife species. A large population of black bears inhabit the Tobeatic, and it contains the largest number of indigenous moose still surviving in the province.

Elsewhere in the province, moose are mostly descended from those introduced in the 1900s, after most of the indigenous moose were wiped out by irresponsible hunting practices.

There are also deer, coyotes, bobcats, lynx, beavers, otters, and muskrats, and in such a large, undisturbed wilderness, perhaps even some eastern cougars.

Fish, unfortunately, are scarce because of high levels of natural acidity in the lakes and waterways due to soil matter such as peat moss leaching into the water. In addition, this general region of Nova Scotia has the most concentrated levels of acidity due to acid rain damage in Canada, caused by wind-carried pollution

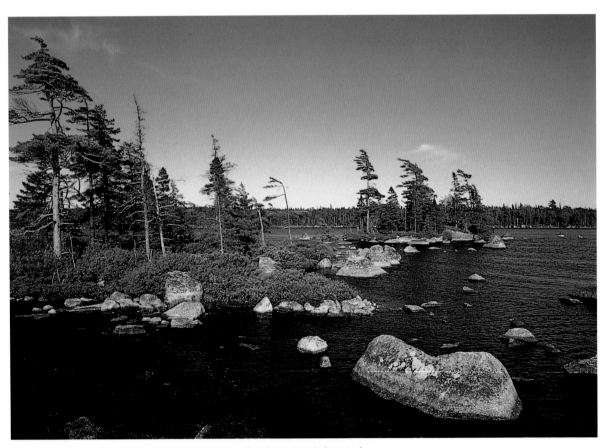

Islands in Buckshot Lake.

from heavy industry in the northeastern and midwestern United States. This poses a serious threat to the lakes, waterways, and wetlands of the Tobeatic region and to the wildlife dependent upon them, such as loons, wood ducks, mergansers, great blue herons, and even the rare Blanding's turtle now thought to exist in some lakes of the Tobeatic as well as in Kejimkujik National Park.

Buckshot Lake

On June 11, 1994, a friend and private pilot from Bear River, Oakie Peck, flew me in his two-seater helicopter over the Tobeatic "outback," Buckshot Lake and then to Kejimkujik along the Shelburne River. This was our first serious attempt at aerial photography. I was hampered by a slow film speed, the helicopter's shadow and a lens-flaring sun, not to mention having to remove the plexiglass door, the only buffer between me and the ground. But from my vantage point above this trackless wilderness, I mapped out in my mind a plan of camping and exploring this astonishing and untamed corner of Nova Scotia.

Several months later, on August 25, I arranged for Oakie to fly me into Buckshot Lake on what the weather office promised would be a sunny and clear next few days.

We landed at the lake's western tip, on a small heath barren clearing that opened out of the surrounding dense stands of conifers, hardwoods, and tall scrub brush which otherwise completely surrounds the lake.

We unloaded my gear among tangles of heath shrubbery on slightly solid ground and said our goodbyes until the next day around noon, when Oakie would be back to carry me

farther up the Shelburne River to Sand Beach Lake.

Perching on a small rock, I watched while Oakie lifted up slowly and then swung back over the lake towards home. The sound of his rotors faded out in the far distance, leaving only the sounds of the slapping waves and the rustling of the breeze across the land.

I set off in search of a campsite on the most distinctive landmark, a huge flat-topped erratic not far away.

I knew right away I'd found my spot when at the top of the gently sloping rock was a small level area covered by dry mosses or lichens, sheltered by trees, and overlooking the barrens and the lake.

There are propitious times in all our lives, when circumstances mesh so flawlessly that it appears much more than mere coincidence. At the risk of sounding pretentious, it felt like this was one of those moments.

That night before I went to bed, I gazed up at a sky as black and as filled with brilliant sparkling stars as ever I've seen. I anticipated photographing a sunrise over the lake with its islands wrapped in a glorious halo of glowing colours. But to my great disbelief instead of starry, paling skies overhead when I peered out of my tent at dawn, all I saw was low hanging layers of grey clouds and a grey fog lingering over the lake, instead of the light I wanted so badly.

Shortly after noon, as expected, I heard the high-pitched humming of Oakie's helicopter. Soon I'd leave this wild lonely place, possibly never to return. But I knew I'd never forget these untamed shores.

Sand Beach Lake

At Sand Beach Lake I could roam about freely because of the exposed flood plain barrens along extensive parts of the lake shore and Shelburne River, not to mention a roomy and spacious pine grove, one of the lake's most formative features. There was no worry about finding a camping spot this time. That night I'd be sleeping somewhere under those wind-singing red pines.

Casting my eyes about, I revelled in the stark and simple beauty around me and I had it all to myself. Already I felt contented just to be there.

Once my tent was up and everything was secured I bided my time, hoping the weather would improve as the day was cloudy with only an occasional flash of sunlight. Around 5 P.M., despite little improvement, I decided to make the most of what light the remaining day had to offer and headed for the barrens. It was only August 26, but already huckleberry and blueberry bushes and even a few small maple trees were painted in scarlets, oranges, and reds. I was suddenly struck by the amount of fall coloration around me. At Buckshot Lake there had been practically none.

After photographing some of the barren's most distinctive colours, I walked down to the lake's narrow cove with its numerous rocks surrounded by reeds sprouting like long bleached blonde whiskers. To the photographic eye this was a prime example of subject matter stripped down to its barest, simplest, and most appealing form.

Suddenly the western skies began to break up and sunlight streamed across the lake shore. With perhaps less than an hour left until

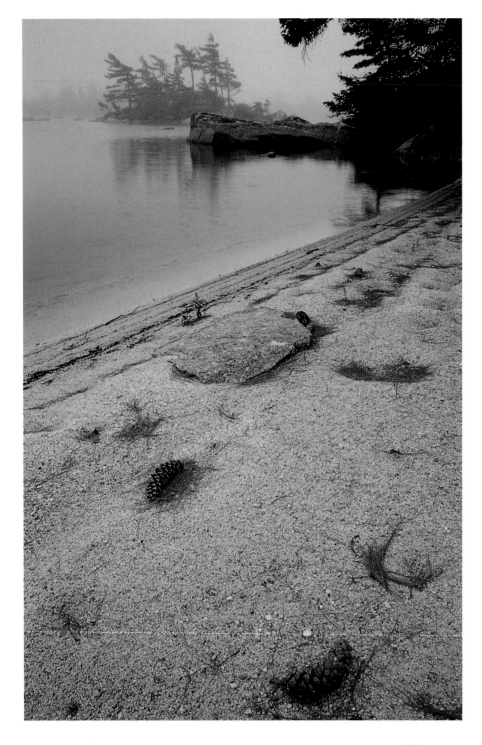

sundown I raced along the edge of the lake, shooting its hulking erratics with their pines crouching above, glazed by the dying sunlight. By the time I worked my way back, I caught the last few minutes of sunlight turning the lake reeds into shimmering strips of molten gold.

In the twilight that followed sunset, I photographed the tall pines and rocks reflected in the lake, and both traced in black against the western sky's orange gleam. With night crashing down around me I was forced to make my way back to my campsite.

After finishing a meal of sandwiches and fruit washed down with cold lake water, I had a momentary desire for a blazing campfire so I could enjoy its cheery warmth. Usually when I'm out camping I don't bother with a campfire because I'm up at dawn. Moreover, after a tiring day of hiking and photographing I'm ready for bed shortly after dark, realizing that dawn the next morning arrives much too soon.

Tonight was different; I felt rested and energetic. But I knew a crackling campfire would be foolhardy. The woods were timber dry and it wouldn't take much for my camping trip to turn into a blazing nightmare. A fire on the beach would have been safe, but I wanted the beach left clean so I could photograph it next morning. Such are the sacrifices one makes in the mad pursuit of photographic subjects. Outdoor photographers have to be some of the most fanatical, long-suffering artists around. We'll face extreme and intolerable conditions at all hours of the day, or even night, from Arctic

Pine cones litter a small beach on a
fog-shrouded morning at Sand Beach Lake.

110

blasts of wind, snow, or freezing rain to searing heat in our quest for that one "great" shot.

What awaited me next morning was even more unexpected than what I had experienced at Buckshot Lake. Proverbial pea soup fog shrouded the world outside. Even the lake only a few metres away was barely visible. No dawn, no sunrise-coloured skies this morning either.

Still, I consoled myself, heavy fog with its eclipsing and shifting veils often lends an air of mystery to the landscape, and sure enough, just a few metres from my tent I spotted my first photogenic subject. There, laying flat atop the low bushes, were dozens of tiny spider webs beaded in globules of condensed fog.

I wandered around the borders of the cape for most of the morning, enthralled by the eerie atmosphere provoked by the fog while trying to capture its effects on film. I photographed the immaculate sandy beaches, the offshore islands, the cape's end point of small misshapen pines, erratics, and white, fluffy-headed cotton grasses, and the Shelburne River with its singular patch of lily-pads and its opposite shore of bent conifers. I even photographed my own tent through the softly outlined shapes of the pines, disguised by pearly grey curtains of billowing fog.

By the time Oakie arrived, this time earlier than expected, I had decided to return with him to Bear River rather than to wait out the unsettled weather. My trip had been cut short, but I was already looking forward to photographing the Tobeatic wilderness festooned in its finest autumn hues.

I returned to Sand Beach Lake on October 7, a warm day of cloudless, deep blue skies. My previous visit to the Tobeatic had been plagued by a malfunctioning camera. Almost all of my sunny exposures from Buckshot and Sand Beach Lakes had been ruined by an erratic camera meter. Strangely, pictures I had taken under overcast conditions were fine. So, for this trip I had brought along my two older but trustworthy cameras in place of my now-being-repaired newer one.

Although, as I soon discovered, much of the area's foliage had already passed its peak coloration, the aspens, birches, and larch trees were in higher spirits, flaunting their bright yellow and golden coats of autumn.

When the evening light was right, I left my old campsite in the pines to retrace my route along the opposite shore. I was determined to rephotograph most of what had been so badly botched on my last visit. I couldn't have wished for better circumstances: the setting sun was unfettered of even a single cloud. Its radiance was even better than previously, highlighting the windswept, lonesome barrens and lake shore in fleeting amber tones.

Of everything I photographed that evening I saved my most spectacular shot for after the sun went down.

I positioned my camera behind a large rock that rose up out of the lake, where before me the cove lay showcased, its waters crystal still, reflecting the surrounding tall pines. I waited patiently while the sky's twilight colours grew bolder until they reached a crescendo in yellow, pink, and magenta shimmering bands, broadcasting this splendour in deeper shades upon the lake's flawless surface.

Out of its surrounding luminescence, a silvery crescent moon hung low in the sky next to the nearest pines, adding its special touch to this grandeur of nature I was witnessing.

I photographed from this spot until the twilight colours finally faded into murky oblivion. As I trekked back to my campsite in darkness, I felt confident that this time around I really was coming away with some highly successful shots.

Next morning, to my surprise and delight the dawning skies threatened to out-perform the previous evening's extravaganza. Profiled in midnight black, the lake's closest island and a smattering of lake rocks stood squarely against an eastern sky evolving into a fiery horizon of dark orange and yellow with a higher, pale layer of peach blending into various shades of blue.

As the sun approached the horizon, the dawn's colours gradually dimmed. I stood my ground until the sun's disk broke the horizon, and I began a frenzy of shooting, bracketing my exposures until the sun's brilliance flared my lens. Then, turning my back to the sun, I photographed the head of the cove with its shoreline of stately pines.

The rising sun's light was magical as it painted the lake shore in a deep, rusty orange tint before it paled into golden tones suffusing every bush, rock and tree, and each single lake reed already bleached golden by autumn's Midas touch.

I dashed about, racing against time, frantically photographing everything of beauty that I could see, knowing this light would ebb away with the ascending sun. I made it to where I had photographed the cove under its twilight skies the previous night before the sun's light

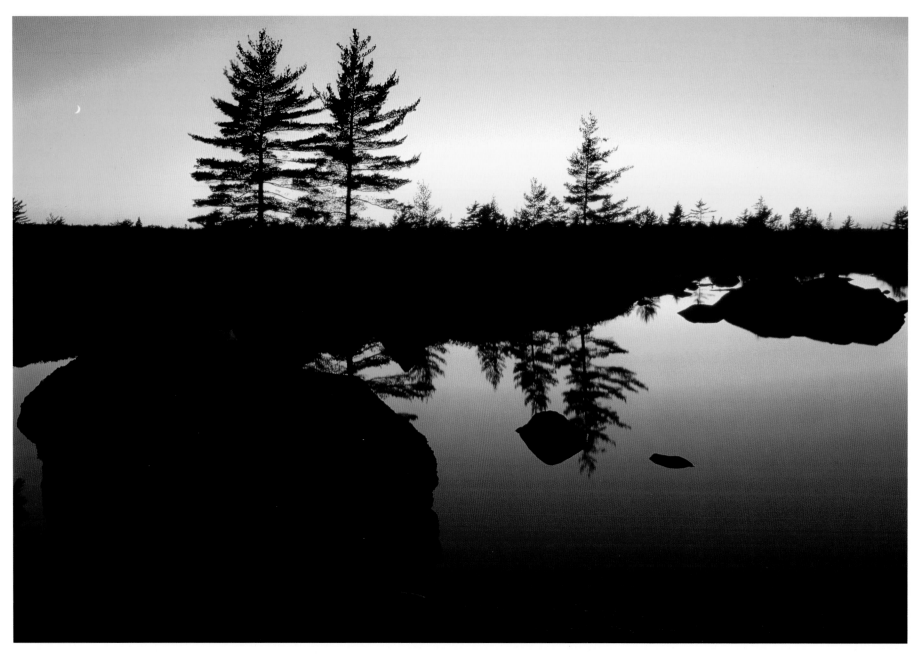

Twilight colours infuse a peaceful Sand Beach Lake.

lost the last vestiges of its golden polish.

All too soon Oakie and I were aloft and swerving off over the treetops away from Sand Beach Lake and its sky-blue sparkling waters. Turning around I caught a farewell glimpse of the pine grove and island and then the lake was gone, swallowed up behind masses of dark green spruce and fir.

Junction Lake

That same afternoon, we set down at the head of Junction Lake in an area of open mossy ground blessedly clear of the surrounding troublesome shrubbery, near a small rise of land dominated by a mammoth erratic.

Junction Lake was dressed in far more colours than Sand Beach Lake had been. Here most of the huckleberry and blueberry bushes were at their climax of reds and oranges, and with the aspens and birches wearing their brightest yellows.

Near where I had pitched my tent, the very northern point of Junction Lake splashed against the barrens where the boundaries of four counties, Digby, Queens, Shelburne, and Yarmouth intersect—hence the name Junction Lake.

I waited for the light of late afternoon before setting out in search of inspiring photographic images. One of the most eye-catching appeals of Junction Lake was its barren's shrubbery—huckleberry and blueberry bushes backlit by the sun glowing with radiant crimsons, reds, oranges, and yellow-green leaves growing among the half-covered boulders and baby larch trees adorned with their brilliant yellow and gold needles.

Directly inland across these sun-flaming barrens at the edge of the woods, I was drawn to a grove of gangling old maples. They had lost half their leaves, but the remnants shone translucent orange against a sky of dark azure, when, that is, I could find the sky clear. That entire afternoon I was plagued by a sky cursed with an endless stream of jet contrails passing overhead, mutilating that gorgeous blue sky with their unseemly pollution.

After much wasted time, I found several moments when the sky was free of contrails and I could photograph this maple grove to my satisfaction. That evening I wrangled my way through the waist-high huckleberry bushes to the outer edge of an adjacent cove of the lake. From that scenic perimeter I managed to shoot various perspectives of the lake with its foreground shoreline of crimson bushes and fresh, young pines. Lastly I turned my camera to overlook the inner cove as the sun rapidly set over it.

My first objective the next morning was to investigate the grove of colourful old maples that lay almost directly across the head of the lake surrounded by a more predominant mix of scrubby spruce, fir, and pine forest.

Sadly, when I arrived at the maple grove the grey skies were discouraging. I regretted not coming the previous afternoon to at least attempt to photograph these lovely trees backlit against a dark blue sky momentarily free of disfiguring contrails.

A nearby cove was my second objective, and after a strenuous hike across the barren, through brush entanglements and down a white pine ridge, I arrived at the water's edge, walking around the shoreline to get a better photographic perspective of the cove itself.

Just as I started to take my first shot, the sun amazed me by breaking free of its cloudy prison and shafting down upon the lake in an overpowering spotlight for a few brief seconds. Within minutes incredibly photogenic blue skies with puffy cottonlike clouds graced the cove above, while below its water, rocks, trees, and marginal barrens were brought alive by tides of sunlight washing repeatedly over them. I had held no hope for fair skies that morning, and now I was overjoyed to find how wrong I'd been.

I reached my tent dehydrated and several kilograms lighter shortly before noon and thankfully was packed and waiting by the time Oakie returned.

Whitesand Lake

As I believed it would be, Whitesand Lake proved itself a marvellous place to cap off my camping trip to the Tobeatic wilderness that fall.

The afternoon of my arrival, I settled into the homey comforts of Oakie's two-room cabin with pleasure. The main room with its large picture window facing the lake was bright and cheerful, with the usual cabin comforts.

Tearing myself away from the cozy cabin warmed by a breathless Indian summer sun, I cut out to explore the predominantly hardwood forest that draped itself around the camp.

I found a path leading down to Moosehead Stream hidden by the brush and trees only a short distance away. After crossing the shallow boulder-studded stream I found myself wading through richly dressed, rusty coloured fern and hardwood meadows that bordered the lake shore. The hardwoods around the cabin still retained bright colour mainly because they were

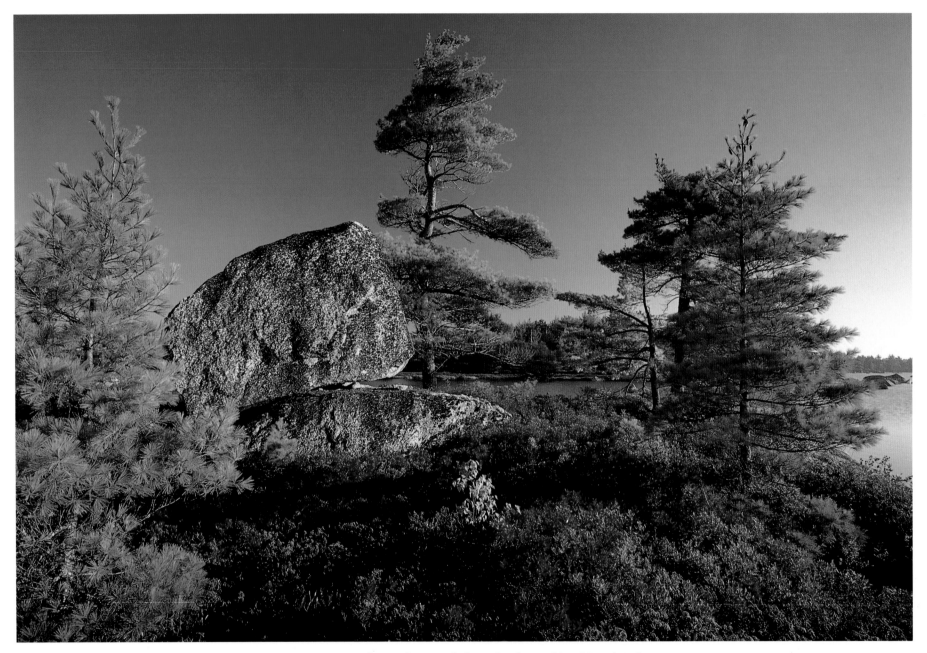

Large erratics and pines keep vigil along the shore of Sand Beach Lake.

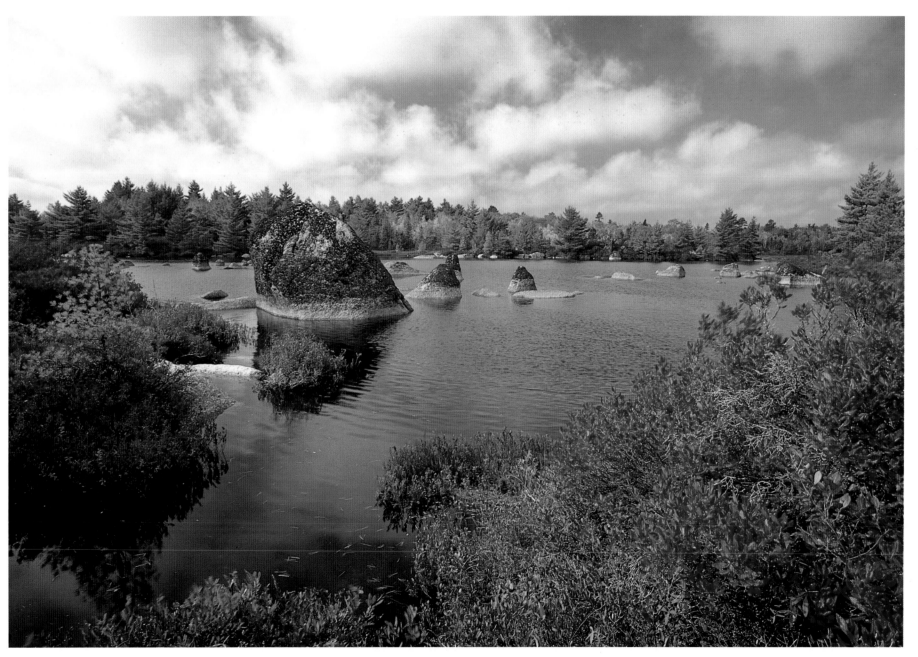

Along the edge of Junction Lake.

the more late-blooming trees—beech, ash, oak, and aspens. Many of the maples populating the lake shore were already past their colour.

After roaming about those golden sun-splashed meadows endowed with their sweet scent of aging ferns, I explored the two elegant, crescent white-sand beaches (the larger around 150 metres long) not far away along the eastern lake shore.

There is another camp at the northern end of the lake that was almost impossible to see, camouflaged in an overgrown clearing up a low hill from the lake. It was along the rocky shores past this camp that I came upon a deeply flowing stream running out of the lake.

It was too deep to cross without getting a lot more than my feet wet, so I returned back along the shore as the setting sun cast the beaches (pockmarked with dozens of moose hoof prints) in a lovely glowing sheen of orange and salmon pink.

While waiting for the lowering sun to sweeten its presence over the land I rested, enjoying the view and listening to the wind as it whispered its secrets across the barren. With the sun plunging close to the horizon I hurried back across the barren to a secluded inlet I had noted previously. Among the erratics many lake reeds popped out of the shallows, and these rocks, reeds, and surrounding yellowed grasses began to be burnished in orange-golden tones as if they were spun from molten gold. I had time for only a few compositions before this golden light was stolen away with the sun below the forested horizon, and twilight's softer shades fell over this watery world.

I continued along the edge of the boulder-strewn lake shore and as the incandescence of the twilight colours deepened I turned my camera back up the lake. What I witnessed was breathtaking. The lake's emerging rocks were black angular lumps of solidified midnight, razor sharp outlines against rainbow-coloured water as still as crystal, a perfect metaphor of the western sky.

Before turning in for the night, I went outside for a final glance at the lake and skies. Mist was readily forming in the cove at the lake's western end. Great news! This was what I was hoping for and much more come morning—a theatrical sunrise seen through wafting, lacy mists off the lake, something I had sought in vain since first coming to the Tobeatic wilderness.

I should have known better. At the first hint of dawn, I struggled out of bed to look outside and saw … nothing. The world was lost, smothered under a thick blanket of fog. I wanted lake mist, but not this much!

Rather than sunrise on the lake, I decided the meadows would be best photographed under the umbrella of overcast light, and the fog would lend a mysterious atmosphere to the entire land-scape. The closest meadows were the largest and most open, swathed in green masses of stooped New York ferns occasionally clumped with small patches of golden cinnamon ferns. As always, the aroma of the hay-scented ferns made exploring the various meadows an enjoy-able experience for the nose as well as the eye.

After wandering around the meadows and barrens for a while, I found myself back at the western end of the lake. Most of Whitesand Lake is free of the big erratics found in the

waters of other lakes in the Tobeatic wilderness, but in the narrow lake channel I was now viewing were numerous erratics photogenically peppered about, their white or grey rounded forms receding through the fog. Across the narrows the shoreline was skirted by a blushing red and crimson huckleberry barren lined by a spacious grove of regal white pines. Moments after I began photographing this lakeside landscape, the fog began thinning, exposing large patches of blue sky.

In step with the weather, I raced to capture the blue of the sky with the last vestiges of fog lingering down the lake shores.

Less that fifteen minutes later the skies were swept clean of all but a few straggling clouds, and it was at this time that I decided to cross the channel and make the entire 5 kilometre (3 mile) trek around the lake back to the cabin.

Rolling up my pant legs and wrestling against dark fantasies of slipping and dunking my equipment, I made two trips to bring every-thing across, without incident. Secure on the other side, I eagerly struck off up the lake shore.

Passing one sandy cove after another, I stopped often to photograph the sweep of various beaches with their perimeters of flaming shrubbery, large rocks, showy hardwoods, and sweet-scented pines.

As I neared the northern end of the lake one scene in particular caught my attention. Sandwiched between two large rocks on the edge of yet another small beach was a young maple tree, its top bereft of leaves, its upper trunk and branches a naked grey outline against a royal blue sky. The maple's fallen leaves were rolled in long lines the length of the beach, as if deposited there by tides upon the shore. There

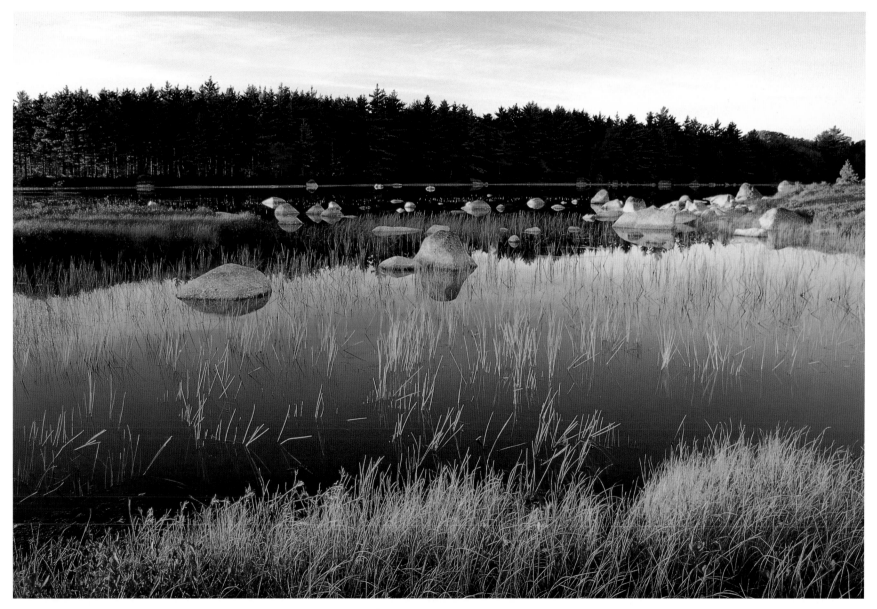

*Lake reeds glow in the evening sun at the western
end of Whitesand Lake.*

was something compelling about this image—so symbolic of autumn and the endless cycle of life with all of its exuberance, then its inevitable decline, death, and final decay.

Just past the next beach I came to a small point encompassed by a collection of large erratics where, just metres offshore, lay Whitesand Lake's only island. This thin strip of land only 15 metres or so long, looked quaint and lovely with its line of white pines and one immature maple in loud orange leaf. The trees stood slippered in crimson and scarlet huckleberry leaves, peacefully reflected in the blue mirror of the lake.

Further along, another inlet of the lake, distinctive for its many clusters of rocks, became a subject for my camera. In the sunlight its white-grey boulders were so reflective and bright that it hurt my eyes to look at them. At the head of the inlet I stopped for a wide-range camera view of this rocky cove with its bordering barren and feathery pines and a small island charmingly set in the background of the lake. In the breathless hush of high noon, the water of the cove was a frozen sheet of cobalt blue.

Under the hard glare of the noonday sun, I continued down the other side of the lake, stopping only a few times to photograph along the remaining two beaches before I came full circle back at the cabin, feeling hot, parched, and tired. And I stayed there until the sinking sun was playing a game of hide-and-seek through the clouds on the western horizon.

Then I lumbered back to my favourite beach. Dominating each end of the beach was a gorgeously coloured maple tree crowding down over the sand: the shorter one hanging its scarlet leaves umbrella-like over the beach in a graceful spreading veil, the taller one standing stately with leaves the hue of bright tangerines.

I was just about to leave when the clouds that streaked the western horizon began to flame into bands of orange, reflecting upon the smooth surface of the lake. Frantically searching the beach for a good foreground subject to include in a shot of the lake and sky, I chanced upon an interesting piece of driftwood. It was a slender tree limb, a barkless white skeleton whose end spread out into five tiny branches like the fingers of a hand. This was perfect!

My last pictures of the Tobeatic wilderness were taken from the beach closest to the cabin, where I waded out into the lake so I could capture the horizontal stretch of the beach, including the tops of its tallest bordering maples.

Whitesand Lake is one of the fairest jewels in the crown of the Tobeatic wilderness, which is the largest remaining tract of unspoiled wilderness left in the Maritime Provinces. It must not be sacrificed on the alter of short-term commercial profits in mineral or timber extraction, destroyed and then abandoned as wasteland, as is now the threat to the Tobeatic Finger. This is our birthright; our wilderness heritage we must not relinquish for a mess of pottage.

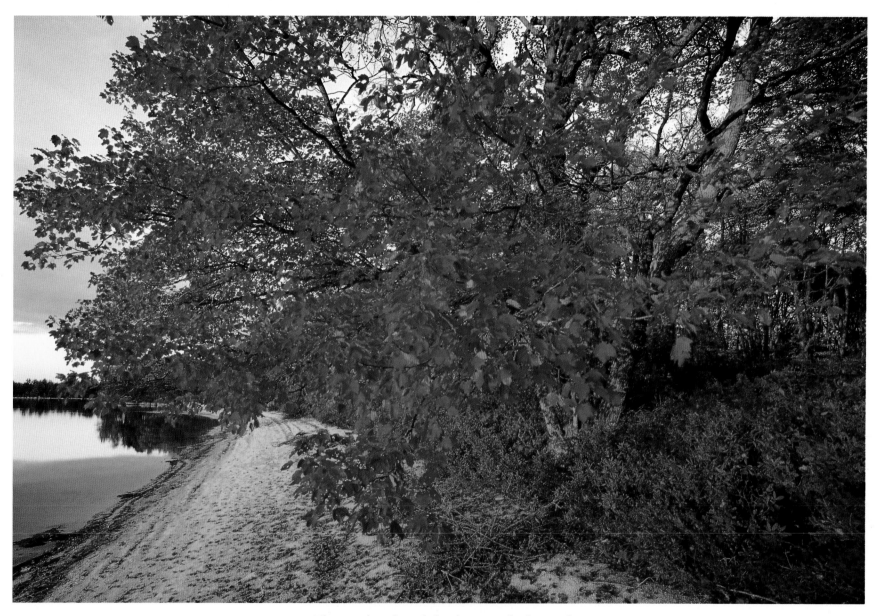

This stately red maple borders one of Whitesand Lake's largest beaches.

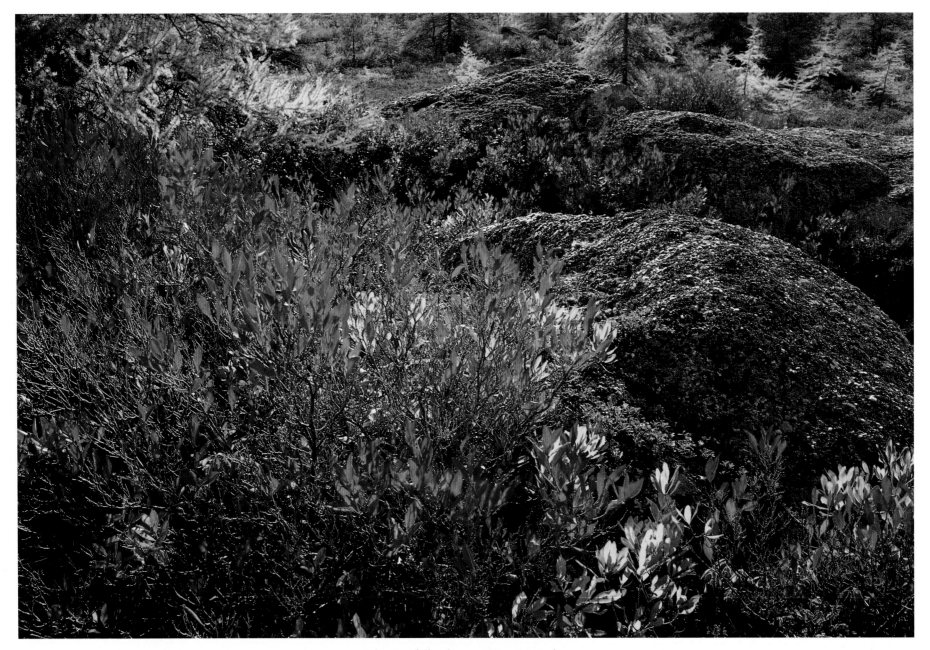

Glowing fall colours at Junction Lake.

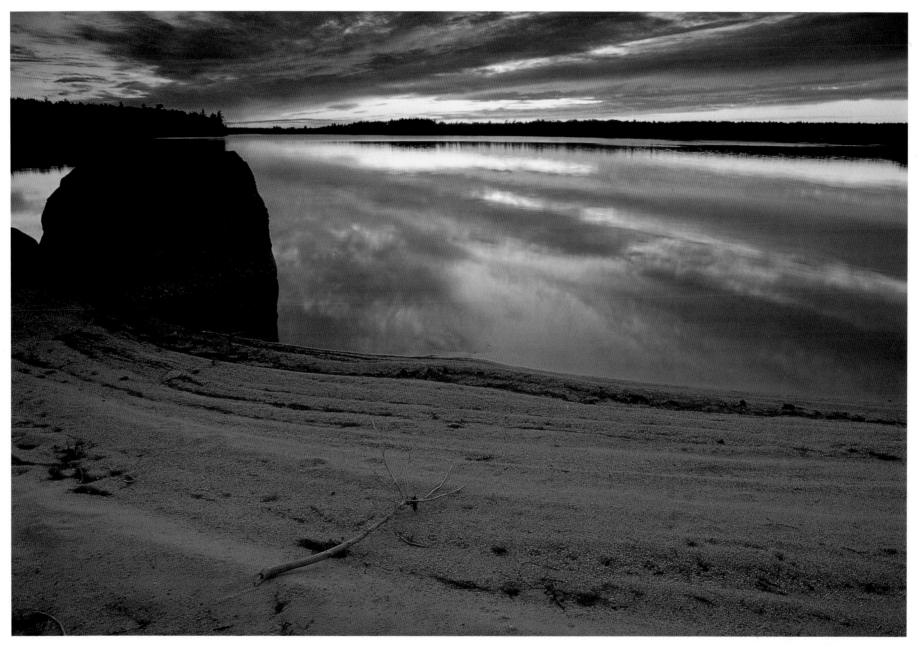

A piece of driftwood litters a beach at sundown.

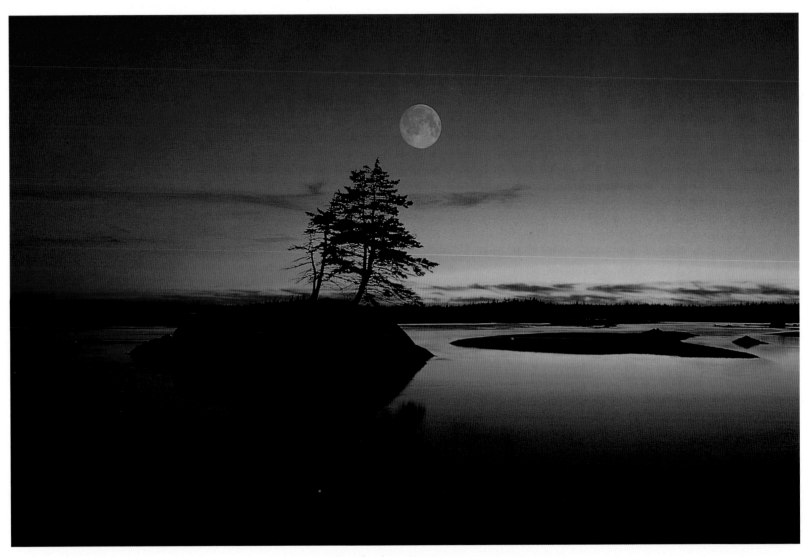

Moon and tidal inlet across from St. Catherines Beach
in twilight afterglow.